Vanishing Points

Vanishing Points

*Three Dimensional Perspective
in Art and History*

MILTON E. BRENER

McFarland & Company, Inc., Publishers

Jefferson, North Carolina, and London

LIBRARY OF CONGRESS CATALOGUING-IN-PUBLICATION DATA

Brener, Milton E., 1930–
 Vanishing points : three dimensional perspective in art and
history / Milton E. Brener.
 p. cm.
 Includes bibliographical references and index.

 ISBN 0-7864-1854-0 (softcover : 50# alkaline paper)

 1. Perspective. I. Title.
NC748.B74 2004
701'.82—dc22 2004006352

British Library cataloguing data are available

Cover art: Fra Angelico, *Coronation of the Virgin* altarpiece from
San Domenico. Detail of predella: *Saints Peter and Paul Appearing
to Saint Dominic,* ca. 1434. Tempera and gold on panel, 83⅞" × 93⅛".
Musée du Louvre, Paris.

Manufactured in the United States of America

McFarland & Company, Inc., Publishers
 Box 611, Jefferson, North Carolina 28640
 www.mcfarlandpub.com

To Eileen
and
to Max and Chelsea

Table of Contents

Preface

This book was not planned. It grew from a developing perception after decades of viewing art in museums and in books. I was absorbed by the phenomenon of the blank, expressionless face with the empty unfocused gaze found in so much of the world's art. In ancient and medieval times, it was all but universal. Ultimately, I began to notice that those blank faces, throughout history, always seemed to come and go with flat two-dimensional perspective.

In a previous book, *Faces: The Changing Look of Humankind,* I explored some possible answers to the mystery of the lack of expressiveness. One of the matters I briefly touched on was the correlation in art between the development of expressiveness and of three dimensional perspective.

About facial expression there is much in the scientific literature, and it connects the expressiveness itself, as well as our ability to immediately interpret it, with the functioning of the right cerebral hemisphere. About three dimensional perspective there is substantially less. But what there is, intriguingly, establishes a connection between that perspective and the proper functioning of that same right hemisphere.

In its broader aspect, the right cerebral hemisphere mediates our sense of visual aesthetics, which is essentially our ability to see—or, better said, to *create*—relationships between things in our visual field. The "beauty" we see in the juxtaposition of rolling hills and valleys, or between mountains and open sea, is as much a creation of our minds as is our fascination with the expressiveness of the human face. It became evident to me that the aesthetic pleasure derived from our innate capacity to see depth in the visual field has had a tremendous impact on the growth of humanism. One thing it has brought about is landscape painting, and thus a changed view of nature, one involving admiration and investigation rather than fear.

Considering these recent scientific findings, the art historian's fre-

1

quent assumption of an unchanging human mentality throughout history, and of a purely cultural basis for changes in "styles," raises some puzzling but interesting questions: Where was the evidence of appreciation of the illusion of depth in the art of ancient or medieval peoples? Why did both expressiveness in portraiture and three dimensional perspective make their debut in the world's art at the same time and place, namely in ancient Greece and Rome? Why did both skills disappear upon the invasion and settlement in southern Europe by the northern peoples? Why did both blossom again, in tandem, to even higher degrees of perfection in the European Renaissance?

Why did landscape art—the depiction of natural beauty entirely for its own sake, now such an important art genre—not make an appearance until the sixteenth century, but a mere hundred years after the development of three dimensional art? If flat, two-dimensional art was merely a matter of choice, culturally conditioned, why did so many of the world's cultures, completely isolated from each other, draw and paint in the same flat style?

To a certainty, the ability to determine depth and comparative distance has been a capability of all humans from the beginning. The history of art and the history of literature alike, however, compel the conclusion that our aesthetic enjoyment of that capability, as opposed to its purely utilitarian value, has been with us only in recent times. If it results, as I am convinced it does, from a change in the functioning of the brain, that change would be a very slight one. The ramifications of that change, however, would be tremendous.

For the past five hundred years there has been a view of nature different from that previously prevailing. It is one that sees nature as an entity apart from humanity (illusory though that may be)—an entity whose various aspects are interdependent and interrelated, an entity that is subject only to its own laws and internal dynamics and does not serve as an instrument of either reward or punishment for human behavior. The cause of this new outlook may be subject to debate. The fact that that it is new in human history is not. This book deals with both the change and the possible causes. If the reader should find the proposed answers to the questions unacceptable, I hope at least that the questions it raises will make the reading of it worthwhile.

Some of the opinions in this book are not mainstream. None of them has been suggested by anyone other than myself, and no one else is to blame for them. I have, nonetheless, been immeasurably helped in my own work by the research and the guidance, in their respective disciplines, of Dr. John Cutting, a psychiatrist, of Forest Row, England; Nikolai Nikolaenko, a neurologist, of St. Petersburg, Russia; Dr. Edward J. Steele, an evolutionary biologist, of Wollongong, Australia; Dr. Eva

Jablonka, an evolutionary biologist, of Tel Aviv; and Dr. Paul Ekman, a psychologist, of San Francisco. My sincerest thanks and gratitude to each. Special credit is also due Dr. Nia Terazakis and Candice Parker for the excellent photographs of the Athenian kosmetes shown in illustration 18. My continuing thanks also to my skilled and patient editor, my wife, Eileen.

I

The "Discovery" of the Third Dimension

Brunelleschi and the first scientific use of perspective in art; its significance for landscape painting and a changing human view of nature; aesthetics of the third dimension in modern and ancient times; ancient perspective and the lack of unity in space; what we see versus what we know; Alberti and the rules of perspective.

One day in the early 15th century, Filippo Brunelleschi could be seen walking the streets of Florence carrying a hand mirror and a painted panel he had recently completed. A painted panel was not unusual; the hand mirror was. No one seems to know the exact year of this strange outing, but it was probably no later than 1420, and Brunelleschi thus no more than 43 years of age. The subject of the painting was the Florentine Baptistry and the open square on which it fronts. They were painted as though seen from a point just inside the door of the uncompleted Cathedral of Santa Maria del Fiore, situated on the opposite side of the square, and at that time still without its now-famous dome. On the face of his painting, at a carefully selected spot, the artist had placed a hole, a very tiny one, but opening wide enough at the back for a viewer to place an eye. At some point, which may or may not have been near the Baptistry, he invited passersby to peer through the back of the painting which was to be held with one hand, and to see the reflection of it in the mirror that was to be held with the other.

Who was Fillipo Brunelleschi, and exactly what was he up to?

He was a Renaissance man, born at the beginning of that creative episode, and a personification of it. It was a time when Italy was alive with burgeoning individuality, a commodity that he fairly radiated. From his monument in the Florence Cathedral, his countenance seems to reflect both steely-eyed determination and audacity; the piercing gaze,

a defensiveness and irascibility, all of which impressions are confirmed by the story of his life.

As a youth, on his own insistence, he was trained as a goldsmith. A contemporary biographer reports that he later took care of business matters for soldiers, but offers few details. It was well documented, however, that he was engaged at times to recruit mercenaries from lands north of the Alps, his contribution to Florence's numerous wars against her sister city-states of Italy. This could have been a thankless and frustrating task at times, as these soldier-businessmen were often known to change sides in mid-war when the price was right.

He is best known for the construction and placement of the majestic dome on Santa Maria del Fiore, the cathedral from which he had earlier painted his panel. Its prominence is such that it is often referred to, in this city of cathedrals, as the Florence Cathedral, or just as often, simply as the Cathedral. Its towering dome, for almost six hundred years now, has dominated the entire city and seems as permanent as the rolling hills of the surrounding countryside. The sacred structure it adorns is Brunelleschi's final resting place, but there are additional monuments to him remaining, namely no less than six other of his architectural works. They include some of the most famed landmarks on the city's fabled skyline, their names resounding with the aura of Renaissance Florence: the Pazzi Chapel at Santa Croce with its sculpted tomb of Michelangelo and those of a bevy of other renowned artists and scientists; the Santo Spirito; the Palazzo Pitti, the famed "Pitti Palace," one of the two finest art museums in a city exploding with them; the Foundling Hospital; the rotunda of the Santa Maria degli Angeli; and the Old Sacristy in the San Lorenzo district. To his credit also are at least four other once-historic structures that no longer exist, and a number of fine sculptures executed in silver, bronze or wood. As artist, sculptor, engineer, or architect, his prodigious output in every creative field to which he turned bore the mark of his genius.

Not all of his projects ended well, however. In 1421, during a conflict with the City of Lucca, he persuaded his fellow townsmen to change the course of a small river in the vicinity on the promise that it would flood the enemy camp. The scheme backfired and inundated only the Florentines. Even Renaissance men cannot be masters of all trades. Nonetheless, he seems to have tried.

From all accounts, he was also a precursor of the prima donna, with an ego and a craving for praise and recognition more often associated with some opera singers of later centuries. He is not known to have exhibited an excess of modesty, nor was he above feigning illness or perpetrating other chicanery to achieve his purpose. By his contemporary biographers he seems to have been much admired, but vanity, arrogance

and a callous disdain, if not contempt, for his competitors all simmer between the lines of their accounts, and often in his own utterances. At the ripe age of 57 he was sentenced to prison for his refusal to pay taxes to the Guild of Stonemasons and Woodcutters, and was freed only through the intervention of officials of the cathedral.

So much for his temperament. What was he doing on a public street carrying a painting with a hole and a hand-held mirror?

He was exhibiting in dramatic fashion to anyone who would look, a new way of painting, a new way of representing a three dimensional world on a flat surface, a new conception of space; and he wanted his fellow citizens to understand just how amazing his discovery was. But even he may have grossly underestimated the magnitude of his accomplishment. According to contemporary accounts, those who first saw it did indeed marvel at how precisely the painting resembled the scene in life that it represented. Those who have written about it in later years have marveled even more at the revolutionary nature of this new style of representation and the dramatic impact it has had on the history of art in the Western world. But they too may have underrated it.★

Its impact has extended far beyond art. It made possible the genre known as landscape painting as we know it today, painting that has as its purpose the reflection of nature's beauty entirely for its own sake rather than as background for human activities or human thoughts or spiritual beliefs. It heralded a new mentality, an all-encompassing perception of beauty, and a different conception of nature than had ever existed. Some few artists were perhaps the first to see this beauty in the unity of an entire vista and, through the windows of their canvases, to reveal it to countless others who had never before experienced it. And it was only when nature was so revealed that humanity began in earnest to investigate its mysteries. But in the early 15th century, true landscape was still a hundred years or so in the future, and fully developed scientific inquiry, and the harnessing of nature's resources, over three hundred years away.

This portrayal of depth in art was the first occurrence of its kind since classical Roman times, but also its first appearance in its fully developed, geometrically controlled form. It quickly became known as three dimensional perspective or, more often, simply as perspective, the term being understood to apply only to the illusion of depth. In the Western world it soon became, at least until the 20th century, the universal method of scenic portrayal.

★*There was an earlier painting by Brunelleschi, also in rigorous three dimensional perspective. This was the front of the Palazzo della Signoria, with two of its defining sides receding at obtuse angles into the distance. Sadly, both of these three dimensional panels have been lost.*

But what is so remarkable about three dimensional paintings? They are dashed out today by every street-corner artist and amateur. Why should they not be? Have not humans always seen the world in three dimensions? And if so, why have they not always represented this depth in art?

First things first: We have always seen the world in three dimensions. From the time that humans first walked the earth, our vision has been three dimensional, an inheritance from our more primitive ancestors. We have been able, that is, to judge depth; to see which objects were closer to or further away from ourselves than others. Not only humans, but all primates, most mammals, all birds and lizards, and many other reptiles and insects and other creatures have this innate ability to judge distance. The human ocular apparatus has, in all probability, changed very little if at all in the several million years of various specimens of human life. The earliest humans and other species were, to a near certainty, able to see and to rely, even without conscious thought, on the same clues as do we to judge depth.

The most important clue is the convergence of sightlines in the distance. The sides of a path or road seem to gradually come together as we gaze down its faraway reaches, though we realize they do not. Objects in the distance look smaller than objects of similar size that are closer, though we likewise know better. Objects further away, even if on the same flat plain or on the open sea, seem higher in our visual field than those that are nearby, though, again, we know otherwise. The same illusion causes birds or clouds in the distant sky to appear lower in our field of vision than do those less far, even though we may know they are at the same height above ground. It is this phenomenon that causes the sky to seem to meet the earth along that illusionary line we call the horizon. Objects in the distance, even large ones, may be largely obscured by very small ones that are near to us. We will know, however, that the hidden part is there, and will often be able to envision it. The world as we see it is largely illusionary, and, consciously or otherwise, we are aware of the fact.

Humans, though probably no other creatures, derive aesthetic pleasure from these relationships. The smallness of the house on the distant hillside, the diminishing size of trees and rocks on the high reaches of tall mountains, the pond showing a mere sliver of an inviting shore from behind the lush greenery of a dense forest, all arrest our attention. For until we are, for compelling reason, focused on a single feature, upon encounter with a new environment we are drawn most often to the entire vista, not to the single object. What gives us aesthetic pleasure is not so much the single hill, the isolated grove of trees, nor the lone house in the distance, but the relationship between them and their surroundings. We find beauty in the illusions.

Relationship between parts is the very essence of beauty. Whether the target of our focus is a natural scene, a human face, a structure, or a room, it is the harmony, order, proportion, symmetry, or the pleasing asymmetry, that makes the whole so much more than the sum of its parts. Often the part may become the whole. A house may be a mere part of the aesthetic appeal of a city street, but when the house becomes the whole focus of our attention, it is its individual features that become the parts. We may focus on a single mountain instead of the range, and the mountain's features become the parts, and with both the house and the mountain the relationships of parts to each other become the stimulus to our aesthetic pleasure.

This relationship between parts is the most significant factor in our sense of visual aesthetics, more important in large or complex views than in more limited ones, but important in even the smallest objects. It is true both in nature and in art, and three dimensional perspective is a vital aspect of our art.

But self-evident as all of this may be, throughout most of history and in most places, human perceptions and aesthetics have been quite different. When the artist of ancient or medieval times planned to include in his painting a structure nearby and another in the distance, secure in the knowledge that they were of similar size, he apparently saw no reason to paint the distant one any smaller than the closer one. If he knew they were the same approximate size, we may assume that neither he nor those for whom he painted saw any purpose in depicting the distant one as smaller merely because it was further away. They obviously derived no aesthetic pleasure from it. When the house or other object in the distance was partially obscured by the one nearby, the artist saw no reason to omit the unseen portion. He knew it was there, so he often painted what he knew the entire structure to look like, a matter he determined by whatever means available. Obviously it had to be studied from a different position, hence in these early paintings we most often see the total scene from many viewpoints, rather than as it would have been seen by one person at one point in space, and at one moment in time.

To be sure, there was at times overlapping of objects intended to be shown as close together; one chariot or horse, for instance, obscuring part of another, thus affording a hint of depth. But it was a hint at most. The illusionary meeting of the sky and earth has likewise often meant nothing to the artist. He knew they did not meet and there is, frequently, no horizon or ground line. Groups of objects or persons that were meant to be seen behind other groups were usually shown in superimposed rows, one above the other.

Thus, though there was compositional relationship among the various objects in the painting, spatial relationship was ignored. Two

descriptions of the works of these earlier artists have frequently been voiced by art critics and historians. It has been said, first, that each object occupied its own space; that is, there was no overall, all-encompassing space. Space was not a unity. Secondly, it has been said that these artists painted and drew what they knew, and not what they saw. Psychologists and art historians alike sometimes refer to such drawings and paintings as "intellectual realism," as opposed to the "visual realism" of most art of recent centuries. This is a term used frequently by, among numerous others, Jean Piaget, the 20th-century Swiss child psychologist, to describe the drawings of young children, which in many respects are remarkably similar to works of prehistoric, ancient and medieval times.

Why did the artists of these periods draw and paint as they did? The absence of three dimensional art seems to cry out for an answer and to demand more than idle curiosity. But first, let us return to 15th-century Florence.

Brunelleschi did not write about his new method of painting, but contemporary authors did. If they report correctly, the artist apparently had worked out from the science of optics, then seventeen hundred years old, what mathematicians now call the rules of "projection and section." In recent times, however, some scholars have come to doubt that Brunelleschi ever formulated or even understood the theoretical under-pinnings of his accomplishment. Some have concluded that his use of perspective was largely intuitive; that his ego would not permit him to say so; and that he preferred to allow others to believe that he held in secret the rules of this new method of artistic portrayal, which he chose not to share with the world. The laws of optics, as first worked out by Euclid about 300 B.C., had been understood, more or less, by scientists of the Middle Ages in Europe, the Far East and the Muslim world. Remarkably, however, no one in those cultures had shown the slightest interest in applying them to artistic portrayal. Brunelleschi may not have understood the rules that underlay his art, but to a certainty they were understood by Leon Battista Alberti.

Alberti, 27 years the junior of Brunelleschi, was the illegitimate son of a member of a wealthy and prestigious Florentine family of bankers and cloth merchants. Banking and the manufacture and sale of cloth were the major sources of the city's wealth at the time. The family's success earned it the enmity of the more powerful Albizzi family and its consequent banishment from Florence for many years. Thus Alberti was born and educated in Padua. Both of his parents met untimely deaths, raising the specter of a life of hardship. It was decided by other family members that he would be trained as a merchant, his own preference for

art notwithstanding. He later earned a law degree in Bologna. It was as part of his attempt to recover from an episode described as a nervous breakdown that he also studied painting.

The ban against the family was lifted in 1434 by the Medici family, a name almost synonymous with Renaissance Florence, and whose ascending star had surpassed that of the Albizzis. Now, in the manner of medieval and Renaissance Europe, it was the turn of the Albizzi family to suffer exile. This turn of events occurred when Alberti was thirty, past the age at which he might become a permanent resident of Florence. Nonetheless, he spent most of the next ten years there owing to his career with the chancery and his service with the Papal Curia, then located in that city. Inevitably, he came into contact with many of the burgeoning Florentine population of philosophers, artists, thinkers and architects, and there is every indication that he looked upon Florence as his spiritual home.

Like Brunelleschi, Alberti, despite his early hardships and the resistance of the family, evolved into a true Renaissance man: architect, musician, painter and humanist, but he is known primarily for his skills as a writer. His literary output was prodigious, both in quantity and in the diversity of his subjects. Among many other accomplishments, he wrote the first printed book on architecture. The word "printed" is important here, as the Roman author Vetruvius penned his treatise *On Architecture* 1500 years earlier, a work which is likewise of great relevance to the subject of perspective.

Alberti also wrote a multi-volume tract entitled *Book of the Family*, which tells us much of the inner man. His expressed contempt for the endless pursuit of wealth and his disdain for matters of finance seem clearly a rebellion against the profession of his family and his enforced apprenticeship to them. But this practical man of the world soon developed an even greater contempt for poverty, with its concomitant lack of respect and honor. Better to be thought avaricious than poor, he concluded. Wealth should be pursued, but only to gain the authority and honor that accompany it. We have it on his word that he often loaned money to friends without interest for purely altruistic motives. True or not, it is certain that his competitive nature rivaled that of Brunelleschi. One must struggle for fame and glory with all of one's energy, he declared, for the alternative is to be part of that obscure and forgotten crowd in the back. Of his contempt for those in the back, he left little doubt. They were neither wholly alive nor totally dead. Brunelleschi he recognized as one of the winners. Alberti was captivated by his work and took on the task of explaining it to the world.

In 1436 he wrote and published his *On Painting*, the first portion of which painstakingly details the theory and the rules for projecting onto

a flat surface with scientific accuracy (some minor discrepancies excepted) the distortion of reality as perceived by the human eye. It was a scientific explanation of Brunelleschi's painting and the first literary description of one-point perspective: the notion of the vanishing point, the meeting point for all lines intended to be understood as right angles to the canvas and receding into the distance. Such lines are known to artists as "orthogonals." He seemed to believe that Brunelleschi himself did understand the process, and, in fact, dedicated the book to him, as well as to a number of others. Other than in the dedication, though, he does not mention Brunelleschi by name in his text.

A few art historians believe that some ancient Roman paintings, now lost, were executed within similar scientific strictures. Certain specimens of Roman art show at least a clear intuitive grasp of it. Some scholars claim also that the Greeks of Hellenistic times, beginning about the mid–4th century B.C., may have been equally as knowledgeable and their paintings in perspective done with equal rigor. Most of the evidence of that proposition must rest upon a literary source, as few such paintings of the Greeks remain, none of which show a scientific use of perspective. That single literary source, from Rome of the first century B.C., refers to painted backdrops for Greek dramatic performances about 350 years previously, a subject to be investigated later in these pages. In all events, whatever advances in this direction had been made in classical times were lost for a thousand years upon the incursions of populations from northern and eastern Europe into the lands of the weakening Roman Empire.

In the 14th century, another great Florentine artist, Giotto, had made significant, indeed remarkable, strides in the portrayal of depth in space, but his work lacked the precision exhibited by Brunelleschi. Though no one living in recent times has ever seen Brunelleschi's three dimensional paintings, they were described in detail by contemporary writers, and the technique was quickly perpetuated by a host of equally gifted artists whose works do survive. The first were by other Florentines: Masaccio in his paintings, and Donatello in his relief sculptures, then others throughout Italy and all of Europe.

A question remains: Why the hole in Brunelleschi's painting? That is perhaps the least important part of the story, interesting though it is, its relevance justifying only a cursory mention. It has to do with stereoscopy, the means by which we are enabled to feel that we are seeing depth and volume in what is really a flat surface. In the ordinary photograph or painting, we see the illusion of depth, but we see also the flat surface on which the image rests. Hence we know, and can see, that the perceived depth is an illusion. Stereoscopic images, most often exhibited as a curiosity in the early decades of the 20th century, use two identical

photographs held in a stereoscope a calculated short distance from the eyes. When the two images merge, we no longer see the flat surface and we receive a startlingly realistic impression of depth and distance. Individual objects seem to be seen in the round. We feel we are in the picture, not looking at it. Though we know intellectually that this is an illusion, our eyes give us no clues of that, and the perception of depth and volume is visceral.

As Brunelleschi had already perceived, this effect could also be accomplished with the use of one picture and one eye, given two conditions: The picture must be seen by that eye from the center of projection of the picture's perspective, and by one means or another all visual clues concerning the flatness of the picture surface must be substantially reduced. It is extremely doubtful that Brunelleschi understood the theoretical basis for stereoscopic vision, for, as far as is known, the theory was not articulated until 1831 in England. But the use of the hole, the placement of it, and the distance between the painting and the mirror created the desired effect, whatever the theory. The mirror itself can diminish the clues of its flat surface. Once again, this Florentine genius may have accomplished through his artistic intuition what others ultimately explained through scientific deduction. The stereoscopic view can be seen from only one point and under controlled conditions. Move a little away from the point and the picture blurs. It is thus something of a gimmick. Normal 3-D representations are less vulnerable. We can move from one viewing point to another and the clarity of the painting and its illusion of depth remain intact.

II

Art before the Third Dimension

Lack of oblique representations; frontal views; twisted per-
spective and its universal nature in ancient and medieval art;
evidence of different psyche in early peoples as opposed to
lack of analytic ability; Platonism and art.

The change in perspective that was perfected in early 15th century
Florence represents as profound and as far-reaching a change in human
perception as is found in all of history. From the earliest times, classical
Greece and Rome excepted, flat, two-dimensional representation had
been the way of artists, with unthinking, unquestioned acceptance every-
where. There was length and breadth, but no depth. From the prehis-
toric caves of southwest Europe and the rock art of sub–Saharan Africa;
from Egypt and Mesopotamia; from Greece prior to at least the
mid–sixth century B.C.; from the Mayans, Inca, and Aztecs as well as from
those populations in the New World that preceded them; from India,
Japan and even the splendid art of China; three dimensional perspective
has been glaringly absent. During the Middle Ages whatever the Greeks
or Romans had known of it disappeared entirely. A related artistic device,
"foreshortening," though not disappearing completely during the Mid-
dle Ages, was used less frequently and with considerably lesser effect.

"Foreshortening" refers to perspective as applied to a single object.
The depth of an object can be shown only when it is seen from an oblique
view. If we see any object entirely from one surface we see no depth or
volume. Yet the fact of obliqueness means that all or part of the object
is at an angle to the surface of the canvas or other medium, which requires
that it must be represented as shorter than it really is in proportion to
objects not foreshortened, in order for the two-dimensional image to
match the illusion of differing size created by human vision. If a boat,
for instance, is shown entirely in profile, in other words parallel to the
plane of the canvas, a sail that is at an angle to the boat must be depicted

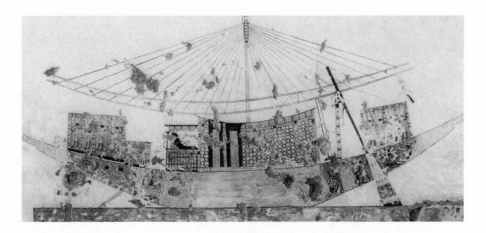

ILLUSTRATION 1. *Ship.* The British Museum. A painting from the tomb of Huy. Thebes, about 1360 B.C., from a reconstructed copy in the British Museum.

as narrower than its true full width in proportion to the boat. That this was a matter of no consequence to the Egyptians can be seen by a number of paintings, exemplified by a reconstructed tomb painting of a boat from Thebes about 1360 B.C. It shows the sail from the front, in its full width, but parallel to the profile of the boat (ILLUS. 1). Likewise a human arm or leg shown almost perpendicular to the canvas should be quite a bit shorter than one shown full length, or parallel to the canvas, but the closer it comes to being parallel with the canvas, the proportionately longer it will be. Whatever the Greeks knew or did not know about three dimensional perspective involving relationships between objects in space, they became masters of foreshortening; the artists of the Middle Ages of Europe, much less so.

Throughout antiquity, with the possible exceptions noted, and throughout the Middle Ages, we see no interest in depth of field or the spatial relation of objects to each other. The scenes we see combine various viewpoints, with the objects in them often juxtaposed according to their importance to the artist rather than their spatial relationships to each other. In Mayan, Egyptian, Assyrian, Oriental and European medieval art alike, we see one object placed above another, though often it must have been meant to be behind and partially hidden by the lower one. In other cases the placement of an object higher than another could indicate that it is further from the viewer, but even so there is usually no reduction in size. The same is true of groups of objects. For example, two lines of Egyptian rowers, in reality side by side, are shown as one above the other.

With regard to the rendering of individual persons or things, the

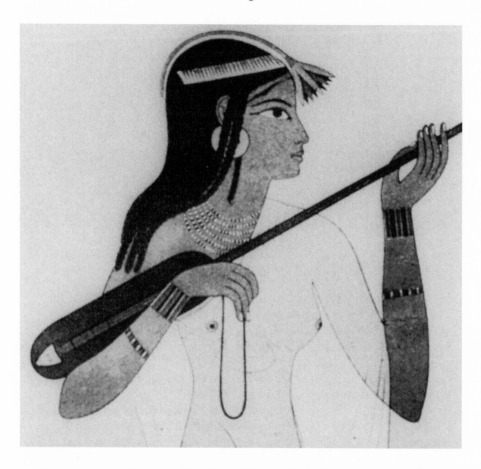

ILLUSTRATION 2. *Musician*. After fig. 9, Richter, Gisela, *Perspective in Greek and Roman Art* (London: Phaidon Press, n.d.), citing Schäfer, H., *Von Ägyptischer Kunst besonders der Zeichenkunst*, 2nd ed. (Leipzig: J.C. Hinrichs, 1922). Drawing after New Kingdom painting.

same propensity holds true. Here we sometimes see what artists and art historians call "twisted perspective." The artist depicts the parts of his subject that he feels are important to be seen, even though they would not be visible in life, given the orientation of the object or person as shown in the painting.

One example of twisted perspective is the 'law of frontality,' which, with about a four-hundred-year period of minor exceptions, dominated Egyptian art for over twenty-five hundred years. It allows views only of the full surface, whether front, side or rear, of the part to be depicted. It does not allow views of partial surfaces as seen in life, nor of oblique angles showing sides foreshortened, likewise as seen in life, and the only

way to depict volume. Because of this practice, in ancient Egyptian paintings of people we often see the head in profile, but shoulders and chest shown from the front, and one eye fully visible and as though also seen from the front, an impossible situation in life. This "frontality" is shown in ILLUS. 2, where we see not only these anomalies but also a profile breast on an upper body shown from the front. Each part of the body was shown from its favored view. The eye was usually drawn without eyelids. But when eyelids were finally depicted, the upper one slanted upward and the lower one slanted downward, thus revealing the full shape of the lids, even though they do not appear so on the human eye, and would be useless if they did. If the artist found the arch of the foot pleasing to his sight, we sometimes see side views of both of a subject's feet with arches. This gives a right-facing figure two left feet, a matter of apparent indifference to the spatial and aesthetic perceptions of the Egyptians.

One art historian wrote that the perspective of any art culture is the "manifestation of the ordering tendency of the brain."[1] Many have agreed that the basic characteristic of the Egyptian's use of space was the separate attention paid to individual parts rather than to the whole. But the practice was not limited to Egyptians.

The art of the contemporary neighbors of the ancient Egyptians, namely the Babylonians and Assyrians, depicted chariots, animals, buildings, furniture and humans, always as shown from the frontal plane, often with front and profile views pieced together, and without indication of depth. Like those of the Egyptians, their scenes show no diminution in size of objects in the distance. There is very little overlapping indicative of one object being behind another, and no hint of oblique views. The same may be said of the art of the Mycenaeans of mainland Greece and the Minoans of the island of Crete, and, in fact, all Greek art prior to the sixth century B.C. Thus a warrior in combat, for one example, is often shown in profile, but with his shield seen as though viewed from the front, implying to our modern eye that it is held to his side, a position that would make it useless to him.

The many chariots represented in ancient art are usually shown from the side but with all four wheels visible in full, in a manner, as pointed out by Piaget and others, very similar to the drawings of children today. In other cases the vehicle is shown with only two wheels visible, with no hint of the other two, rather than showing them partially occluded (that is, with overlapping of the distant two by the nearer ones). This does not involve a twisted perspective, but does represent a strict adherence to the law of frontality. The view is directly from one side and thus shows no indication of depth. Two-wheeled chariots in such cases often show but one wheel.

In the paintings of the Mayans of the Yucatan, hundreds of years

before Columbus, we see virtually the same characteristics. Faces in profile, bodies from the front, the similarity to Egyptian paintings is almost startling, though the possibility of influence by either art culture on the other is nil. In the Mayan paintings of warriors, the toes sometimes face the viewer on a right angle from the face. If a belt fastening is normally seen in the back, it will nonetheless be shown in the front should it strike the fancy of the artist to do so. This twisted perspective is a feature of art almost everywhere, classical cultures excepted, until the Renaissance.

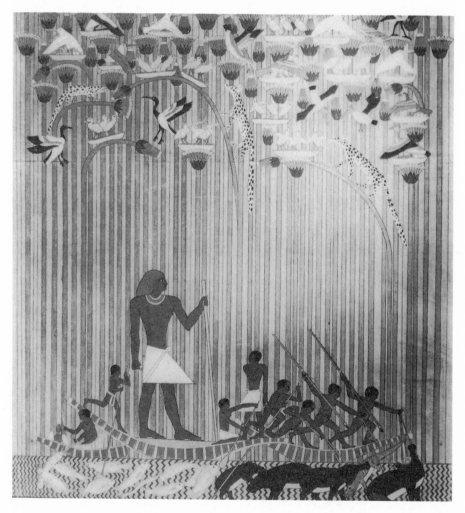

ILLUSTRATION 3. *Hunting Hippopotami in the Mashes.* Giraudon/Bridgeman Art Library. Egyptian 4th or 5th Dynasties.

Though rarely is there any diminution of size to show distance, size does often indicate the relative importance of the person or object to the artist and presumably to his intended viewers. An Egyptian hunting scene, for example, shows a nobleman in a boat as being many times the size of his oarsmen, not because he is closer; he obviously is not, and, further, the painting shows no hint of depth. He is larger because he is more important (ILLUS. 3). The same is true of parts of bodies. In a prehistoric sculpture from southwestern Europe we see the right arm very expertly molded, the left neglected, almost as though atrophied. Sculptures and engravings from the same area show female bodies without faces but with exaggerated breasts, buttocks and vulvas. Battle and hunting scenes from outcroppings of rocks in Spain, painted twelve to eight thousand years ago, show men with grossly elongated torsos and legs.

Many caves of southwestern Europe are filled with paintings, sculptures and engravings executed from over thirty-two thousand to about twelve thousand years ago by highly skilled artists. By virtue of that very skill their art can tell us much about the psyche and world view of those early populations. There are virtually no scenes or compositions of any kind. There are individual animals, marvelously depicted, but shown almost always without any relationship to, or interaction with any other animal, person or thing. There are in fact very few persons or things, over ninety-five percent of the figures being animals. Further, the artists apparently never depicted a horizon or a ground line, the animals seeming rather to float in space. The prehistoric artists often seem also to have given little thought to orientation, many of the animals being angled at forty-five or ninety degrees from the horizontal. The natural position of back up and legs down seems to have meant little to them.

Except for a few geometric forms which may represent plants, there is no representation of nature, not a tree, a stream or a mountain. Unlike the beautifully executed animals, the few humans, except for female bodies, are most often stick figures, with single lines for torsos, legs and arms. There are, remarkably, some few instances of foreshortening of the animal figures, a stunning feature at this early date. But there are many more instances of twisted perspective. Bison, for example, are most often shown in profile but with both horns and at least two hooves facing forward and fully visible.

From the art of the ancient Egyptians, the Aztecs, and the medieval Europeans, we see particular examples similar to twisted perspective, though involving scenes rather than individual figures. They all result from the same lack of concept of three dimensional perspective and are all similar to each other. In each case the artist wished to show a scene as seen from above, thus showing all features of the setting as in an architect's floor plan. The Egyptian example is a lake in a garden; the Aztec,

a palace court; the medieval European of the 12th century, the table at which sat Christ and his disciples at the last supper. In each case, looking from above, we would in life see only the heads and perhaps shoulders of any people in the scene. Each of the artists, however, wished to show the people in full and did so. They are shown in full body length. Even the boat on the Egyptian lake is shown from the side, in full profile, as are its occupants. The disciples at the last supper, shown as from above, seem to be stretched out from the table like spokes on a wheel (ill–4).

These artists were interested in the parts, not the whole. Proper relationship of parts meant little. The propensities of many prehistoric artists to draw what they knew, rather than what they saw, went far enough that they often depicted the internal organs and skeletons of animals, though these were obviously not visible in the animals as drawn or painted. The so-called x-ray paintings of pre-history are found almost everywhere: northern Scandinavia, Russia, Alaska, western North America, India, Malaysia, New Guinea and Australia. The proposition, sometimes made, that they are intended as anatomy lessons is less than convincing.

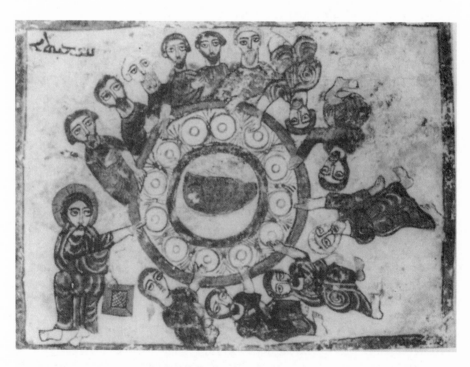

ILLUSTRATION 4. *Last Supper*. After fig. 135, Bazin, Germain, *A Concise History of Art,* 3rd rev. ed. (London: Thames and Hudson, 1964). Miniature from a Syriac Codex, 12th century, London.

Another curious feature of much prehistoric art concerns the abundance of abstract geometric forms of countless variety and figurations. They may tell us something quite significant about the mentality of those early peoples, a matter we will look at more closely somewhat later. The forms include rectangles, quadrangular-type checkerboard designs, circles, dots, stars, tridents, objects that are tent shaped or wing shaped, and curvilinear mazes, to describe but a few. They abound everywhere and thousands have been discovered on outcroppings of rocks in Africa, the New World and Australia as well as in the caves of southwest Europe, often on the very walls that contain the vitally realistic paintings of animals.

The art of some populations, usually those without written language, even to the present time reveals another curiosity: an affinity for so-called split drawings of animals. These are drawings of the creatures as though seen as from above, but with the legs extended full length out to the sides, thus making all four fully visible. Though an anatomical impossibility, in southern Africa, Siberia and New Zealand, and among the Native Americans of the northwest coast, to name a few, these drawings are often preferred by the population to any view of the animal that could be seen in life.

Artists do not work in a vacuum. No less than the performing artist, the painter and sculptor need an audience. They are stimulated and inspired by other artists and by the viewing public. The product of their talents must evoke a response. It is noteworthy that in Egypt for a period of about 370 years, on and off, between 1570 and 1200 B.C., there are sporadic and tentative suggestions of depth and volume. On occasion four legs on furniture are shown with overlapping and, hence, partial occlusion instead of the usual full view of all legs, and on the human body there are some few hesitant suggestions of an oblique view. But even these equivocal beginnings were abandoned and came to nothing. Obviously they meant nothing to the Egyptian viewers and struck no responsive chord in their spatial sensibilities. The populace of Brunelleschi's Florence was ready for and responsive to three dimensional perspective and derived aesthetic pleasure from it. With the Egyptians of ancient times this was obviously not the case.

There seems no lack of skill on the part of the ancient artists. It appears to a certainty that we are dealing not with inability, but with a different mindset, a different mentality and a different sense of aesthetics, both in the artists and in the population in general. The difference is not insignificant. As one art historian put it, every artistic utterance reflects man's attitude toward space; and, as another added, that attitude is the reflection of his psychic world.[2] Almost as revealing as the two-dimensional style that previously predominated is the once-universal nature of it.

❦

Painting in three dimensional perspective is so taken for granted throughout the Western world, and much of the rest of it, that it hardly rates a mention in any description of a work of art. We accept without conscious thought that a scenic work, if representational, will be in three dimensions. If such a painting or drawing is out of perspective we find it jarring and assume it to be the work of an amateur or a less than excellent student unless purposely done for some specific effect. To most of us today, a three dimensional representation, and it alone, is realistic, a true depiction of the world we live in. New styles may come and go in the world of art—impressionism, pointillism and numerous others—but none of them, modern abstract and cubism excepted, have abandoned the three dimensional perspective in which the work is anchored. So natural does it seem to us that we assume that it must have always been part of the human psyche.

Why then did the ancient and medieval artists not paint in three dimensions? Was it, as has been sometimes claimed, because of the simple failure or inability of these artists to devise the rules of perspective as articulated later by Alberti?

It seems highly implausible. There are, to be sure, very definite rules of what is now termed "projection and section." It was these very rules, spelled out in detail by Alberti, that stimulated the development and ultimately resulted in the laws of projective geometry, a very important field of mathematics. This specialized geometry was first realized in concept in the 17th century by two French mathematicians working independently of each other. Their work was unappreciated by their contemporaries and for two hundred years was totally neglected. Not until the 19th century did a copy of the manuscript of one of them find its way into the hands of an appreciative geometer, one Gaspard Monge. He was a friend of Napoleon Bonaparte, and first to articulate the rigorous rules for projective geometry. For this Monge utilized projection and section, rules first developed not by scientists but, as we have seen, by artists.

Ultimately, one Jean Victor Poncelet, a mathematician and engineer and an officer in Napoleon's ill-fated army in Russia, confined for almost two years as a prisoner of war, decided to put his time in captivity to good use. He may have been the first to appreciate the significance of projective geometry as a new branch of mathematics. That significance is considerable. Projective geometry has been utilized, among many other ways, in the development of Einstein's laws of relativity, involving as they do the relationship between factors that remain stable through transformation from one coordinate system to another.

The laws of projective geometry are in many respects the same or similar to those of the basic plane geometry developed by Euclid, a Greek

mathematician, at about 300 B.C. In other ways they are quite different. Among the most significant differences is the rule with regard to parallel lines. In plane geometry, as every schoolboy knows, they never meet. In projective geometry any two lines always meet. The concept of parallel lines has no place in projective geometry. The difference between the two systems can be seen in the difference between, on the one hand, the plans of an architect for a building, drawn in accordance with the rules of Euclidean geometry, with different drawings for horizontal and for vertical structure, that is, for floor plan and for height, and with their parallel lines, right angles and circles, depicting the building as it really will be. On the other hand, is the artist's rendering of the future building, shown at an oblique angle from which at least two sides may be seen receding into the background, with its converging lines, its acute and obtuse angles, and with ellipses or parabolas instead of circles, depicting the building as it will look to human eyes. For reasons we need not dwell upon here, most artists' renderings or paintings do not show convergence of lines that are vertical, though in fact the eyes see vertical convergence too.[3] Whether they know it or not, the work of most artists today approximates the laws of projective geometry, or at least the rules of projection and section, or at the very least something close to it.

Most of them probably do not know it. It is to be doubted that many artists know much about these mathematical concepts, and to be doubted even more strongly that those who do, follow the very esoteric and tedious rules to any significant degree. What is significant is that ancient and medieval artists made no attempt to paint what they saw, something that could have been approximated without any regard to mathematical rules had the visual illusions meant anything to them aesthetically. One does not need mathematical measurements to know that objects in the distance appear smaller, or scientific study to know that closer objects block the view of others further away.

Until the time of Giotto in the 14th century, classical times excepted, the most obvious effects of visual illusions were ignored. Even the scientifically determined laws of optics, known for centuries, the basic ones written down by Euclid, meant nothing to these artists. When Giotto and others began to show spatial relationships and depth, however imperfectly, no rules of perspective had yet been formulated. It was not rules that led to the use of perspective. What led to it was a new aesthetic, a new feeling, a new appreciation of three dimensional relationships. It was a matter of sight and imagination, not of rules. And when the ability to appreciate these relationships took root both in the artists and those for whom they painted, when it became something "in the air," rules

were devised. They were devised by Renaissance men, men who were often scientists or engineers as well as artists. Giotto made a very interesting beginning without the rules. But within a few decades of Brunelleschi's famed panels and Alberti's analysis, artists throughout Europe began painting with more correct perspective than had theretofore been the norm. The work of these two Florentines thus had a powerful impact, but probably by causing more careful observation, rather than a study of mathematics.

The notion, sometimes bandied about, that ancient and medieval artists did not paint in three dimensions because the rules for perspective had not been formulated, seems highly suspect. There seems little basis for any conclusion that earlier people lacked the analytical ability or the intelligence to formulate such rules had the illusion of depth meant anything to them. Quite the contrary, it seems remarkable how much our species has been able to analyze, and how quickly when the motivation for it exists. Sometimes the motivation is pure curiosity, or the drive for novelty or innovation. But, when the spirit has moved us, there has been little that humans could not deduce. And in the litany of problems solved by our ancestors, late or remote, the rules of perspective seem far from the most difficult.

Even assuming that knowledge of some mathematical rules are a prerequisite for three dimensional painting, which they assuredly are not, it is highly unlikely that this problem would have been a serious barrier. The basic technique for putting depth on a flat canvas seems simplicity itself, compared to the rules of more complex mathematical problems they solved. Even the more rigorous rules of projection and section, admittedly not simple, could hardly be said to compare in complexity to the laws of algebra, calculus or a host of other branches of mathematics, not to mention scientific problems in astronomy, architecture, agriculture and so many other fields of human accomplishment.

When through desire or compulsion they needed or wanted to do so, ancient peoples solved through observation and reason whatever problems confronted them. Ancient Egyptians, Mayans, Aztecs and Mesopotamians devised means of raising large blocks of stone to construct their pyramids and ziggurats. They and others determined not only the times for planting and harvesting, but also for proper crop rotation, means of irrigation and flood control. To determine the time to make sacrifices, or war on their neighbors, or for succession of royalty, various cultures including the Egyptians and the Chinese determined (several thousand years before Christ) the number of days in both lunar and solar cycles. Both of those ancient peoples, almost four thousand years ago, also discovered the properties of the "Pythagorean" triangle, which was by then already being used by the Babylonians as part of a highly

developed geometric system for astronomical measurements. Hundreds of years before Christ, the Minoans, the earliest culture on the island of Crete, were using a decimal system, and Babylonians and Chinese had plotted the movements of the planets. Between A.D. 500 and 1100, Asian Indians explained powers and roots of numbers, formulated the rules of algebra and determined the importance of the zero, unaware that the Mayans were already using that concept.

Nonetheless, in all of these cultures the artists painted in flat, two-dimensional perspective. Is it possible, as sometimes suggested, that no one among these early peoples could figure out how to show depth on a flat surface had it really meant anything to them? Or was the reason for this lacuna perhaps that the illusions of the human eye evoked no aesthetic appeal, no pleasurable sensation?

The suggestion of some art historians that the Romans, and perhaps the ancient Greeks, may have used three dimensional perspective has already been noted. Is it possible that the theoretical underpinning of it had also been worked out, as has been claimed by some? If the Greeks did in fact use perspective—and the evidence for it is admittedly equivocal—it would be difficult to believe that the scientific basis involved would have escaped their grasp. Unlike their contemporary cultures, the Greeks were not content merely to observe and measure, or to record their information purely for practical purposes. They looked for the causes of the phenomena, and some of the most brilliant among them sought to find common explanations for all aspects of nature. Their accomplishments in this regard are without parallel in the ancient world, recent revisionism notwithstanding.

In the sixth century before Christ, a Greek philosopher, Thales, accurately predicted a solar eclipse. About 250 years later, as we have already noted, Euclid worked out the rules of optics as well as those of plane geometry, which are still used in basic texts in Western schools. More than two hundred years before Christ, a Greek poet, mathematician, and geographer, Eratosthenes, measured the circumference of the earth to a figure remarkably close to the precise measure known today. He measured also the tilt of the earth and the size and distance from the earth of the sun and the moon. Just a few decades later an Athenian astronomer, Hipparchus, was the first to devise the system of trigonometry, to discover the precession of the equinoxes, irregularities in the motion of the moon, and the length of the seasons. Also to his credit is a comprehensive chart of the heavens, showing the positions of about 850 stars, divided into classes of brightness.

If the Greeks did respond emotionally to the third dimension, it seems certain that their enquiring minds would have found the rules by which to portray it in art. This seems particularly true as the laws of

optics had already been formulated by one of their countrymen. If they did not discover the rules of perspective, or at least apply to art the rules of optics as laid down by Euclid, it seems likely that the motivation, the emotional response to depth, was lacking.

Which artistic method has the greater aesthetic appeal today? Most art lovers, critics and historians would no doubt select the way we really see things, rather than the way they really are. Few these days would find more beauty in the representation of objects in a scene shown as we know them to be at the cost of the spatial relationships that we see between them.

With the ancients it was obviously different. Perhaps as good a reference point as any for an inquiry into the mind of those early peoples might be the works of Plato, the great Athenean philosopher of the early fourth century B.C. He articulated so much about so many things that, through him, we may be afforded access to the mindset of the early Greeks. Writing in the fourth century B.C., Plato could not truly be said to be of the early Greek period, but his outlook, at least in art, certainly was. He is often termed a conservative in his view of art; reactionary may be more appropriate. He lived in a time of momentous change in Greek art, foreshortening being much in evidence, and possibly, to some uncertain degree, three dimensional perspective, matters we must examine more closely later. But he was impervious to change, at least in art, and resisted the inevitable. He was fighting a rear-guard action.

The articulation of his ideas came in the form of dialogues, so called; but in substance they were monologues, or perhaps cross examinations. One of the characters of each dialogue is the questioner, who is always the alter ego of Plato himself. The other character must be every advocate's dream of the ideal hostile witness, one led blithely along the desired path by the force of the examiner's logic, and always to inevitable agreement with his pre-determined conclusion. This is the structure of Plato's *Dialogues*, even in those cases when life's experience seems to make the questioner's overbearing logic more entertaining than useful.

More likely than his having influenced ancient attitudes, he probably reflected and brilliantly articulated a traditional point of view, at least with respect to art. But it was a view more likely held by the earlier Athenians than by those of his own time. It was probably also the prevailing view of most other contemporary cultures, even of his time. What was important to Plato was the essence, the reality of an object, not the appearance. He considered the objects of the physical world to be ephemeral, the reality existing only as an abstract concept. The reality is not any particular object that we see or touch in this world, not this or that chariot, toga or man, each specimen of which is different in some

respects from others of its kind. These objects that we perceive in our sensual world can merely be an imperfect imitation of what is real, namely that abstract image of chariot, toga or man, existing only in pure thought. A painting, which can show a picture of the object, necessarily from one view only, is a step still further removed from reality.

In the dialogue of *The Republic* he develops this subject at length. He uses the example of a bed. The maker of a bed, says Plato (speaking through his protagonist, Socrates), is not the maker of the idea of the bed, the essence of the bed, but the maker only of a particular bed. God alone is the maker of the real bed, the abstract idea, of which there can be only one. The bed made by the carpenter has no real existence, but only some semblance of existence.

In turn, the artist who paints a picture of the bed imitates not the bed that originally exists in nature, that abstract concept made only by God, but merely the imitation of the carpenter. Thus while the carpenter imitates the abstract idea, the artist imitates it not as it is, but only as it appears. So with the artist there is the further step of removal from reality. He, in effect, is imitating an imitation. "You may look at a bed from different points of view," says Plato through his protagonist, "obliquely, directly or from any other point of view, and the bed will appear different, but there is no difference in reality." He does not specifically mention three dimensional perspective, which may have been used at least in theater backdrops during his own lifetime, or foreshortening, which assuredly was. But it seems likely that the greater the development of perspective the further it heightened his disdain for the art of painting, which was quite deep to begin with.

This is the crux of the Plato's philosophy as it bears on the value of the plastic arts. In the dichotomy between reality and appearance, he leaves no doubt as to where "truth" lies, and leaves nothing to any possible misunderstanding. He makes his point explicit by having his main character, Socrates, explain to the fictional student, Glaucon, some of the illusions to which our vision is subject: namely, that a body that seems small when distant, seems larger when near; that an object will appear straight when out of water, but crooked when submerged; and that a concave object may appear convex due to illusions about color to which the sight is susceptible. These matters Plato refers to as confusions revealed within us, a weakness of the human mind, through which the clever use of light and shadow can be used to manipulate us like magic. Further, "The arts of measuring and numbering and weighing come to the rescue of human understanding—there is the beauty of them," and appearances no longer have mastery over us, but give way before calculation and measure and weight.

"There is the beauty," says Plato. He leaves no doubt that the beauty

for him was in what he knew, not in what he saw. "That part of the soul," he says, "which has an opinion contrary to measure is not the same as that which has an opinion in accordance with measure." And the better part of the soul, he concludes, is that which trusts to measure and calculation. Painting or drawing, according to Plato, is "far removed from truth." He calls such art inferior.

"Truth is beauty and beauty truth," said Keats. However, that line of poetry itself may contain beauty, but little truth. In much of the world today, art lovers see beauty in illusion, caused most often by perceived relationships between objects in space. If Plato spoke for the Greek art culture, even as that culture had been decades before, or for any other culture, there should be little surprise that flat two-dimensional paintings dominated so much of the world's art for so long. It was bad enough that painting was inherently inadequate to depict reality, but to fall prey to the obvious illusions, the weaknesses of the human mind, as Plato called them, must have been anathema.

Plato saw his truths as eternal and everlasting. He seemed to despise change, yet it was all around him. Contrary to the almost unchanging monotony of contemporary cultures, in the sixth century B.C. that of the Greeks became dynamic. It fostered some profoundly significant and far-reaching changes in human thought and outlook that ultimately became the foundation of Western societies and the modern world. One of these was, in some unknown degree, three dimensional perspective. Plato bitterly and vainly fought against it, and even as he denigrated the art of his native Greece, he seemed to extol that of the Egyptians.

In another of his dialogues, *The Laws*, he has his main character, the Athenian, heap praise on that ancient people for their fixed forms and patterns. "No painter or artist is allowed to innovate upon them, or to leave the traditional forms and invent new ones." No alteration is allowed either in these arts or music, says the Athenian wistfully, and their art is painted or molded in the same forms as for the last ten thousand years. Little was known then of the true time lines of history, but the correct figure of perhaps twenty-five hundred years would be quite enough. The ancient paintings and sculptures of the Egyptians, continues Plato's alter ego, are not a bit better or worse than they are today. The idea of progress obviously did not loom large in the mind of most ancient populations. The notion of such severe strictures imposed from above would apparently not have been so abhorrent to Plato as it would to many of us today. It would, on the contrary, have been all in accordance with his vision of the ideal Republic.

There is, however, little reason to believe that his ideal truly existed. If any king or priest in Egypt or elsewhere demanded the two-dimensional or twisted perspective we see in the art of those ancient cultures, evidence of it is most difficult to find, and it seems quite likely there is none. The Egyptian painters, in all probability, were never ordered to paint in that same unchanging style. Neither the rulers, the populace, nor most of the artists knew of any other style. The artists painted as they did because that is what pleased both them and their audiences, the kings included no doubt. They painted essentially the same as the Mesopotamians, the Minoans, the Mayans, the Aztecs and almost all ancient and medieval artists, namely, what they knew rather than what they saw; and with each object occupying its own space. It was true almost everywhere, except in Plato's Greece and later in Rome.

There is no reason to think that the Egyptian painters who made such tentative beginnings of foreshortening were punished for their novelties. During one period their hesitant innovations continued on and off for almost four hundred years. They were not prohibited; they were simply unappreciated. Even to those who otherwise believe that there were royal strictures to be followed, it is obvious that during the reign of King Amenhotep IV (also known as Akhenaten), beginning in 1379 B.C., artists were free to paint as they chose, as very personal and individual characteristics show up on many portraits. But flat, two-dimensional paintings continued even during that relatively liberal period, as did the so-called frontality.

Scholars have often claimed, as to various other cultures, that the artists painted as they did because of the requirements of kings or priests. Thus, in the Middle Ages, this flat two-dimensional style is laid at the door of the church. It was the hierarchies of the Christian Churches, both Byzantine and Roman, say some art historians, who demanded this style, as it allegedly was deemed more spiritual in nature and better reflected the religious aspects of the art. Yet when the artists of the Renaissance began to paint in depth and to utilize the rules of perspective, there is no evidence of papal resistance, though the authority of the Church of Rome had hardly diminished. It was at the late date of 1633 that the Inquisition in Rome compelled the retraction by Galileo of his heresy concerning the less-than-central status of the earth in the solar system. Yet more than a hundred years earlier the church had honored the "grace and excellence" of the art of Filipo Lippi, whose frescos were very much three dimensional and in accordance with the rules of perspective. And of course even the earliest of three dimensional paintings were intended for the churches in Florence and Rome, and have adorned those structures since the 15th century.

At the Meso-American site of Teotihuacán, which endured for about

the first eight hundred years of the Christian era, painters executed murals in a flat, two-dimensional, mostly geometric style in which neither overlapping nor perspective diminution had any place. One scholar claims that the third dimension was deliberately suppressed as the use of perspective would have obscured the identity of the symbolism.[4] That would seem to be a problem, however, that could only affect people without three dimensional concepts. Modern people today have no trouble recognizing figures in three dimensions on flat surfaces. Another scholar of Egyptian art, Wilhelm Worringer, also claimed, early in his career, that the ancient Egyptians artists had voluntarily suppressed the use of the third dimension. After twenty years of further study, though, he modified that view significantly, and made it a point to say so. He acknowledged that the three dimensional concept of space had never existed in most ancient peoples, including the Egyptians, and that they could not suppress what they never knew.[5]

What, then, could have changed the perceptions of artists and their viewers so profoundly and so permanently? Many cultural causes, such as political or economic circumstances, have been advanced. They may have played a role. Certainly no one can prove otherwise. Standing alone however they seem a most unlikely explanation for three dimensional perspective. We may have to look to other factors, factors that may also have played a role in the cultural changes themselves.

III

The "Right" Brain

Asymmetry of the human brain; the input of the right cere-
bral hemisphere in appreciation of three dimensional per-
spective and in other human attributes that accompany
perspective throughout history: appreciation of part-to-whole
relationships and beauty in nature, facial expressiveness, indi-
viduality, use of metaphor, and pleasure in novelty.

The most fruitful place to look for causes for this change in human
perceptions may be certain discoveries of modern psychology. The rea-
son for such a seemingly unrelated inquiry is that throughout history
the rise and fall of the third-dimension in art has not been a solitary
journey. Perspective has traveled always in good company. It has been
accompanied by the almost concurrent rise and fall of expressiveness
in portraiture, of emotional response to visual beauty, of the use of
imaginative metaphorical language, of novelty and innovation, and of
individuality. All of these traits, three dimensional competence included,
have been found to be under primary control of the right cerebral hemi-
sphere of the brain. Hence throughout our inquiry into the use of per-
spective, we will look from time to time more closely at the findings of
scientists who have studied what they term "hemispheric asymmetry,"
meaning the difference in the functions of the two hemispheres of the
brain.

Let us begin with the observation of a French country doctor named
Marc Dax. He practiced his profession in a rural area in the southern
part of his country during the early nineteenth century. In 1836, near
the end of his life, he traveled to Montpellier to present, for the first time
in his career, a paper to a medical society. He explained to the society
that over the course of his practice he had treated over forty patients with
brain injury or disease, many of whom suffered from aphasia, a loss of
ability to coherently formulate their thoughts in language. This much was
known to his audience, as reports of that condition date from ancient

times. What Dax had noted, he explained, was the fact that the aphasi-acs he had treated all had injury to the left side of the brain. It seemed that injury or disease to the right side alone would not interfere with coherent speech. So, concluded Dax, speech was obviously controlled by the left side of the brain, a claim that ran contrary to current belief that no mental function could be pinpointed to any particular area of the brain. His findings were met with a collective yawn, and Dax returned to his country practice. Death followed within a year.

Twenty-five years later another French physician, a surgeon named Paul Broca, delivered a paper to the Society of Anthropology in Paris. He had done an autopsy on a patient who suffered paralysis on the right side of his body and loss of speech. Broca found lesions in the left side of the brain, the rear portion of the third frontal convolution, to be more precise. That a lesion on the left side of the brain should cause paraly-sis on the right side of the body was no surprise to his audience. It had been known for many years that each side of the brain controlled the physical functioning of the opposite side of the body. But now Broca, like Dax, argued that control of speech was centered in the left brain, a claim that still elicited only skepticism and another yawn. But a similar report shortly thereafter, about a former patient who had suffered loss of speech, finally caught the attention of the medical community. Later, pointing to the left hemisphere's control of speech and to the primacy of the right hand, Broca termed the left the "dominant" hemisphere.

The right hemisphere, for almost a century thereafter, was consid-ered to be only a relay station for control of the left side of the body, and was known as the minor hemisphere. The area of the left brain that Broca found to control speech became known as Broca's area. The inability to articulate, in patients with damage to this area, is exemplified by the report of one recent researcher who quotes a patient's halting response when asked about a dental appointment: "Yes ... Monday ... Dad and Dick ... Wednesday nine o'clock ... ten o'clock ... doctors ... and ... teeth."[1]

In 1874, thirteen years after Broca's first report to the Anthropo-logical Society, German neurologist Karl Wernicke found that an area of the left temporal lobe, located to the rear of Broca's area, controlled aspects of speech other than articulation. In patients with damage to this area, the words flow freely, the problem consisting of their inappropri-ate, often nonsensical, nature. That area of the brain became known as "Wernicke's area." When asked how he felt, one such patient replied, "I felt worse because I can no longer keep in my mind from the mind of the minds to keep me from my mind and up to the ear which can be to find among ourselves."[2]

Despite the rather simplistic designations of the hemispheres as

dominant and minor, within only two years of Wernicke's findings there were suspicions that the right hemisphere might have a more significant role to play in human behavior than had been supposed. There was an intriguing report from a British neurologist of a patient with right hemispheric damage who had considerable trouble recognizing persons, places and various common objects. But recognition of the important functions of the right hemisphere advanced at snail's pace until the advent of World War II and treatment of thousands of brain injuries of innumerable types and their resultant disabilities. It sparked a burgeoning interest in research and experimentation beginning in the 1960s. By 1990, some sort of consensus, at least as to the basic differences in the functioning of the two hemispheres, seems to have been reached, though the research and experimentation continue with considerable fine tuning of accumulated knowledge.

In a study of anything as complex as the human brain, oversimplification should not be a cause for surprise. For theories and hypotheses to change in the face of accumulating knowledge is virtually inevitable. It must also be borne in mind that human behavior is never uniform, never identical in one hundred percent of humans; nor do researchers expect it. Students of human behavior look at statistics. Is the incidence of symptoms following a certain type of injury, for instance, high enough to rule out any reasonable probability that the correlation could be pure chance, mere coincidence? There are proven laws of statistics that determine the percentage of certainty, that is, the possibility that the seeming relationship results from chance rather than from cause and effect. Most often, if those laws tell researchers that the possibility of that correlation by chance, rather than by causal relationship, is greater than one out of twenty, the correlation will be considered not to have been proved or, as they term it, "not significant." In most cases in the study of hemispheric functioning, only when that possibility of chance has been found to be less than one out of a hundred, and often only two or three out of a thousand, will the researchers term their findings significant.

A number of methods have been used to determine hemispheric function. Some tests involve patients with damage or disease to one hemisphere or the other. In some patients, as a treatment for epilepsy, there has been a severance of the corpus callosum, a body of about three hundred million nerve cell fibers that connects the two hemispheres. This causes each hemisphere to function separately, without input from the other, making research in this area more effective. Persons with normal minds, brains intact, have also been studied. A process known as the Wada test allows researchers to suppress temporarily the function of each hemisphere sequentially. In recent times the use of magnetic resonance imaging and other electro-physiological methods has permitted

scientists to determine exactly what areas of the brain are active during particular mental processes.

It appears certain that practically everything normal humans do involves some input from both hemispheres. The two do not ignore each other. Information received by one hemisphere is communicated to the other through the corpus callosum. But it is also true that information is processed more quickly and more accurately by the hemisphere first receiving it, and that certain mental processes and behaviors are primarily within the domain of one hemisphere or the other.

Various terms, intended to be all-encompassing, have been used to categorize the differences in functioning between the two. For decades, the operative term was "verbal" or "sequential" for the left; "visual" or "spatial" for the right. The right hemisphere has also been described as involving primarily recognition of relationships in space, or of part-to-whole relationships. Another scientist, unsatisfied with these terms, spoke instead of categorization of information in the left hemisphere and spatial coordination in the right. It does seem certain that, however categorized, the right hemisphere is the seat of our ability to take in, in a single glance, and to immediately recognize without conscious thought, relationships between objects in space, and to find pleasure in them, whether of a rural scene, a city street, a building, a single room, or a human face. On the other hand, analysis, computation and calculation all are primarily in the domain of the left hemisphere. That hemisphere is the seat of our ability to reason deductively, and to use the vocabulary and the syntax of language. Psychological experiments have shown that the left hemisphere invents reasons for events and for the subject's own behavior, no matter how spurious. But rather than a definition or shorthand description of the functions of the two sides of the brain, a comparison of the processes in which each excels may tell us more.

The left hemisphere solves problems by deductive logic, the right by intuition, without step-by-step analysis. The right hemisphere has been shown to be primary in our ability to assemble puzzles. An uncompleted figure drawing, one with important lines missing, can be completed significantly faster and more accurately by persons operating only with the right hemisphere, than by those operating only with the left. The manipulation of geometric forms, whether by rotation or otherwise, and the recognition of identity of forms seen from different perspectives, can be likewise better accomplished with the right hemisphere.

Recognition of familiar faces by a glance, as opposed to a search for distinguishing marks or characteristics, is markedly superior by the right hemisphere. Those who do best at recognizing faces do worst at remembering specific details of the face. The reverse has likewise been found, those doing worst in recognition doing best in remembering details. A

condition involving the loss of capacity for facial identification, often extending to close friends and family members, is known as 'prosopagnosia,' and is almost always associated with right-brain damage or disease. It is also the right brain that permits us to make and to immediately recognize facial expressions; the left does this too slowly to enhance meaningful social interaction.

As one writer has put it, "The left brain sees a hundred trees; the right brain sees a forest. The left brain sees a nose, a mouth, an ear and lips; the right brain sees a face."[3] Another scientist, summarizing recent research, emphasizes the propensity of the left hemisphere to see and absorb detail; the right to take precedence in perception of "global" forms, the large overall shape of a scene, which is generally the first to be noticed, details usually following.[4] The left brain, he claims, processes information on smaller scales, the right on larger ones.

The left hemispheric advantage in use of language is largely limited to the literal use of it, syntax and vocabulary being its major skills. What linguists call the pragmatics of language, understanding language in context, reading between the lines, understanding what is implied as well as what is said, and the understanding of metaphor, are the skills primarily of the right hemisphere. The tonal aspect of language is likewise a function of the right brain, the left brain alone often being unable to distinguish between a happy, sad or angry tone of voice. Our ability to express feelings and to understand such expressions in others is largely mediated by the right. The left side of the brain is associated with doing or hearing familiar things, such as action by rote. Pleasure centers of the right side give us a feeling of well-being or satisfaction in response to novelty and innovation. The left seems often lacking in an understanding of humor. Our response to humor seems primarily a function of the right and has been found to correlate with an individual's ability to mentally rotate a physical object (likewise a right hemispheric function). In recent times it has also been determined that important aspects of our sense of individuality, our separate identity from the outside world, are in many respects a function of the right brain.

We will return to these matters in more detail at a later time. We will especially have occasion to revisit the observation concerning the hundred trees and the forest, a metaphor that will most powerfully impact our understanding of certain aspects of the course of art history and of our changing view of the world. For now, perhaps we should mention only two other closely related areas where the right hemisphere's function has been found to be so markedly superior: One is the sense of aesthetics, including the ability to derive pleasure from relationships in space; what psychologists often call part-to-whole relationships. One, Ronald Laing,[5] describes the left hemisphere as almost obsessed with

parts." The other is three dimensional competence. They are not unrelated.

Dr. John Cuttting, in an exhaustive analysis of the disorders of the right cerebral hemisphere, concludes that the right hemisphere has a virtual monopoly on three dimensional space.[6] One example underlying his conclusion involves an artist who suffered a right hemispheric stroke. He suffered no loss of ability to draw two dimensional representations, but exhibited a dramatic deterioration of three dimensional work. Other researchers have found that following a surgical severance of the corpus callosum to control a patient's epilepsy (a procedure known as a commissurotomy), the right hand, controlled by the left hemisphere, was incapable of drawing a cube, even by copying a drawing of one. The patient's attempt was flat, with no suggestion of depth. The left hand of this right-handed patient, however, controlled by the right hemisphere, was able to copy the cube without difficulty.

The disability obviously does not come from an inability of these patients to perceive depth when necessary to deal with immediate problems in their world. It stems from a lack of sufficient concept of part-to-whole relationships. A patient with lesions on the left hemisphere, for example, was asked to copy a simple line drawing of a house. He succeeded in drawing every part of the house; the problem was that the parts were all askew.[7] The door, for one example, he put in the roof. It is doubtful if, upon entering any home, he would truly have looked for the door in the roof. In the real world he would no doubt have found the door where he had always found it. But the relationship of the parts to the whole meant nothing to him. He obviously saw every part individually, but could not grasp the pattern, and had little interest in it. Other patients who had undergone commissurotomies to control epilepsy were asked to rearrange a number of colored blocks in a pattern shown to them. The left hand, controlled by the right hemisphere, could not copy the pattern as shown, but they did rearrange the blocks in pleasing manners, symmetrical or otherwise. The same patients, working with the right hand, controlled by the left hemisphere, could neither copy the pattern shown nor create any other discernible pattern or aesthetically pleasing arrangement.

Scientists have found that a degree of effective treatment for mania has resulted from suppression of the left hemisphere, and that, conversely, depression has been somewhat successfully controlled by suppression of the right hemisphere. The means of suppression in each case has often been by what neurologists describe as unilateral electroconvulsive means, or by drugs. These were the methods used by a team of

Russian neurologists, headed by Nikolai Nikolaenko, to reduce symptoms in a number of hospitalized patients in St. Petersburg.[8] Before and after suppression of each hemisphere, patients were asked to draw from imagination various objects, including a person, a flower, a house, a table, a cube, a bridge, two houses of which one was close and one distant, and rail tracks receding in the distance. The stated purpose, as described by Nikolaenko, was to determine the degree to which the drawings reflected "visible geometry" and to what extent "objective space geometry." Phrased differently, these researchers wanted to know to what extent the patients drew what they saw, and to what extent what they knew.

As reported by Nikolaenko, the drawings of these individual objects by patients with a functioning right hemisphere and with the left hemisphere suppressed showed substantially correct spatial relations of the parts. Further, they reflected volume. The drawings show that this was done through overlapping and foreshortening. Nikolaenko ascribes the illusion of volume as resulting from the ability of the patients to "mentally rotate" the objects.

With the left hemisphere functioning and the right suppressed, patients created drawings that in many respects (not including the degree of artistic talent) resemble the art of ancient, medieval, and even prehistoric times. According to Nikolaenko, these patients construct a symbolic sign system and display a conceptual system of reality, that is, what is known rather than what is perceived. Examples of that trait are found in the frequently seen drawings of tables. One important part of a table is of course the top, the surface on which objects are placed. That is often shown by these patients as though from above, with the full area of the surface in view. However from such a view one cannot see the legs. But these patients know that a table has legs, so the legs are also drawn in, usually hanging down from the bottom of the four sides, each leg being shown in full and often of the same length.

There are other similarities between the drawings of patients without fully functioning right hemispheres and the art of earlier peoples. These right-hemispheric patients often showed a person or a tree with a simple cross. Other times a vertically-oriented rectangle would represent a tree, a horizontal one a table. The drawing often represented the conception of the object rather than the object itself. The symbols are similar to the drawings of prehistoric art found on outcroppings of rocks and in caves as described earlier. It may be still one more indication of a lesser development of the right brain in earlier times.

In another similarity, some patients treated with drugs to suppress the right hemisphere became more schematic in their drawings of humans. Parts of the body in these drawings, obviously hidden by clothes and not visible to the viewer, were nonetheless drawn in as though seen

by x-ray. This seems very similar to the inclusion of the inner organs and skeletons of many of the animals painted on rocks and in caves in prehistoric times.

No one is suggesting, of course, that ancient, medieval or prehistoric people had non-functioning right brains or that they suffered the same disabilities as did the neurological and psychological patients whose drawings we have discussed. These studies do suggest, however, that the functioning of the right hemisphere may have been less developed in earlier times, and the world outlook, and the conception of beauty among earlier peoples, correspondingly different. If the essence of beauty is the relationships between parts, a scientific phrase for what we more often call order, harmony and proportion, what are we to make of a different concept of part-to-whole relationships that seems to have existed? Their drawings, as we have seen, were different. But nature itself is a source of aesthetic pleasure, which suggests there may have been a different concept of beauty, not only in art, but perhaps in all aspects of life, most particularly in nature itself.

Though loss of response to visual beauty may have profound long-term consequences for temperament, mental health, and enjoyment of life, other adverse impacts of injury or disease of the right hemisphere, such as inability to recognize faces, facial expression or tone of voice, might, especially in the short term, be far more important to both doctor and patient. Our focus here is the possible difference in behavior of an entire population resulting from a response to nature different from that of most modern people. Such a difference could conceivably affect virtually all aspects of their cultures, including their ceremonies, rituals, and religions. For that reason, it would be interesting to know whether modern right hemispheric patients suffer such diminution or loss of emotional response to visual beauty, and to natural scenery in particular.

On occasion, such loss of interest has been reported, but usually in a secondary, almost incidental manner. In 1982, Dr. Russell Bauer reported the case of a 39-year-old American, an assistant city planner who very much enjoyed hiking.[9] He was injured in a motorcycle accident, and suffered a bruise to the lower part of the rear of the middle lobe of each hemisphere of the brain. Dr. Bauer noted that the bruise on the right was larger than the other and that the patient suffered no disability normally suffered through injury to the left brain. He suffered minor impairment to certain extremes of vision, but the doctor noted that his vision was still 20/20 in each eye even without correction. We may assume that he could still see everything he could see before.

Except for beauty. He could see buildings and everything about them

that he had seen before. But he could no longer appreciate their subtle aesthetic differences, differences that had previously been so clear. This was a severe handicap in his job and had adverse consequences. Perhaps equally as important to this patient, he gave up hiking because natural scenery seemed now to be dull and all the same, where previously the view of scenery had been one of the joys of hiking. Dr. Bauer expressed the opinion that this loss of sensitivity and enjoyment of natural scenery often accompanies prosopagnosia resulting from right brain injuries. But he added that it is infrequently reported because the physicians do not look for it.

Another reported case involved a 71-year-old French woman who lived in a rural area surrounded by flowers and hills. She enjoyed painting aquarelles and taking care of flowers. In 1986, Dr. Michel Habib reported that she had suffered a stroke on the right side of the brain, an infarct of the rear cerebral artery. She experienced a number of resulting problems, including the lack of recognition of faces.[10] But she also discovered that she now lacked emotional response to visual beauty. To this lady, the loss was no small matter. The scenery had previously aroused powerful feeling of contentment and of well-being. "I loved the flowers so much before," she told the doctor. "Their charm doesn't enter my mind anymore. Looking at the landscape through the window, I see the hills, the trees, the colors, but all those things cannot convey their beauty to me.... Everything looks ordinary, indefinite. I feel indifferent about it. What I lack is feeling."

The loss of emotional response was confined to the visual. She reacted normally, according to Dr. Habib, to sounds such as voices, laughter and cries.

Studies of normal persons tend to confirm the role of the right hemisphere in appreciation of beauty in general, scenery in particular. Electroencephalograms of volunteers, asked by the testing psychologists to imagine scenic beauty as well as emotional events of personal significance, have revealed that relationship of both to the right brain was found to be primary.

From the frequent concurrence of symptoms, the conclusion appears justified that a number of human behaviors and perceptions are closely related, as are the emotional responses they invoke. The pleasure derived from seeing the mind's creations of part-to-whole relationships, seeing those relationships in three dimensional space and particularly in the illusions of human sight, and the enjoyment of natural scenery, all seem intricately bound. Perhaps a unifying element of these and so many other right-hemispheric functions may lie in still another aspect of human personality, aspects of which are also found to reside primarily in that hemisphere: the notion of self, at least insofar as that notion involves factors

of emotion and response to novelty. The notion of self, in all of its aspects, involves the concept of the individual as unique, separate and distinct, and the idea of personhood. One manifestation of it appears to involve the idea of the individual portrait, the uniqueness of each human face and its individual reflection of life's experiences.

The lack of evidence of an emotional response of earlier peoples to what we see as sublime in nature, like a number of other responses apparently different from those of modern times, is a cause for wonder as to when, where, and how the change came about. History's initial encounter with what appears to be a relatively sudden change in the human world view calls for a closer look. This would bring us to Greece, beginning in the sixth century before Christ.

IV

The Greeks

Changes in Greek cognition and in many behaviors involving right-hemispheric mediation, beginning in the sixth century B.C., including use of metaphoric language, recognition of individuality, facial expressiveness in art; the simultaneous reversal of right/left facial orientation in portraiture and its psychological significance; change in direction of Greek script; early search for unity in nature.

It was a time of momentous change. It is doubtful that human perceptions and behaviors had ever undergone such dramatic transformations so quickly. It marked the birth of the idea of individual uniqueness, the notion of man as the measure of all things. It was the cradle of democracy, in which all free men were expected to participate. Though it began in Greece, it was not perfected there; slaves and women were not included. It was the Greeks who first looked for answers to the world's mysteries in the observation and study of nature without resort to gods and supernatural explanations. The tragedies of the fifth century before Christ, for the first time, express individual emotion and portray self analysis. In those tragedies and in other Greek poetry we see true metaphor for the first time, an outpouring of linguistic inventiveness manifested in uniquely expressive imagery. It was honed to the specific dramatic situation, as opposed to the stilted, repetitive stock phases of the literatures of other lands. Though most of this was not without its progenitors in Greece and elsewhere, it was in Greece in the sixth century B.C. that the groundswell of change began.

With some few, very equivocal exceptions, it was the artists of ancient Greece who sculpted, and perhaps painted, the first true portraits. The essence of this portraiture was the inclusion of human idiosyncrasies and the individual expression, without idealization or glorification. This was in sharp contrast to the lifeless, stereotypic representations of the human face, so devoid of expression, character or per-

sonality, that abounded in the sculptures and paintings elsewhere in the ancient world. Those formerly missing, lifelike elements exude from Greek sculpture portraits of the Hellenistic Age, beginning about the mid–fourth century B.C. The Hellenistic Age derives its name from the sharp increase in Greek influence on the non–Greek world beginning with the conquests of Alexander the Great. It is said to end with the last of the successor kingdoms of his empire, that of the Ptolemies of Egypt in 31 B.C.

Such changes as those in Hellenistic portraiture are never so abrupt as they seem when looking backward from the vantage point of several millennia. There are always some precursors, progenitors that anticipate the profound changes to come. But acknowledging some few expressive portraits in earlier times and from other lands, practically none equal that of the mass of surviving portraiture of the Greeks of the Hellenistic Age. In that same period, it should be noted, the Greek genius gave birth to Aristotelian logic and Euclidean geometry.

These profound changes augur for some type of change in the function of the mind at that place and time, unrelated to historical events. Many of the important artistic and cognitive behaviors involved have been found to relate, in modern people, to right-hemispheric function. There remain the important questions of when, and to what extent, if at all, the Greeks developed and utilized three dimensional perspective and the Greek enjoyment of natural scenery. Prior to addressing these matters, we might look to some findings by modern scientists whose work is deeply involved in human behavior. Not surprisingly, some intriguing evidence they have developed takes us back to ancient Greece.

The changes in these human behaviors, occurring in Greece over a period of several hundred years beginning in the sixth century B.C., are obvious to even the casual student of history and to the most cursory inquiry. Much less obvious is a particular change occurring about 600 B.C. It is one that is seemingly unimportant; in truth, it may speak volumes about a major cause of what has been called the Greek miracle. The very subtlety and apparently inconsequential nature of this change dictate that it could not have been consciously intended, making it all the more significant.

Our knowledge of it results primarily from the studies of Dr. Hans-Joachim Hufschmidt, a German neurosurgeon.[1] His avocational interest was in the field of cerebral asymmetry as it may be reflected in art. He studied 50,000 profile portrait specimens, mostly of humans but some of animals, from prehistoric to recent times. They included paintings, drawings, coins, gems, cameos and vases. His purpose was to determine

the predominant orientation, namely, whether the profiles faced right or left as seen by the artists and viewers.

He was interested because he knew that today and in recent times most people have a strong tendency to draw profiles facing left, whereas in ancient times most profiles faced right. He knew also from his professional work and studies that patients, operating with a diminished left hemispheric capacity but with a functioning right brain, and volunteers among normal persons with artificially diminished left brains, draw profiles facing left and in fact usually begin all drawings from the upper left; but that subjects with a diminished right hemispheric capacity and a functioning left brain draw right-facing profiles, and usually begin all drawings from the lower right. These observations have been reported by numerous researchers including Nikolaenko.

What Hufschmidt found in his study, published in 1980, was a rather sudden and dramatic change from predominantly right-facing to even more predominantly left-facing profiles. It documents the change as occurring first in Greece. Prior to about the beginning of the eventful sixth century B.C., in all art cultures including Greece, sixty percent of all profiles faced right, a modest predominance, but certainly caused by something more than chance. Thereafter, eighty percent of profiles in Greece faced left, a proportion that continued in Greece and Rome until the virtual collapse of the Roman Empire in the third or fourth century A.D. The change has nothing to do with handedness. Ninety-five percent of the human race consistently has been right handed from early prehistoric times, as documented by studies of art works going back thirty-five thousand years,[2] and of tools fashioned as long as two million years ago.[3]

In the Middle Ages, says Hufschmidt, there were insufficient profile portraits with which to make a meaningful study, most being frontal views. Beginning with the Renaissance, in the cultures of Western Europe studied by Hufschmidt, the predominance of left-facing profiles again surfaced. This left-facing tendency is a common observation, but there is of course nothing preventing an artist or anyone else from drawing a right-facing profile. When the subject matter requires it, it is easily done. A picture of two persons speaking to each other, for example, requires that one face right, one left. Certain ceremonies may require that portraits face in a certain direction. Such instances were excluded by Hufschmidt from his studies.

But the left-facing tendencies today have been often noted. In the early 20th century, long before any meaningful research into right/left hemispheric differences, a German educator, S. Levinson, wrote: "Stand a child before a school class. Have the child face to the class's right and tell the class to draw a portrait of the child." You will, he said, "be

astounded at how many left facing portraits you will see."[4] The anomaly that in ancient times, on the other hand, most portraits faced to the viewers' right has been the subject of much speculation. Heinrich Schäfer, a leading authority on Egyptian art writing in the early 20th century, and likewise before much of the research on asymmetry, was puzzled.[5] He speculated that the right orientation of the Egyptian art resulted from the fact that their writing was from right to left, whereas we, whose writing starts from the left, usually draw left-facing figures.

Hufschmidt, well conversant with cerebral asymmetry, had other ideas. He stated that the change in profile orientation represented a change in that asymmetry, which he believed occurred over a few generations and resulted in three centuries of development in human thought and behavior in the Greeks of that time. He mentioned several of them specifically, including the axioms of mathematics, a purely intuitive formulation; the symbolism in speech, an undoubted reference to the new and brilliant use of metaphor; what he called the theater of self-reflection, an equally clear reference to the new and intimate expression of deep emotion in the dramas of the fifth century; and the reduction of the physical world to a geographical land map. He did not mention facial expressiveness, but within two hundred years came the marvelously expressive portraits of the Hellenistic age.

But he did mention one other development of overriding importance: the Greek capacity to portray three dimensional perspective as opposed to the prevalent two dimensional perspective of all other art cultures. As to this change he stated unequivocally: "That is not a difference in custom, but in cerebrally conditioned capability." There was, in short, a change in mentality, a change in the inborn view of the world and in the sense of aesthetics. To the extent that part-to-whole relationships are appreciated on an emotional level, there will be an innate concept of the unity of space. Space will be seen as an all-encompassing, overarching whole. Most ancient and medieval peoples saw nature as fractionated. As we will see later in more detail, their literature, art and religion reflect this view of a disjointed nature, each part seen separately and largely unrelated to others.

But it is a prevalent view of psychologists and art historians alike that to appreciate nature for its own sake and its own beauty, one must step back from it and see it as a separate independent entity, apart from ourselves, with its own dynamic and its own existence in time and space. That view of nature is vital to an appreciation of its beauty, and likewise vital to a full appreciation of the self as a separate and unique individual. These thoughts have been put forward by scholars of various fields of study, not as abstract musings, but as results of disciplined research and analysis.

Schäfer's idea about profile orientation following the direction of writing is interesting. But in more recent times much attention has been paid to the fact that, at the time of the change in profile direction, Greeks, like others of the time, had been writing from right to left. Not until about a hundred years after that change in profile orientation was there a change in the direction of the script, from left to right. Those who have studied this matter in recent decades, and there are several such scholars, suggest that this reversal also signals a change in brain asymmetry, though implying perhaps that the writing caused the change in asymmetry rather than the reverse. There are, to be sure, certain practical reasons why right handed people would prefer left-to-right script and might make the change consciously. In writing right to left with the right hand, that hand would tend to hide, and perhaps to smear what had been already written.

But these scholars reckoned without Hufschmidt's findings concerning profile orientation, which occurred about one hundred years before the change in writing. Practical reasons for the change in profile orientation would be hard to imagine. It appears that the change in the "cerebrally conditioned capability," that is, a new dimension in cognition, or spatial competence, probably came first and that the various behavioral changes followed. In all probability, however, the behavioral changes then reinforced the original cerebral impulses in turn, a mutual interaction that scientists often call symbiotic.

There have been other interesting findings concerning facial orientation in art. One of them, conducted by Otto-Joachim Grüsser and his colleagues seven years after Hufschmidt's, picks up where he left off.[6] It traces the left/right tendency in portraiture beginning in the 15th century and continuing through the 20th. Grüsser's usage of "right" and "left," as with that of Hufschmidt, refers to right or left of the viewer. His study also looks at the location of light in paintings and drawings, another aspect of art that could tell much about brain asymmetry. In fact, Grüsser's study may point up the significant difference between a true profile, and a frontal with the head but slightly turned. In the latter case what first attracts, and what is the focal point of the picture, is its more lighted side.

When determining right-hemispheric dominance in portraiture, the ultimate matter of importance is the location of the focal point. Right dominance would dictate that it be on the left side of the picture's midline. That matter is not at issue on a true profile with only one side of the face in view. If, for instance, the profile faces to the viewer's right, it will certainly be the features of the face as opposed to the rear part of the head that attracts, despite the rear part of the head being to the left of the midline. Hufschmidt's exemplars were almost all true profiles, with

only one side of the face showing. Frontals in ancient times were not the norm.

Grüsser concluded, based on studies of almost a thousand paintings, that in the 15th century, the beginning of the Renaissance insofar as art is concerned, and continuing through the 17th century, there is a stronger tendency to show the left side of the face than the right, meaning that the portrait is facing to the viewer's left. He also found this tendency, for some unknown reason, to be stronger for portraits of females than those of males.

He concluded additionally that this left-facing tendency decreased over the years until in contemporary times an overall right-facing tendency prevails as to men, but not as to women. Significantly, he also found that the light in paintings and drawings more often orients to the left side. This may be a clear indication that, in speaking of portraits facing to the viewer's right, he is speaking primarily of frontals with the head slightly turned, rather than true profiles. The center of focus would thus be on the left side of the portrait, but emphasizing the right side of the subject's face, which is turned slightly to the subject's own left, the viewer's right.

He concurs with Hufschmidt that there is indeed a biological, genetically induced preference for left-facing and left-sided interest in paintings. He points also to the importance of historical and cultural factors which can, especially in the individual's early years of development, modify the genetically programmed asymmetry of the brain. The existence of these factors of personal experience is obvious, he states, as the probability that the trend beginning in the 18th century is caused by "some change in the genetic code is practically nil." Grüsser gives us no authority for that conclusion, but it obviously rests on the general assumption that any genetic or evolutionary change requires eons. In recent decades, however, there has been much scientific evidence to the contrary.

Nonetheless, assuming that there truly was a change in the center of focus, he may be correct that no genetic change was involved in any change in facial orientation after the first two centuries of the Renaissance. For one thing, there does not appear any other evidence of widespread cognitive or behavioral changes. Hence, any such change merely in profile direction may certainly appear to have been based, at least to a large extent, on cultural factors.

However, the profoundly significant change in profile orientation about 600 B.C. as well as the similar appearance of left-facing portraits in the 15th century are different matters. First, there are the almost simultaneous changes in other related behavioral traits in both ancient Greece and Renaissance Europe. Secondly, there is scientific support for accepting a biologic basis for those changes, based on the mixing of popula-

tions. This factor would appear to have no application to any such change in 18th century Europe.

Typical of this scientific support is the work of two evolutionary biologists, Charles Lumsden and Edward O. Wilson. They have detailed a process of genetic and cultural "co-evolution" in which beneficial forms of genes will be selected by cultural factors and become prevalent in a population.[7] They conclude that evolutionary changes in human behavioral or mental processes can, under some circumstances, proceed as rapidly as a cultural change, and in special circumstances in as little as ten generations, or several hundred years. But for any highly efficient new trait they believe that fifty generations, or a thousand years, is sufficient.

Most relevant to our own focus, they add that the rate of co-evolution may depend upon the amount of "genetic variance" within a population, which refers to the relatively sudden mixture of long-separated populations, a circumstance that today we might refer to as "multi-culturalism." Such mixtures result in a wide variety of new genetic combinations, resulting from intermarriage, on which selection by culture and by nature can act. New spatial skills, and new ways of viewing nature, the human face, and the surrounding world would seem to be the essence of beneficial traits, the type that are referred to by Lumsden and Wilson.

It is interesting to note in this regard that both the Greek "miracle" and the European Renaissance occurred within about a thousand years of the mixing of native populations with those of many invaders. With the Mycenaean Greeks it was the Achaeans, Aeolians and Ionians. With the Europeans it was the Lombards and Ostrogoths, both groups settling mostly in Italy, and Franks, who settled in France. These invaders, in each case, did not conquer and leave. They moved into the conquered areas and wedded daughters of the native populations, and the conquerors and conquered merged into single populations. These historical situations find no parallel in 18th century Europe.

Nonetheless, assuming the correctness of Grüsser's postulated 18th century shift away from the left-facing tendency of profiles, there is indeed a possible explanation for it that does involve a biologic factor as opposed to merely cultural factors. It would not involve a change in the genetics, but the functioning of the brain's asymmetry as it presently exists. As will be discussed later, novel matters are apprehended more strongly by the right hemisphere. Once the basic pattern has been established or, as it may be phrased, after the novelty wears off, it is the left hemisphere that develops practiced skills as the process becomes more routine and habitual.

Individual portraiture was novel in Hellenistic Greece. Subtle and

finely shaded expressions of feeling and emotion in the human face
became a subject for artistic portrayal for the first time in history, and
was followed for several centuries in Rome. It was new again in the early
Renaissance, having disappeared for about a thousand years beginning
late in the declining Roman Empire.

Perhaps after several hundred years of splendid portraiture by hun-
dreds of artists, it became a matter of routine for the later European
artists in a way that those of classical times never experienced due to the
vicissitudes of history, namely the invasions from the north. This is a
possible explanation for the seeming conflict between the tightly con-
trolled studies of Grüsser, involving professional, mostly renowned
artists, and the more random observations of Schäfer and Egyptian
scholar Adolph Erman, whom he cited, involving a broader range of
paintings and drawings. This would be even more true of the observa-
tions by the German educator, Levinstein, of young school children.

Obviously, this is speculation. But it is speculation based on known
scientific facts. The change, if it existed, could have been purely cultural
in nature, but what the cultural factors could have been are not readily
apparent, and Grüsser offers no suggestions.

But let us return to ancient Greece. Hard of the heels of the docu-
mented change in profile orientation in the sixth century B.C. came other,
more dramatic ones. Among the first were in the teachings of philoso-
phers. It was in the beginning of that century that were first heard the
novel ideas of Thales from Miletus, sometimes known as the founder of
all philosophy. It was he who first urged the Greeks to look to principles
of nature itself to explain its own phenomena, rather than to myths or
gods. It was also the century of Pythagoras, who advanced as abstract
propositions the concepts of numbers and spatial relations. No longer,
as with the Egyptians and other contemporary cultures, were the rules
of mathematics used purely for specific, practical, utilitarian purposes,
such as architecture, surveying, commerce, or finance. They were con-
ceived now as abstractions to be used universally, as Pythagoras demon-
strated by affirming the shape of the earth as a sphere, rather than as a
disk as had been more generally assumed. And it was he who advanced
the geometrical explanations of eclipses, rather than accepting the unex-
plained tables of the Babylonians, based purely on observations.

This all coincided with or shortly followed the change in Greek
profile orientation indicating visual primacy in the hemisphere honed
for spatial rather than verbal or analytical competence. And it preceded
by a mere 200 years the remarkably expressive faces of the Greek Hel-
lenistic Age, something as new in art as the teachings of the philosophers

of the sixth century had been in religion or in codes of conduct. Both may have resulted from a greater sensitivity to facial expressions of feelings in other persons, a greater degree of empathy. And all of these developments may have resulted, in whole or in part, from a more pronounced, perhaps reorganized, asymmetry of the brain.

Instead of unconnected, unrelated facts, the Greeks saw relationships, and there began an obsession for systematic study and classification quite apart from any immediate goal. Though the concept of verification by experimentation remained as foreign to them as to other ancient cultures, the Greeks found pleasure in study and analysis for its own sake. They hoped to discover the secrets of the universe through pure logic. It was a vain hope, but their sharpened intuition drove them to seek the primary element of the universe, one underlying basic element constituting the entire material world.

It was not air as was suggested by one, nor water as by another. But these philosophers were motivated by the same intuitive drive as are the most sophisticated and brilliant of the modern physicists who still look for a Theory of Everything. With scant evidence, they are driven largely by their modern innate insistence on unity in nature. Unable to accept their empirical findings that there should by one set of laws and equations, relativity, for the unimaginably large, and another set, quantum mechanics, for the unimaginably small, they are convinced that all aspects of nature must be governed by the same laws. In their world outlook, the ancient Greeks were indeed modern.

Another change, occurring somewhat later in the sixth century B.C., seems at first blush to be unrelated. But it too, in all probability, resulted from enhanced spatial sensibilities. It involved foreshortening in art and, to a degree not precisely known, three dimensional perspective, the interrelation between objects in space as seen by the human eye. Its true significance would surface later, haltingly in classical times, brilliantly in the Renaissance, when it would manifest itself as a new genre.

That new genre would be known as landscape painting, and would afford a view of nature as a unity, an all-encompassing panorama of the visible natural world in all her aspects. It was to reveal nature, for the first time, with all its parts interrelated, an entity unto itself, occupying its own time and space, and operating according to its own internal dynamic, with any humans or human handiworks shown as props.

It started as something less dramatic, but quite significant nonetheless. Foreshortening had not been seen before, except, spasmodically, for a few hundred years in Egypt, and, astoundingly, in a few instances in the upper paleolithic of southwest Europe, probably between 15,000 and 12,000 years ago. Perhaps it is not so astounding. In evolution and in all new human behaviors, there are always precursors.

V

Reaching for the Third Dimension

Early Greek feeling for depth in art; oblique views, foreshort-
enings and diminution of distant objects in relief sculptures;
evidence of early monumental painting; literary evidence of
third dimension in art.

In 479 B.C., following costly victories during the previous year on
land at Thermopile and on the sea at Salamis, Athens and her sister
Greek cities finally subdued their perennial enemies, the Persians. Their
empire was eliminated as a military threat, and it was then that began
the Greeks' most fruitful period of innovative genius. But even fifty years
earlier, in the dark days when Cyrus, King of the Persians, was still cap-
turing Greek cities in Asia Minor, Greek artists for the first time in the
history of art seemed seriously concerned about the actual appearance
of things. Something new in their psyche must have afforded pleasure in
viewing the depth and volume of the objects around them, a pleasure
they felt worth capturing in art, and they began their first fledgling
attempts to do so. They abandoned the complete dominance of the
frontal plane and showed figures in oblique, sometimes called three quar-
ter views. It came about gradually; it was not a sudden event, however
much it may seem so in retrospect.

But however slow the progress, evidence of the new absorption with
depth is persistent. Very little of Greek monumental paintings survives,
but this new style appears in marble reliefs, in paintings on large, broad-
bodied, wide-necked jars or mixing bowls known as kraters, and on taller,
narrower vessels known as amphoras. It appears also on smaller objects
such as cups and jars, items that are much larger than those words imply
today. It is doubtful that the curved surface of the vessels hindered the
development of depth. The pictorial space developed on the vessels was
similar to that later used on walls, panels and pages.

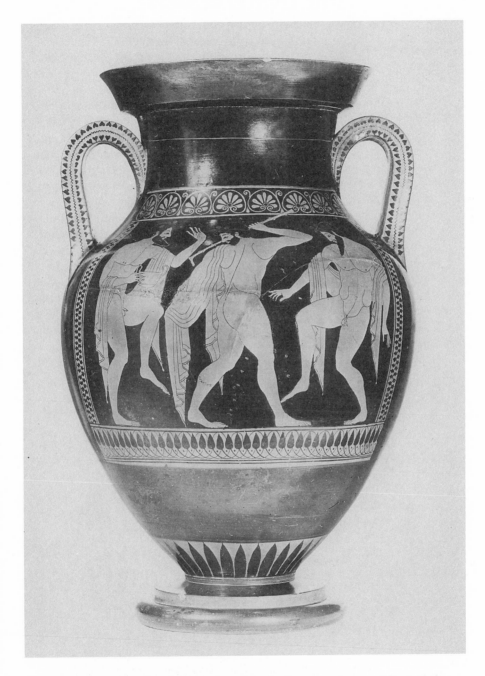

ILLUSTRATION 5. *Revellers*. Munich: Staatliche Antikensammlung und Glyptothek, Munich. From an amphora, 510–500 B.C.

Compelling evidence of progress comes toward the end of the sixth century, and seems to have been spurred on by competition. The names of Euthymides and Euphronios are among the most prominent at this early date. Two accomplished examples of the use of oblique views, one from each of these competitors, stand out. The one from Euthymides, on an amphora, depicts three revelers, all realistically shown, except perhaps for being a trifle too corpulent to really revel with such gay abandon. The one from Euphronios, on a krater, depicts Anataios and Herakles, the Greek hero. Herakles, better known today by his Roman name of Hercules, was famed for, among other feats of strength, the killing of a lion and a three headed giant. He was also known, unfortunately, for having killed his family in a fit of madness; and for having in a single night made love to the 50 daughters of King Thespios. Interesting character though he was, it is on the other vessel, the amphora (ILLUS. 5), where foreshortening seems more skillfully handled. In depicting the revelers in three quarter views, showing side and front on two of the figures, and side and back on the other, Euthymides was breaking new ground. And he was obviously aware of it. He added the inscription, "Euphronios never did anything like this."

Other contemporary artists seemed to have some problems with this new technique. The artist Psiax, about 515 B.C., has given us, on a cup (ILLUS. 6), his representation of an attacking warrior and his fallen vic-

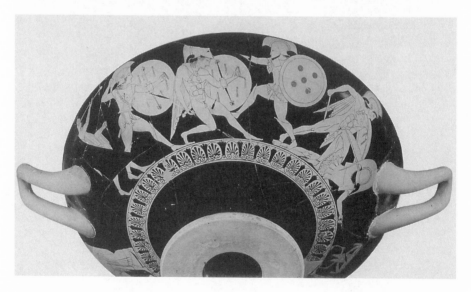

ILLUSTRATION 6. *Attacking Warrior*. New York, The Metropolitan Museum of Art, Rogers Fund, 1914 (14.146.1). From an Attic red-figured cup (kylix) by Psiax of about 520–515 B.C. Attic.

tim (far right). Advances in showing depth are certainly in evidence as it is done for the most part in three quarter view. The body and the one visible leg of the standing warrior do show volume through appropriate foreshortening. The warrior is shown largely in profile and his shield, held to his chest, is shown from the side, properly foreshortened, rather than in the improbable front view as in earlier art. The warrior's eye however, Psiax saw fit to show us in full front though the head is otherwise in profile, and the chest itself seems oddly as a frontal view. Further, the fallen victim seems pieced together with disparate parts, all shown from the view deemed most attractive or important, as in the art of earlier times. Most of his body and head, for example, are shown from the rear, but his left leg is in an impossible profile position, and his helmet shows both crests, both in profile, though only an edge of one could possibly be visible at that angle.

In a scene by another contemporary artist, representing a Greek spearing an Amazon, the warrior woman shows her chest from the front, but her breasts in profile and each fully visible, a highly unlikely contortion. Equally so would be the legs and head of her Greek attacker in profile with the chest seen from the front.

By the early part of the fifth century, it is apparent that the artists are achieving greater facility with depth. In the first decade there is an interesting composition on an oil jug showing Helios, the sun god, rising from the sea. Departing chariots are bearing Night and Dawn, while Herakles roasts food over a fire. This work is sometimes referred to as a landscape, a somewhat elastic use of the term, since the central figures are humans or deities, and the presence of the land or sea is minimal. Its chief interest lies in the use of foreshortening and depth rather than depictions of nature.

One of the very few paintings of the time with no human involvement, dating from 500 B.C., shows trees and dogs on a large drinking cup all placed in a single line, the only attempt at portrayal of depth being the placement of spreading branches of the trees (ILLUS. 7). As late as 455 B.C. a composition on a krater depicting a battle between Greeks and Amazons reflects the continuing problems. A central figure is an Amazon on horseback, which the artist has apparently attempted to portray in depth, but which nonetheless contains a piecing together of parts shown in frontals with those in profiles. Unfortunately, this anomalous mixture diminishes the effect of other parts shown with volume portrayed through the use of three quarter views. Perhaps one of the finest works of the period in its treatment of depth is on a vessel, painted by a famed artist, Douris, about 470 B.C., portraying two women folding their wardrobes. Influences of the earlier flat style are minor in this impressively modern work, and foreshortenings are executed with skill and subtlety.

ILLUSTRATION 7. *Dogs and Trees in an Orchard*. New York, The Metropolitan Museum of Art, Rogers Fund, 1907 (41.162.23). From an Attic red-figured cup (skyphos) of about 500 B.C.

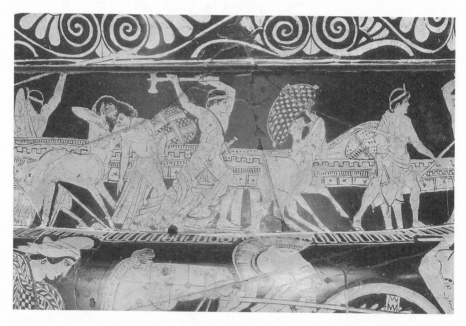

ILLUSTRATION 8. *Battle of Centaurs and Lapiths*. New York, The Metropolitan Museum of Art, Rogers Fund, 1907 (07.286.84). From a volute-krater, terracotta, ca. 450 B.C.

By the latter part of the fifth century the human figures in oblique, three quarter views seem easily mastered, even with the lingering archaic influences. One, of interest for its exhibition of both the advances and the remaining difficulties, is a depiction of the struggle of Lapiths and Centaurs, those creatures, half man, half horse, that populated Greek mythology. It is represented on a mixing bowl (ILLUS. 8). One centaur (right of center) is shown with the human head and body in oblique front view, the horse body in oblique back view. The artist apparently wanted to show both ends of the creature more than he wanted to show realism. Both ends, individually, are shown with admirable skill, but in relationship to each other they are somewhat skewed. It was an ambitious artistic undertaking, however, and the impression of the entire scene is powerful, despite such inconsistencies.

There were other advances. Instead of a single wing on a bird's profile, or a single horn on that of a bull, we see overlappings with their opposite numbers. Among the most significant advances were those in representation of the eye. No longer was there a frontal view of an eye on a profile head. First the circle and dot of the iris were moved near the inner corner and elongated, as they would appear from a profile view. A few years later, some paintings showed a three quarter view of the entire eye with the iris in the middle rather than the corner. Finally, a line for the eyelash was added. The changes were few and simple, but the result was strikingly effective.

On a vessel from about 475 B.C. there is a scene from the Odyssey, with rowers, the steersman and Odysseus all in proper placement and relationships, rather than in a line; but the sail is still shown as from the front, like nothing to be seen on a real craft. There is also progress in the representation of chariots and their harnessed horses. No longer are they limited to the strictly frontal planes, and the attempts at depth, though incomplete, show much progress. Both the railings and the wheels are properly placed. Most significantly, the problems attendant to showing the human body in various positions seem to have been solved. Throughout the entire fifth century, however, correct relations between parts of furniture and interiors seem to have eluded many of the artists.

There remains the larger question of the use of perspective in its fuller sense, the convergence of parallel lines with distance and the proper relationship between various objects as seen in a field of vision. There were some hesitant beginnings of it in the mid–sixth century, such as overlapping and diminution of far-off objects, but evidence for substantial progress, even during the entire Greek period, is slim. The paucity of tangible proof may be due to the absence of a significant body of

Greek monumental paintings, little of it having survived to modern times. The Greek reliefs, like the Greek vases, exhibit at best an inconsistent degree of mastery of depth even in foreshortening, but even less in diminution of objects in the distance.

The claim of some historians that the Greek artists did not realize that distance ought to make the objects smaller certainly cannot mean that the artists did not know that they appeared smaller to the eye. They must mean that the smaller size meant nothing to the Greeks aesthetically. It obviously did not—at least not yet. In paintings from the second half of the fifth century, for example, we often see rounded, expertly foreshortened individual figures, sometimes of boys exercising, sometimes of soldiers in combat, but with distance represented only by figures shown higher in the visual field, without diminution in size. On a late fifth-century jar there is a rather complex rural scene, complete with a musician, his wife and child, Aphrodite and Muses, as well as individual plants, rocks and trees (ILLUS. 9). The scene is engrossing, but once again depth is suggested only by certain figures placed higher than others, without diminution. From about 420 B.C., there is a tall vessel with a narrow tapering neck, showing Diogenos in a landscape of hills with satyrs and maenads in various positions and different levels, but still all the same size.

The center of artistic activity in the period known as the Hellenistic, beginning about mid–fourth century, shifted from Greece proper to her colonies across the Adriatic and the Mediterranean. But decades later we still see evidence of the same general reluctance by Greek artists to substitute what they see for what they know insofar as the relative size of objects is concerned. Even where some diminution is shown, there remains the lack of a common vanishing point. A water jar from Campania, about 330 B.C., shows three figures in a small building, the ceiling beams of which slant downward and toward the center of the picture, as they should to show depth; but they do not reach toward any common vanishing point. The representation of a kitharist and a child, painted about 50 B.C. in the Villa Boscoreale, a suburb of Pompeii, shows admirable facial expressiveness, a hallmark of both the Hellenistic and Roman art. But the farther leg of her chair is shown, jarringly to modern eyes, on the same plane as the one nearer the viewer. A painting of Roman houses decorating one of the walls of the same villa shows balconies, roofs, doors and windows drawn with receding sides, but with many vanishing points rather than one (ILLUS. 10). Each building shows its depth, but the relationship between them is far from clear. In this, as in many other such paintings, we see the scene from a number of different points of view rather than from one.

Nonetheless, in this late Hellenistic period, the pleasing effect of

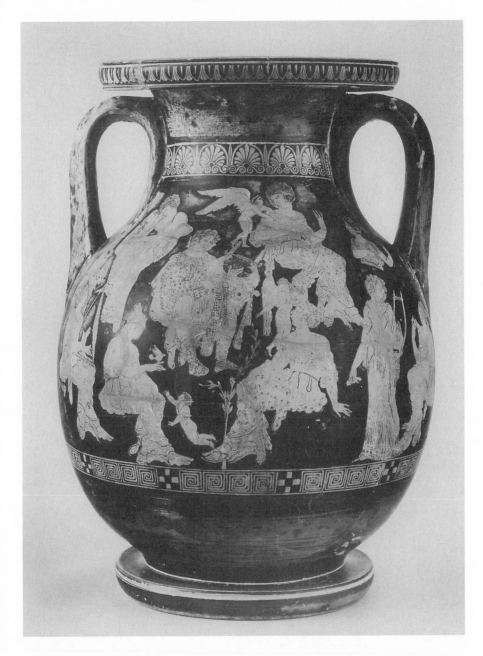

ILLUSTRATION 9. *Mousaios with Wife and Child, Muses and Aphrodite.* New York, The Metropolitan Museum of Art (37.11.23). From an Attic red-figured jar (pelike) by the medias Painter, late 5th-century B.C. Muses are Melpomeme, Terpsichore, Erato, and Calliope.

ILLUSTRATION 10. *Wall Painting from a Villa at Boscoreale.* New York, The Metropolitan Museum of Art, Rogers Fund, 1903 (03.14.13). First century B.C. Wall from the Cubiculum.

ILLUSTRATION 11. *Detail of the Rape of Persephone.* After fig. 111, Andronikos, Manolis, "The Royal Tombs at Aigai (Vergina), in *Philip of Macedon*, M.B. Hatzopoulos and L.D. Loukopoulos, eds. (Athens: Ekdotike Athenon S.A., 1980). Photograph: S. Tsavdaroglour. Detail from painting in the small tomb at Vergina.

diminution with distance does seem to have been grasped by some artists. There are a number of paintings executed in the Roman period, some apparently copied from Greek originals, showing such diminution of figures grouped in the distance. One, depicting the "Cannibalistic Race" involving Odysseus and the Laestrygones, shows consciousness of the relationship.

The surviving monumental Greek paintings are very few in number, but those few may tell us much. About forty miles southwest of the city of Thessaloniki in northern Greece, at the foot of the gently rising, green mountains known as the Pierian, lies the village of Vergina. There, for many years, archaeologists have been excavating a complex of structures housing the tomb of Philip II of Macedonia. In 1977, wall paintings dating from the mid–fourth century were discovered in one of them. At least two of the paintings arrest our attention. One painting, often known as *The Rape of Persephone* (ILLUS. 11), depicts a mythological subject. In the myth, Persephone is abducted into the underworld, where she thereafter rules as its goddess. The abductor is Hades, god of the underworld and the brother of Persephone's mother, Demeter, the goddess of agriculture. The abduction is believed to have been reenacted yearly in the rites of a secret religion known as the Eleusinian mysteries. The painting shows an excellent grasp of foreshortening. The carriage of the abductor is shown at an angle, and the wheel is depicted properly as an ellipse. Both Hades and the terrified Persephone are shown in rounded, full bodied, naturalistic portrayal. No greater mastery of depth is warranted by the nature of this painting.

The other painting, of more interest from the point of view of perspective, is a painted frieze (a decorated panel), on the side of the tomb. It is known as *The Lion and Boar Hunt,* an important detail of which is shown in ILLUS. 12. The importance of the detail resides in the advanced mastery of three quarter views and foreshortening by the artist in his depiction of the horse and rider moving away from the viewer toward the rear of the scene. In the balance of the painting, not shown here, trees in the distance are smaller than those in the foreground. Otherwise, many fine qualities of the painting notwithstanding, there is little to distinguish it from other of the best, though still imperfect, examples of Greek use of perspective.

But it is a third work that may be of the most importance. Over two hundred years after the paintings from Philip's tomb, a fresco (a water color applied on wall plaster while still wet) was painted in the "House of the Faun" in the Roman city of Pompeii. Like a number of other surviving works of art in Pompeii and in the nearby town of Herculaneum, it was buried and preserved under the ashes of Mount Vesuvius in A.D. 79, as were the bodies of many of the terrorized citizens of both com-

ILLUSTRATION 12. *Detail of the Lion and Boar Hunt.* After fig. 113, Andronikos, Manolis, "The Royal Tombs at Aigai (Vergina), in *Philip of Macedon*, M.B. Hatzopoulos and L.D. Loukopoulos, eds. (Athens: Ekdotike Athenon S.A., 1980): Photograph S. Tsavdaroglour. Restoration of detail of the Mosaic adorning the upper part of the large tomb at Vergina.

munities. The fresco, the undamaged portion of which is shown here as ILLUS. 13, depicts the Battle of Issus, fought between the forces of Alexander and the Persians. The work dates from the first or second century B.C.

Its advanced mastery of depth would not be too unusual for a Roman painting; the interest in it lies in the fact that art historians are convinced it is a copy of a Greek painting from the late fourth century B.C. That Pompeii, as well as Heraculeum, were originally Greek settlements may lend that claim some credence. The historians disagree as to whether the artist was the same as the painter of the Vergina frieze depicting the hunt (ILLUS. 11). A number of similarities have been noted, including a horse, shown from the rear, disappearing into the background. The Pompeii work is fairly packed with warriors in close combat, and the three dimensional effect seems significantly more effective than any known Greek art from the fourth century. If the work is a true representation of an original Greek, one or more—perhaps many—of the Hellenistic artists had greater facility with perspective than has generally been credited to them.

The examples mentioned are not typical of other known Greek works, however, and are of insufficient quantity to permit general con-

ILLUSTRATION 13. *Battle of Issus between Alexander the Great and Darius.* Museo Archeologico Nazionale, Naples, Italy. Photograph credit: Alanari/Art Resource, N.Y. Mosaic from Pompeii. Roman copy (1st century B.C.) of a Hellenistic painting. 8' 11" × 16' 9½". Width of portion shown ca. 10½'. Mosaic.

clusions as to two important questions: To what extent did the Greeks ever use diminishing size to represent depth in art, and proper spatial relationship as seen by the eye? To what extent did they understand the theoretical underpinnings of this apparent diminution, which is a common, shared experience of all humanity?

The scientific description of this phenomenon was set out at length by Euclid about 300 B.C. in his laws of optics. Euclid was a mathematician, interested in optics as applied to natural situations, not to art.

To modern artist, though, they may read like a handbook on perspective in art: When objects of the same size are placed in different locations, those nearer the eye appear larger. In planes appearing above the eye, the farther parts appear lower; in those below the eye, the farther parts appear higher. With lines extending forward, those on the right seem to angle to the left; those on the left seem to angle to the right. However, neither the rate of convergence of lines nor the diminution in size of objects is exactly in proportion to distance; with increasing distance, convergence and diminution both become proportionately less. If the arc of a circle is placed in the same plane as the eye, it appears as a straight line, as we are seeing the edge of the wheel straight on. From this last theorem it is obvious that a circle in a plane between that of the eye and that of one perpendicular to the eye will appear as an ellipse.

Though there is no certain evidence of the systematic use of these rules in surviving Greek art, what about the art that has disappeared? Other than pure speculation, the only source for a possible answer is in surviving literature. What did contemporary writers say about Greek art?

The most direct evidence comes from Marcus Vitruvius Pollio, a Roman known to history as Vitruvius. Like Alberti, about fifteen hundred years later, he was a writer, engineer and architect, engaged at one time to work for the Emperor Augustus. Also like Alberti he was a prodigious writer, and is best known for his one surviving treatise, *On Architecture*. In further parallel with the Renaissance writer, his treatise describes three dimensional perspective allegedly used by a particular artist, a scenic designer for the stage named Agatharcus. There the similarity ends. Vitruvius gives us no explanation of the technique supposedly used by his subject. Further, whereas Alberti was writing about Brunelleschi, his contemporary, though not mentioning him by name, Vitruvius was writing about one who lived over four hundred years earlier. The source for the writer's knowledge, if knowledge it truly was, is unknown. Some modern writers seem to accept his statements at face value. Others do not. Still others seem much in doubt.

Vitruvius wrote his treatise about twenty-five years before Christ. In the course of it he made two passing but very intriguing references to perspective. First, after mentioning representations of elevations and

plans, he noted that "In like manner, scenography is the sketching of the front and of the retreating sides and correspondence of all the lines to the point of the compasses." The reference to scenography makes clear that he is speaking of scenic effects, used in stage settings.

Any doubt of that proposition is dispelled later in the same document where he stated that when Aeschylus, in the early fifth century B.C., presented his tragedies, Agatharcus required that a "fixed center" be established and that

> the lines correspond by natural law to the sight of the eyes and the extension of the rays, so that from an uncertain object certain images may render the appearance of buildings in the paintings of the stages, and things which are drawn upon vertical and plane surfaces may seem in one case to be receding, and in another to be projecting.[1]

The explicit reference is thus to single objects. Does it apply by inference to entire scenes? Do these sentences, though not specifically saying so, refer to a common vanishing point?

A thorough study of this and other ancient texts has been made by Dr. John White, lecturer in the history of art at the Courtold Institute in London.[2] He answers both questions unequivocally in the affirmative. He acknowledges that there is no physical evidence to be found in the few artistic remains from the fifth century B.C. that corroborates Vitruvius's belief in the use of a vanishing point at that early date. The earliest evidence of such expertly done perspective to be found, in fact, are frescoes from Pompeii, which came under Roman influence only in the early part of the first century B.C. The frescoes themselves are dated to sometime in a twenty-five year period between the middle of that century and the writing of Vitruvius's treatise on architecture.

Dr. White discounts any possibility that the system shown in those frescoes evolved in Pompeii itself. It seems, he says, rather to be the tail end of an earlier development elsewhere. That its use in Pompeii was not long lasting, and that it soon gave way to significantly different styles, further convinces him that this fully perfected system did not arise there. Dr. White can do no more than place its origin at sometime between the fifth and first centuries B.C., most likely no earlier than the third or second, and at some art center other than Pompeii. One of the best executed and most important, if not quite perfected, examples of perspective in Pompeii is to be seen in a painting on the wall of the House of the Labyrinth (ILLUS. 14). According to Dr. White,[3] over 40 receding lines in widely separated vertical and horizontal planes vanish to a single point.

A similar claim of systematic use of the vanishing point has been made for the painting on the east wall of the Room of the Masks, found

ILLUSTRATION 14. *Wall of the Corinthian Oecus.* After fig. 61a, White, John, *Birth and Rebirth of Pictorial Space* (New York: Thomas Yoseloff, 1958). House of the Labyrinth, Pompeii.

in the villa of Publius Fannius Sinistor on the Palatine, the central hill on which ancient Rome was built. It dates from about the same time as the House of the Labyrinth. Gisela Richter, like White, notes the isolated nature of such correct drawings, but believes that it is indicative of keen observation on the part of a few artists[4] rather than the dying gasp of a system developed elsewhere.

Decorations in at least two other houses there contain important evidence of the use of the vanishing point, though sometimes even less perfectly, yet no general scheme of this method is to be found in Pompeii or elsewhere. In nearby Boscoreale, a single wall shows compositions that exhibit vanishing points and others that do not. Dr. White speculates that from whatever site the method in question was transplanted, it was, in all probability, more advanced and more elaborate than what is now seen in Pompeii. All evidence, he insists, points to the use of a theoretically based system of three dimensional perspective in antiquity, somewhere at some time. Still unresolved are the questions of where and when, and the use to which it was put.

Richter, also steeped in the history of Greek and Roman art, points out that the Greek word for perspective is "scene painting."[5] In the light of Vitruvius's work, this is an interesting fact. And if a system of perspective in the early fifth century was not used in stage performance, it is worth more than a passing thought as to why he said that it was. Why, in short, would he have ascribed to that early time, four hundred and fifty years before his treatise, a use of perspective without some significant evidence of it? Could it have been based on some earlier writing, now lost? Or might it have been pure speculation?

The answers to these questions may never be known. What seems certain is that before the classical civilizations went their way, in all probability either the Greeks, or, more likely, the Romans who inherited their culture, had discovered and used the notion of the common vanishing point. But whether they utilized a theory or worked through intuition and observation alone, is also unknowable. Like much of the rest of the culture of those civilizations, the grasp of three dimensional perspective was lost upon the incursions of northern populations into the area of the Roman Empire, and was neither sought nor retrieved until the Florentine Renaissance.

VI

Nature in Ancient Art

"Landscape," in painting involving nature as the primary focus; "secularization of the visible"; Oscar Wilde and Nature's Imitation of Art; early representations of nature as limited primarily to solitary figures; nature in Greek relief sculptures; monumental paintings from Vergina and Pompeii.

It is a fair conclusion from the history of art that it was three dimensional perspective that gave birth to landscape painting as a genre, meaning portrayal of the beauty of a natural scene as something to be admired for itself alone. Yet the term landscape has other less restrictive uses, for landscape may be an element in paintings which cannot themselves legitimately be termed landscapes. In that less restrictive sense, "landscape" and "perspective" are not so closely joined in art history.

True landscape, in the sense the term is used here, may arguably exist in a few of the Greek and Roman works. To the extent that it did, it will be interesting to note the degree to which those works evidence three dimensional perspective.

A question arises at the outset. What degree of prominence must a painting reserve for a view of nature in order that it may rightfully be called a landscape in the more restrictive sense of the word? To what extent is it permissible that there be incidental representations of deities or humans, or human handiworks such as dwellings, gardens, farmyards, bridges, roads, temples or shrines, before the painting loses that designation?

Blurry though the boundary may be, it seems more likely than not that in the majority of works there will be a general consensus as to whether the natural panorama is the central focus, or merely incidental background for something else.

Of importance here is the degree to which a work represents a view of the world seen from outside of and apart from nature, one that makes the viewer seem independent and separate from it. Like much else about

our vision, this view is an illusion. We are very much a part of nature. But what true landscape shows also is the independence of nature from us, a nature profoundly beautiful, yet unconcerned with humans and human affairs. That view is part of the modern psyche. Difficult as it may be to imagine it ever being otherwise, nature was once, almost everywhere, filled with gods who controlled the destiny of humanity and every individual member of it. Every element of nature, groves, streams and hills, as well as seas, sky and earth itself had its special gods; and they predominate in much of early art.

They were personal gods who granted or withheld rain, or caused or prevented earthquakes, volcanic eruptions, floods or other catastrophes according to whether they were angry or slighted or appeased or pleased. Often they were placated by animal, sometimes by human sacrifice. Belief in a single deity has not always ameliorated the depth of the personal quality of this relationship with nature. Neither the ancient Hebrews nor the medieval Christians saw nature as anything other than an expression, a tool, of a deity who granted or withheld favors or inflicted punishment according to his stern view of human behavior. With the exception of classical times, and then to a degree limited in time, place and number of adherents, only in the last three or four centuries have most humans seen the vicissitudes of nature as resulting from its own dynamic, its tidal waves, hurricanes, floods, droughts and earthquakes occurring irrespective of the behavior or even the presence of humans.

A 20th century writer, Karsten Harries, has written that perspective has resulted in a "secularization of the visible."[1] History proves the truth of that statement, though it would perhaps be even more precise to say that it is landscape in perspective that has made the change of which he speaks. But it was indeed perspective that gave rise to landscape, at least as a separate genre in Western art.

It is tempting to regard our different view of nature as resulting from the discoveries of modern science, the harnessing of nature for the benefit of humanity and our resulting knowledge about it, and our ease of travel. The chronology, however, is otherwise. The world became beautiful to humans, at least in the sense that we find it so today, after the widespread use of three dimensional perspective and the growth of landscape paintings, but before the harnessing of science and the comforts of modern life it created. The great industrial revolution that brought about the ease of travel came at least 200 years after the almost explosive growth of landscape painting in the 16th century, and about one hundred years after the similar blossoming of effusive literary descriptions of nature, beginning in the 17th century.

Oscar Wilde, with deadly accurate insight, explained this phenomenon with an illustration of one small aspect of it in an incisive essay

entitled *Nature's Imitation of Art*.[2] The small aspect in question was the London fog. According to Wilde, it was art that "created" fog, the art in this instance being the works of the impressionist painters:

> Where, if not from the impressionists, do we get those wonderful brown fogs that come creeping down our streets, blurring the gas-lamps and changing the houses into monstrous shadows? ... The extraordinary change that has taken place in the climate of London during the last ten years is entirely due to this particular school of Art.

But did not nature create fog? Wilde's answer seems on the surface to be hyperbole, or perhaps a self-conscious witticism. But on reflection it seems to grasp a deeper truth. What is nature? he asks rhetorically. His answer:

> She is our creation. It is in our brain that she quickens to life. Things are because we see them, and what we see, and how we see it, depends on the Arts that have influenced us. To look at a thing is very different from seeing a thing. One does not see anything until one sees its beauty. Then, and only then, does it come into existence.

There may have always been condensation of the moisture in the air near the ground. There may have been reduced visibility. There may have been a heaviness to be felt upon breathing. But fog as the poets were then describing it, and as artists were painting it, had not previously existed. As he explained:

> At present, people see fogs, not because there are fogs, but because poets and painters have taught them the mysterious love lines of such effects. There may have been fogs for centuries in London. I daresay there were. But no one saw them, and so we do not know anything about them. They did not exist till Art had invented them.

Hence, the fact that no one had written about fog, or had painted it, meant to Wilde that for previous generations it had not existed. Indeed, what is there about the particular arrangement of atoms in a mountain range or in a flower that inherently makes it beautiful? Jerre Levy, a 20th-century author, wrote that part of the aesthetic experience is the forms, configurations and orders that came into existence only when minds came into being.[3] In short, there was no beauty in nature at all until there were humans to see it. And, as Wilde also put it, one does not see anything until one sees its beauty.

There have undoubtedly been a few humans throughout history and prehistory who, before all others, first found beauty in some particular aspect of the world. Only when artists were able to capture it did the

admiration of it become universal, either in a culture, or, as in later times, in all cultures. The natural processes of the earth had been going their inexorable way for billions of years before there were humans, and for several million years after humans arrived. Water flowed, plants and flowers lived and died, hills and mountains uplifted and eroded. But nature, as an entity, as an object of admiration, nature as we speak of it today, and as artists paint it and as poets and authors write about it, did not exist.

Levy claimed also, and with equal force, that it is the construction of beauty from the raw materials of nature that leads to scientific investigation. The chronology of history supports that observation. The scientific discoveries, and the inventions that made travel so easy, came after the discovery of beauty in the landscape. They came after the painting of it and after the poetry and other literary paeans to it. But this is a matter that, for the time being, we can postpone.

Humans have been around for almost three million years; modern humans for at least a hundred thousand. But not until about 35,000 years ago did prehistoric people begin to represent nature in their art; only when they began to see beauty in it. But their vision of beauty seems at first to have been limited. They first saw it only in the animals that for countless generations they had both hunted and feared. The cave dwellers of the Upper Paleolithic, as recently as twelve thousand years ago, painted no trees, mountains, valleys, or streams. They showed no horizon nor ground line. The animals they painted were almost always single specimens, solitary figures. There was no interaction between them, with very few exceptions, and questionable ones at that; nor composition of any kind.

The Egyptians also painted animals, but unlike the art of the cave dwellers, that of the Egyptians often included composition. Animals are seen in groups. There are hunting scenes in their two-dimensional paintings, including humans, waterways and trees, but it is always the human activity that predominates. Beautifully done though the birds and other animals may be, they are foils for the representation of humans and their activities. The Mesopotamians on occasion showed mountains, barely sketched in however, and as background for the humans—mostly kings and their warriors—and their glorified activities. Frequently in ancient paintings, including those of Egypt and Mesopotamia, the solitary representations of natural elements are shown in borders around the scenes of human activity, and form no part of the scene itself. The figures are decorative only.

Changes begin with the Greeks and Romans of classical times. Greek

monumental paintings have, with some few recently discovered exceptions, disappeared with their ancient civilization. We are as uncertain of the existence of ancient Greek landscapes as we are of ancient Greek perspective. It is probably no coincidence, however, that the equivocal beginnings of three dimensional perspective coincide with similarly equivocal beginnings of landscapes. Except for those few but highly significant finds in northern Greece dating to the fourth century B.C., those tentative beginnings occur in the last century before Christ. The technique progresses for about two or three hundred years, at which time the focus in art turned to the Romans. Both perspective and landscape, or features of nature, are represented with varying degrees of mastery in the late Roman Republic and early Empire. They are witnessed especially in the monumental art of Pompeii and the magnificent frescoes from that city and from Herculaneum.

From the earliest Greek civilization on the Island of Crete, known as the Minoan, we see for the most part solitary figures. From the palace at Knossos and from Hagia Triada on that island, there are frescoes, designs on seals and gems, pottery with naturalistic representations of birds, bulls and antelopes, and others with sea life, including animals and plants, lilies, fish and octopi. About 1400 B.C., with the destruction of the palace at Knossos, probably by Greek invaders, the focus begins to shift to the Greek mainland and the Mycenaean civilization.

The designs there are mostly on cups, some of them of gold, and on daggers. They contain lions and gazelles, but otherwise are similar to the Minoan. One example of an early hint of landscape would include the painting of the cup executed about 500 B.C., previously mentioned for its lack of perspective (ILLUS. 6), with dogs and trees all in a row. For seven hundred years, however, the quality of representative art does not seem to improve. From the decline of the Mycenaean culture, at about 1100 B.C., until the age of Hellenism beginning in the fourth century B.C., the figures became more abstract, less naturalistic.

Though Greek monumental art is largely missing, from with the fifth century B.C. onward relief sculptures are not. Scholars who have studied the subject feel that the reliefs, which number in the thousands, can tell us much about the nature of the lost paintings, and are, in any event, an interesting study in themselves.

Elements of nature in these reliefs first make a significant appearance toward the end of the fifth century. For over two hundred years they appear on architectural reliefs (decorations on buildings). For another hundred years they also appear on monuments to the dead or other specially dedicated stones. Our interest here is in the degree to which such

elements appear as objects of admiration for themselves, and to what extent merely as a background, or prop, for humans or human activity.

Depictions of natural elements appear on reliefs, usually dedicated to heroes or gods, on grave monuments and tombstones, and on the decorated stones called 'metopes,' elements placed between panels of the Doric friezes that adorn architectural structures. Usually the friezes themselves are in a sequence narrating a well-known story. The natural elements are primarily trees and rocks, and less often, fish or other animals.

In the fifth and fourth centuries B.C. there are examples of rocky terrain and of trees, and at times, some evidence of representations of the sea. These early representations are present only as background for human activity, which is the focus of the scene. Rocks are sometimes used, apparently only as symbols to denote the ruggedness of the landscape where the action occurs, or other times merely as a convenient prop for the action. Trees, usually bereft of leaves, symbolize a woodland, or as with rocks, they are used as props, or to set out or clarify the composition

A typical example is that shown on two of the several friezes on a building on the island of Delos, dating from the mid–fourth century. They narrate the exploits of Theseus, the hero of Athens, who may or may not have been an actual person. On one he is knocking his adversary from a rocky perch. On another he is bending a bare tree, in the legend a symbol of his strength. A tree depicted on a relief in the Acropolis Museum in Athens, dated to shortly before 400 B.C., is used as a support for a shield. On another of approximately the same date, the broken branches are conveniently present as a mount for the spoils of war, clearly not as things of beauty. Trees abound, but almost always with some utilitarian purpose rather than as objects of admiration.

Through the end of the fourth century rocks are often present, their purpose being to serve as seats for heroes and gods. From the end of the fifth century, on a dedicated relief from the southern mainland, there is Pan, half human, half goat, seated on a small outcrop of rock. On a dedicated relief from Corfu we see Zeus seated on one. On another, from the early fourth century, a boulder is the seat for Dionysus. It seems certain that had the creator of any one of these works preferred not to have his character seated, the rock would not be there. For Herakles an outcrop of rocks partially supports the club he is holding.

Not until the late Hellenistic period do we see evidence of any natural object portrayed to be admired for itself. From the second century B.C., there is a deservedly famed, dedicated relief from Greece, generally known as the *Family Sacrifice Relief* (ILLUS. 15). It depicts a family performing a sacrifice at a sanctuary in the presence of two gods. Both the size and obvious age of the overhead branch of a tree underscore the

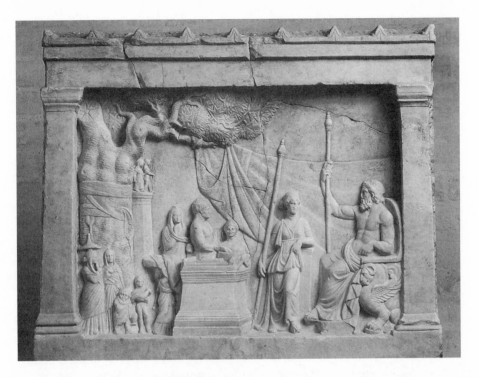

ILLUSTRATION 15. *Family Sacrifice Relief.* Staatliche Antikensammlungen und Glyptothek, Munich. Photograph: Courtesy Saskia Ltd., ©Ron Wiedenhoeft. Votive Relief.

stateliness of the sanctuary. But in addition there is thick bunching and detail of leaves, and the foreshortening of the gnarled branch itself gives the impression of recession and depth. It is a rare example of a natural object shown for its beauty and stands in marked contrast to the stark simplicity of the tree trunk, and the detailed work goes well beyond that required for the mere depiction of the theme. But this work is not typical. Other contemporary works show no hint of depth, and the trees of this century are often abstract sketches rather than naturalistic portrayals. More typical is a relief to Apollo, from Bithynia (in present day Turkey), dated to about 120 B.C., with a single tree set off as background to the human figures.

A rather remarkably detailed portrayal of natural elements, though still as background for human activity, comes from the ancient Greek city of Pergamon. The town was once situated on a hill in the valley of the Caicus, almost a thousand feet above the coastal plain in what today is western Turkey, in plain sight of the legendary island of Lesbos. In the second century it included a complex of buildings, one of which is

known as the Altar of Zeus. Today, the entirety resides in a Berlin museum bearing the name of that ancient city. Two friezes with scores of panels narrate the life of Telephos, a son of Auge, who was a daughter of the king of Arcadia. His birth results from the rape of Auge by the libidinous Herakles.

The story of Telephos is remarkably similar to that of Oedipus Rex, except that he was saved from an impending marriage with his mother by a snake, and that he lived to lead the Greeks to Troy during the great Trojan war. Like Oedipus he had been unaware of his filial relationship to his intended bride. In the sculptures on at least four of the panels of the Pergamon altar there are trees and rocks, and also a cave and grape vines. Crowns or branches of the trees are richly endowed with foliage, many leaves being rendered in exquisite detail even to the ribs and veins. On one panel Herakles stands by an oak tree, naturalistically rendered, complete with acorns hanging in lifelike manner from the branches. Hills and rocks are depicted with equal realism. In one more instance of the correlation of perspective and naturalism, there is overlapping of distant persons by the hill nearby and diminution of the figures in the distance.

Nonetheless, both rocks and trees invariably serve a purpose in support of the action that is depicted, the rocks sometimes serving as seats for the characters of the epic, trees to divide the scene. And the display of beauty is still confined to the single objects. Despite their beauty, they are each there for a purpose. This is, despite its many remarkable features, not a landscape as we understand the term today.

For the most part the representation of rocky landscapes does not seem to have gone apace with the increasing naturalism of the trees in this period. Even in the second century B.C. we see a rocky ledge curiously arranged as a row of seats. Divisions of hills seem contrived to accommodate the human figures. Elsewhere, rugged rocks are obvious foils to heighten the effect of the figures. In a dedicated relief from Volos, Dionysus and Ariadne are afforded an opportunity for distant observation by their position on a fortuitously placed rocky outcrop on a hilltop.

From the tomb of Philip of Macedonia at Vergina, despite the superb quality of the paintings in so many respects, little is added to our knowledge of the use of landscape. Like the relief sculptures of that period, the natural elements include rocks and trees, some foliated, others bare. The scene of *The Hunt* (ILLUS. 11) is bounded on both sides by outcroppings of rocks, and six trees dot the intervening landscape. There are ten hunters (not shown in ILLUS. 11), some on foot, others on horseback. The game—a bear, a lion, a boar and two deer—are attacked by the hunting dogs. Hence, there are many landscape elements, but the painting is not a landscape in our sense of the term; the emphasis is on

the hunters. The Alexander painting from Pompeii (ILLUS. 12), though raising important questions about Greek perspective, raises none about landscape. Even more than with most works, the few landscape elements are minimized by the frenetic battle around them.

Thus the comparatively few vase paintings and reliefs with significant natural features are minimal. And neither the Telephos reliefs of Pergamon, nor the paintings of the Macedonian tomb of Philip, the specimens that are closest to what we are looking for in landscape, seem indicative of any pervasive use of it. Nor from the literary evidence does it appear that the lost Greek monumental paintings included such works. Many imports of art objects into the Roman areas from Greece in the last century before Christ, for instance, are described by Pliny the Elder, a Roman naturalist and writer on matters of science. His descriptions include no mention of any works that could be so categorized.

There is, in fact, no evidence that landscape painting as a genre in ancient Greece ever existed. It seems, rather, that ancient Greek art is totally lacking in scenes or panoramas of nature that clearly supersede in importance the human presence. For anything further in that direction we must wait for the Roman artists. They were heirs, it is true, of their Greek predecessors; but what the Greeks very tentatively began, in both perspective and in landscape, the Romans treated with reverence and carried to great heights.

VII

Nature as Religion in Ancient Literature

Greek admiration of the smaller aspects of nature only; lack of appreciation for the majestic; elements of nature seen as symbols of gods; growth of skepticism and concurrent growth of appreciation of nature; in Greek literature also, nature only as background for human activity; lack of nature and of scenic setting in *Iliad* and *Odyssey*; later development of both in Greek literature.

The Greeks' view of nature, as it appears in Greek literature, is similar to that revealed in their available art. Their literature also dwells on the narrow, the singular, and the small. A grove, a stream, flowers, trees, or an outcropping of rocks was their focus, not the grand panoramas. It has been pointed out in opposition to this view that the Greeks built their temples and shrines in scenically beautiful settings. But it is difficult to find a location where the Greeks might possibly have built these structures that would not have been scenically beautiful, at least to modern eyes. The Greek landscape is such that each temple must necessarily have been on the top or side of a mountain overlooking a large panorama or valley, or in the valley itself where mountains were to be seen on all sides. That we now find these sites beautiful is a different part of our story.

There are more fruitful areas of inquiry into the Greek view of nature than our own emotional response to these sites. The Greek religion, which we today call mythology, was intimately related to nature, and, as one Greek scholar expressed it, the fate of religion is determined by the masses.[1] Hence, an overview of their religion may afford the best view of nature through the eyes of the Greeks available to us.

In the early 20th century, writer Alfred Biese noted that, the Greek love of natural beauty notwithstanding, their feeling for it was but the germ of our modern one.[2] He observed, as have others, the focus on its

76

smaller rather than its larger aspects, the preoccupation with details as opposed to the larger scene, and with its animate rather than its inanimate components, plants and animals rather than mountains and seas. Others have also paid heed to the seemingly skewed emphasis on its material benefits to humanity rather than enjoyment of its beauty. For this undeveloped state Biese blames the restraint imposed by Greek beliefs concerning the world, particularly the belief in deities. He expressed agreement with Rudolph Lotze, the 19th-century German philosopher, that the artistic impulse was ill served by a view of life in which everything referred to or symbolized something else, and retained no independent significance. Nothing in nature had independent significance, and the dependence each aspect had was not on nature in the abstract. Each single aspect of it was the dwelling of a different god, nymph, satyr, maenad or other divinity. There was no "god of nature."

Henry Rushton Fairclough, writing a quarter of a century after Biese, takes a different view of the plethora of gods. He points out that "Woods and hills, meadows and brooks, all were peopled with fair forms divine."[3] The Greeks, says Fairclough, saw behind the water, the cliffs and the hills to a divine spirit. They saw no lifeless bodies, but saw instead the spiritual powers which made them their homes. They personified each aspect of nature. He quotes, with approval, Gilbert Murray, an earlier writer who explains the dearth of descriptions of nature in Greek literature: The Greeks did not write about nature, he claimed; they worshiped it.

Worship, however, does not necessarily imply love or admiration. It can imply respect or even fear, though the fear of the gods most often experienced by the Greeks was not of retribution, but of favors withheld. But about the ubiquity of the Greek gods there can be no doubt. The Greek philosopher Strabo, writing at about the time of Christ, described the area near the mouth of the river Alpheus as full of shrines of the nymphs; of Artemis, goddess of the hunt; and Aphrodite, goddess of desire; and on the headlands by the sea, a forest of shrines of Poseidon, god of the sea. Everywhere one looked, according to him, was a shrine or sacred enclosure, and every cave and fountain, stone or tree, was the home of a divinity.

From a vantage point of over two thousand years, and a different world-view that has taken much of the mystery from nature, we have distanced humanity somewhat from it. We can look upon these mythologies, of Greeks and others, as beautiful fairy tales, delightful stories, and marvel at the richness of the imagination that gave birth to them. It seems certain, though, that these gods and goddesses, satyrs, nymphs, and their sisters of the sea called Nereids, and the complex stories woven around them all—stories of lust, violence, fear, anger and revenge—were not

mere legends or fanciful characters to the Greeks. They were awed by their gods, and they must often have feared them. They took very seriously their obligations to appease and not to provoke them. As Fairclough himself points out, river and mountain gods were real beings, more powerful than mortals, and could be either friendly or hostile toward them. Hence, it will not be possible to understand the Greek mind through modern eyes, even by looking at their mythology, which was their religion.

Martin Nilsson, after a lifetime of study of all aspects of the ancient Greek culture, has written that what interested the Greeks was not nature in itself, but nature only insofar as it interacted with human life and served as a necessary basis for it.[4] Upon nature depended the issue of whether humans would starve or live amidst plenty. In the summer months, heat and drought can be severe in Greece. Throughout the land there were many manifestations of Zeus, king of the gods and the source of thunderbolts and rain. In each of his many manifestations it is likely that Zeus, as god of the weather, made his abode on the highest peaks of every area of the country. The home of one such manifestation, Zeus Lykaios, was on a high mountain near the center of the southern peninsula, the Peloponnesus. So when drought threatened, a priest went to a nearby well, dipped a twig from an oak tree into it, and caused rain. The twig was not always sufficient. Sometimes sacrifices, and in extreme need, human sacrifices, were required. In historical times one such sacrifice to Zeus Lykaios was recorded, as was another to a different manifestation of Zeus residing on Mt. Laphystion in Boeotia.

Human sacrifice was not limited to the need for rain. For centuries the Greek rulers kept criminals or other outcasts called 'pharmakoi' for sacrifice, not only to abate drought, plague or other catastrophe, but to serve as scapegoats, the collective sins of the community being symbolically laid upon them. This was but one more expression of what seems to be a universal yearning: for one person to bear the burdens of the sins of everyone. Generals would often refuse to wage battle until a sacrifice brought forth a favorable sign from the gods, no matter how many consecutive deaths were required. The large majority of sacrifices, however, involved animals. Such ubiquitous sacrifice of life, especially human life, to the elements seems difficult to reconcile with a feeling of awe at nature's beauty.

Gods, great and small, were everywhere. Along the roads were many tall heaps of stones, the dwelling places of Hermes, the protector of wayfarers. A passerby would often add a stone and sometimes place an offering atop the heap. These would be available to a hungry wayfarer who would give thanks, not to the supplicant, but to Hermes. It was also the function of this god to show the way to Hades, the underworld, abode

of the souls of the departed. Poseidon, god of the sea and the tempests, brother of Zeus and Hades, with a stroke of his trident created a spring near the Acropolis in Athens—a mere trifle considering that, as was well known, with that trident he could split open the earth. Pegasus, the winged horse, brought forth two other springs on Mt. Helicon in Boeotia with strokes of his hoof. Each river had its god, usually shaped like a bull, or half bull and half man. Both the rivers and their gods were individualized.

There were gods of healing, of whom Asclepius was one of the most sought-after. The key to this god's services was often a promise of an offering if the cure were effected. Preventative medicine usually required a sacrifice in advance. Gods affected the outcome of battles and the conception of children, the results of agriculture and general health and prosperity, likewise often requiring sacrifices in advance.

It appears, however, that the primary function of the gods was to grant or withhold favors. The Greeks gave thanks to the gods for good fortune. For bad fortune they often blamed the more amorphous entities sometimes called daemons, though often the line between gods and daemons seemed to fade. Gods intervened on their own initiative in human affairs only in cases of serious crimes directly affecting them, such as impiety. Otherwise, they seem to have acted only on request, and then upon conditions of some favor, sacrifice or good behavior. For the most part the gods were considered to require moral behavior. Gods seem usually a reflection of the people who believe in them.

We focus on Greece because it was in Greece alone that perspective in art may have come to life at this early date. But her early religion and the mores and ceremonies of her people were no more primitive or bloodthirsty, nor steeped further in superstition, than those of other contemporary cultures. They may have been, especially in later times, a good deal less so. Nor is the multiplicity of gods a unique Greek phenomenon. The Mayans had scores of them. One record of Celtic gods from the Roman period lists about four hundred. In ancient and not-so-ancient India every village and every part of it had a separate god, all in addition to the major deities (of the sky, sun, moon and underworld, for example), the totality numbering in the hundreds of thousands.

There is evidence, and some scholarly opinion, that the Greek belief in the gods was beginning to wane in the late fifth and in the fourth centuries. A number of factors may have contributed.

One was the intensely rational nature of the Greeks, especially that of the intellectuals among them. This manifested itself early on. Already in the first part of the sixth century, Anaximander, a disciple of Thales,

systematically sought natural explanations for all aspects of nature. A more direct attack on the gods came from his contemporary, a poet, philosopher, cynic and skeptic named Xenophanes. Born in 570 B.C., his highly productive and provocative life spanned almost a century. He questioned, in verse, the very existence of the gods.

Ethiopian gods are black and flat-nosed, he pointed out. Those of the blue-eyed, red-haired Thracians have blue eyes and red hair. He did not doubt but that if cattle and horses could make pictures and statutes of the gods, they would look like cattle or horses. One by one he deflated the gods, converting each to mere natural phenomena. He made no appeal to authority, neither of prophets or teachers, nor claimed any divine revelation. Relying only on his conception of what a god was generally presumed to be, he claimed that it was contrary to the nature of a god that he should have a master, and that one god could not be the ruler of other gods. Yet in the Greek pantheon, even Zeus was held to be descended from more ancient gods, and to be still subject to a superior force known as Fate, or Destiny. In such a rarified atmosphere of cold reason, the gods could not long survive.

In the place of the gods he was undermining, Xenophanes proposed one god, everywhere at once, not at all like a man, and with no sense organs, but who nonetheless thinks, sees and hears all over. He did not seem to imagine a god in the sense of the Judeo-Christian one. He probably believed the entire universe itself to be a god, something akin perhaps to the Eastern idea of immanence, the presence of a god, or of a universal soul, in the universe and every object in it, but without its manifestation in the plethora of the Eastern gods. Even at this early date Xenophanes and several of his contemporaries saw a unity in nature.

The unique humanization of the gods, as opposed to the terrorizing aspect of those of many other cultures, may also have been a factor in the growing doubt and skepticism. The Greek absorption with humanity manifested itself, among many other ways, in the artistic representations of their gods in human form, and in their human-like behavior.

This is in sharp contrast with the gods of many other cultures, quite a few of whom have frightening appearances and exhibit extreme violence in behavior. Many are pictured with grossly distorted shapes. The great Indian god Indra is often shown with four arms; the son of Brahma, another great Indian deity, had three heads. One of the manifestations of Shiva's wife, Kali, who eats the flesh and drinks the blood of the dead on the battlefield, is shown sometimes with four arms, other times with long teeth and a tongue of fire. Ravana has ten heads and twenty arms. Rudra, the god of storms, has eight. The Japanese god of love, Aizen-Myoo, had four; other Japanese divinities had wooden hands, eight eyes, eight hands, two bodies or twenty-four stomachs. African masks were

often purposely made to terrorize and intimidate, as the more terrible the world seems, the greater the power of the shamans. The gods of the Mayans of the Yucatan were equally frightening and grotesque. This was not the way of the Greeks, whose gods were shown not only in normal human form and countenance, but as unusually beautiful.

Humor, even with the Greeks, was often more powerful than logic. The great Athenian author of dramatic comedies, Aristophanes, especially with his play *The Frogs* at the end of the fifth century, may have accomplished more than all of the finely reasoned arguments of sophists and philosophers. His spoof of the somewhat pompous gods, not to mention heroes, philosophers and the great tragedians, draws laughs even from modern audiences. Upon viewing it in the fourth century, it is possible that few Greeks could ever take their gods quite so seriously again.

But most expressions of doubt were necessarily hesitant and cautious. In the late fifth and the fourth centuries a charge of impiety was still a real danger. To deny the existence of the gods or to introduce a new religion was not without risk. Trials were conducted for such offenses as assembling groups of men of illegal religions, ridiculing the Eleusinian mysteries, and causing damage to a statue of Hermes. It is impossible to say to what extent the gods were still respected as such. To some degree, by some of the populace, they undoubtedly were.

But just as certainly, the inquiring mind of the Greeks, their propensity for probing questions, unique among contemporary cultures, caused grave doubts among others. What was manifested in this new view of nature, as in the new forms of Greek art, was a germinating interest in scientific inquiry and a growing "secularization of the visible," the very attribute that was said by Harries to be a result of three dimensional perspective. Or was this secularization perhaps a cause of perspective? More likely they evolved together in a symbiotic, that is, a mutually reinforcing relationship.

Inasmuch as the early Greeks, as far as we know, did not place much emphasis on landscape in their art, the question arises as to whether they did more in describing it in their literature. And because there is such a close correlation between perspective and landscape, it would also be interesting to inquire as to what extent they did describe a scene and the relationships between the various components of it. How important were these factors to the Greek authors? In the visual arts, though both the portrayal of landscape and the use of perspective by the Greeks is meager compared to that of their modern counterparts, it is certainly far advanced from that of other contemporary cultures. When considering the Greek literature we find substantially the same circumstances. Modern

commentators tend to compare Greek literature only with that of modern writers. They rarely mention other literatures contemporary with the Greeks; literatures, in fact, that seem almost totally lacking in the elements that here concern us.

In literary descriptions of nature we do not always deal with words of definite, objective meaning. We are dealing with human emotions and with words used to describe them by people who lived and felt them over two thousand years ago. Many such words will mean different things to different people, even to those who spoke and read them in antiquity as part of their native tongue. How much more uncertain must such words be to modern scholars of ancient Greek. Nor are we aided by any records of the Greeks' own view of such matters. Greek literature is filled with disagreements between men of intellect over questions of philosophy, natural science, the role of gods, or the merits of dramas; but we find no such inquiry, such as occurred in 17th-century Europe, into what kind of scenery is deserving of admiration, or why. So the evidence of these subjective feelings, described as they are by words of an elusive nature, is necessarily entirely circumstantial.

Further, just as with Greek art, the Greek view of nature, as treated in the literature, was changing one. What was true in the time of Homer was less true in the fifth century, and perhaps largely untrue in the Hellenistic period from approximately the mid–fourth century. The quality of the descriptions of nature appears to grow in inverse proportion to the reverence for the gods.

All of these factors notwithstanding, the task is not hopeless. A number of modern writers have devoted themselves to this subject, and some consensus may be discerned even if the outlines are hazy and, in places, somewhat blurred.

One of the these writers was Alfred Biese. He remarked that "Nature only discloses her whole self to a whole man."[5] It is clear that this great admirer of the Greeks and of Greek culture did not feel that nature fully disclosed herself to them. Nonetheless, he took sharp issue with a number of earlier writers who denigrated the Greek love of nature. They included Friedrich Schiller, the great German poet, and Alexander von Humboldt, the equally great German naturalist, both of whom believed, as Humboldt phrased it, that in Greek art everything moves in the circle of human life. Landscape, said Humboldt, appears "only as the background of a picture, in front of which move human forms." He was speaking figuratively, describing poetry with the metaphor of painting and sculpture, but it could have been an accurate description of the plastic arts of the Greeks.

In his very rebuttal of their view, Biese, wittingly and unwittingly at different times, confirms the subtle but important difference between the

classical Greek and the modern view of nature. The Greek feeling for nature passed through stages, he points out. In the epics of Homer, descriptions of nature serve only as frames for human action. These Homeric descriptions, in fact, exist almost entirely in similes that compare natural occurrences or features to the human actions he wishes to convey. The purely objective similes, according to Biese, give way in time to poetic personifications and descriptions in which scenery was used to describe a character's inner life as opposed to his actions. Finally, in the Hellenistic period, about five hundred years after Homer, "Nature was treated for her own sake, and man reduced to the position of supernumerary," thus approaching more closely the modern view in both poetry and landscape painting. This was part, he claims, of the "discovery of the individual in all directions of human experience." Speaking in more general terms, however, he notes that the Greeks still looked at phenomena in detail, rarely at things as a whole.

According to George Soutar, writing in the mid–20th century, the Greek tendency to view the land from the point of view of its utility to human life, or its connection to some deity, rather than as a scenic stage is apparent throughout the entire classic period,[6] meaning until that period known as the Hellenistic. Whatever controversy may exist concerning the treatment of nature in classical times, concerning the epics of Homer there seems very little. His are the earliest of all epics, excepting only the Mesopotamian tale *Gilgamesh*, in which descriptions of nature are virtually non-existent.

Homer's *Iliad* and *Odyssey*, written probably in the eighth century B.C., deal with events that are believed to have occurred about four hundred years earlier. *The Iliad* involves an episode in the Greek-Trojan war and centers around the death of Patroclus at the hands of the Trojan Hektor, and the revenge against Hektor by the fiery tempered Achilles, the commander of the Greeks and the central character of the epic. The story of the *Odyssey* begins ten years after the fall of Troy to the Greeks, and describes the adventures of the Greek hero Odysseus during his journey home, and his bloody vengeance on the suitors of his wife Penelope.

The two epics are universally considered as masterpieces of world literature. This results in part no doubt from the unified structure of the stories, the characterization of the heroes and gods, and the gripping nature of the narratives. Our concern here is with none of those factors. But the very genius of the author gives us a keen insight into the foci of our inquiry: landscape description and perspective. Scholars have written in depth about every conceivable aspect of Homer's epics, and these elements are no exceptions. Soutar is one such scholar. His focus is less on spatial relationships, that is, perspective, than on descriptions of landscape.

He finds such descriptions singularly lacking; in the *Iliad*, almost entirely so. We see only an isolated epithet, phrase or clause.[7] Both in the *Iliad* and the *Odyssey*, Homer uses a shorthand system of fixed epithets to describe a town or district, all quite ornamental and conventional. One class describes characteristics of climate, situation, or configuration: "windy," "rocky," "sandy," "full of ridges," "wide-lawned," and "white" (chalky). Another denotes economic advantages: "horse-pasturing," "mother of flocks," "deep-soiled," "deep-meadowed," "abounding in vines," "rich in wheat," and "grassy." Special richness gives rise to "flowery." Some phrases denote sacredness and connection with deity. Others would seem to have some aesthetic aspects. In some cases the reference may be to specific aspects of scenery; more often the meaning may be no more than "pleasant" or "desirable" in an indefinite way.

Description of scenic background is scarce enough that everything described seems practically beneath our feet. Nature, Soutar claims, lies before us "cold and dumb, nearly independent of time, soulless and apart from humanity."[8] The description of the bay at the beginning of the *Odyssey's* Book Ten concerns its benefit as a landlocked harbor for the ships, little more. Athena's description of Ithaca in the middle of Book Thirteen deals entirely with what the soil can produce, and what beasts can and cannot thrive or be trained there.

Homer's most characteristic attitude to mountains, says Soutar, is purely objective. He speaks of them as great, or high, or steep. He does not indulge in mountain description or in mountain sentiment. They are in general "shadowy" and "lonely." Neriton in Ithaca is "clothed with wood," and has "quivering leafage." A factual pictorial epithet now and again is all he cares to give. Ida is "many-fountained" and "mother of wild beasts." It is "wooded," and its valleys lie like fold on fold. Olympus is "steep," "many-ridged," "glittering," "snow-capped." Homer describes places as sometimes pleasant, desirable, charming or beautiful, but according to Soutar, he finds them so not because of mountains, but in spite of them. Homer's description of the sea fares no better. It offers "wide ways" for ships; its paths are wet, its bosom is wide. As compared to earth, the "grain giver," it is barren.

In one of his rare ventures into Homer's use of perspective, Soutar points out that in the description of the landscape in the beginning of the fifth book of the *Odyssey*, variation of distances is scarcely perceptible.

Though Soutar reserves his sharpest arrows for Homer, he has much to say about others. If Archilochus, a seventh-century poet, thinks of scenery at all, says Soutar, it is as nothing compared to its fertility or the lack of it, a matter of much greater importance. He points to one passage from Plato's prose work *Critias*, that says of surrounding mountains

that their number, size and beauty exceeds all that are to be seen elsewhere. To Soutar, the Greek descriptive word for "beautiful" that Plato uses is completely inadequate to express the feeling of a modern person faced with nature's sublimities. It illustrates rather the Greek "contentment with the finite."[9] He summarizes classical Greek poetry concerning nature: "It is not too bold a generalization to say that to the Greeks the 'power of the hills' was a religious power and that their mountain sentiment rested on a basis of sacred associations."

Four decades after Soutar's analysis, Theodore Andersson turned his attention to the same subject on a broader scale. He sought to trace the development of scenic description in epic narratives throughout history. He begins with those of Homer, but continues with the *Aeneid* of the first-century A.D. Roman poet Virgil. (He also discusses a number of medieval epics, which will be more germane to our subject at a later time.) To a much greater extent than Soutar, Andersson finds himself forced to consider perspective. He obviously finds it too intricately bound with scenic description for him to ignore.[10]

Andersson claims that in the *Iliad* we are given only sparse and poorly conveyed spatial information. We are, for instance, given no visual picture of the wide battlefront between the opposing forces. He speaks of the unsurveyability of the epic as an inherent feature, of an "indifference to perspective" and a lack of effort to chart positions or events. Though the action of the epic takes place almost entirely on the plain of Troy, the setting must be pieced together by the reader from details provided only gradually and incidentally, and then only when necessary as loose attachments for fragments of the action. But the details are neither descriptive or even complete.

Priam's palace is a structure of importance to the narrative, but we are given no plan or description of it, nor its location in the city of Troy. Nor are we given any suggestion of actual distances between the city and the camp. That the tents are parallel to the ships can be reasoned out, but not before Book Twelve. The situation is, in fact, never visualized, but, according to Andersson, can only be deduced by the reader who wishes to do so by painstaking analysis. It seems certain that it was a matter of little importance to Homer and his intended audience. We have no reason, continues Andersson, to suspect that the two opposing camps were visible to one another until we suddenly learn at the conclusion of Book Eight that Hektor has set watch fires to prevent the Greeks from escaping unseen into the night.

Another form of disregard for spatial relationships comes in Book Four. Pandarus aims his arrow at Menelaus, severely wounding him.

When he takes aim, the focus is not on the scene in general, the inter-
vening space, or on the target. We are focused only on Pandarus's bow
and arrow, the most immediate concern of Pandarus or the reader, to
the total exclusion of the surrounding scene. When the arrow finds its
mark, once again there is a closeup, this time on the two participants.
We are never shown the enlarged area, nor do we see the action in scenic
terms. We see only the participants.

Interestingly, Andersson rarely mentions, the absence of description
of the natural features. His lack of focus on that is curious considering
it is his avowed subject. But he becomes consumed with the lack of spa-
tial indications to the extent that his mention of scenic description seems
almost an afterthought. He points, however, to the misleading picture of
the plain that we deduce for most of the narrative, one of aridity, with
nothing underfoot but dust. He finds it somewhat startling to later find
that there is vegetation along the river.

As in the *Iliad*, Andersson finds in the *Odyssey* the same indifference
to scenic description as well as to setting, and to the location of places
relative to one another. There is, rather, in the latter epic the same exclu-
sionary focus on the human aspect. In Book Five, we see Odysseus caught
for two days and nights in a violent storm. Finally he catches sight of
land. But Homer's focus is not on the view or any aspect of it; it is on
Odysseus, the observer. The wooded hillside is mentioned only when he
must decide how he will spend the night. His surroundings are impor-
tant only to the extent that "they highlight his skill, his stamina, his fear,
and his will to survive." Andersson concludes that Homer is concerned
not so much with pictures as with responses. Details are more compo-
sitional than scenic, and emerge only as incidental.

There is a matter that permeates Homer's epics but was not
discussed by these scholars. Particularly in the *Iliad*, it is the gods who
control the actions of the heroes and direct the course of battle. The
humans, their apparent heroics notwithstanding, are pawns only. In the
Odyssey the gods also intervene often, but usually to offer beneficent
advice.

In the *Iliad*, at the beginning of Book Four, for example, there
appears Pallas Athene, daughter of Zeus and the protector of heroes. By
order of Zeus, the goddess appears suddenly before the armies of Greeks
and Trojans, and goads Pandarus to shoot his arrow at Menelaus, the
same episode discussed by Andersson for another purpose. She promises
success upon his agreement of a sacrifice to Apollo, but she saves
Menelaus from death by steering the arrow so that it pierced his belt
buckle. The raging battle described in the early part of Book Thirteen

is not to be determined between the warriors. They seem like mere chess pieces. The conflict is one of wills between gods; namely, Poseidon, whose sympathies lay with the Greeks, and his brother Zeus, who, also supporting the Greeks, wished first to allow some measure of success to Thetis, the sea nymph and her son Achilles. And at the start of Book Twenty we are admitted into the inner councils of the gods, who discuss to what extent they will or will not intervene in an incipient battle.

In the *Odyssey* the actions of mortals seem somewhat more in accordance with their own wills, but gods still intervene. When Odysseus and his crew make landfall on the island of Aiaia, home of the witch Kirkê, all of his crew save one are captured by her. Seeking to rescue his men, Odysseus is confronted by the god Hermes, who warns of the dangers and counsels sexual seduction instead of force, thus saving both the hero and his men. When Odysseus finally washes up on the shores of his homeland, he is not at all aware of where he is. But Pallas Athene appears from the thin air, a fact unknown to him as she has woven a shroud of mist over him and has disguised herself as a boy. After hearing the recitation of his adventures she reveals herself to him as the goddess, and reveals also the craven courtship of the many suitors of his wife Penelope. Thereafter she counsels and guides his actions.

Obviously, when Homer lived and wrote it was not the description of nature or of perspective with regard to scenes that interested the Greeks of the Archaic period. Their interest lay rather with the actions of the gods who symbolized nature. Homer's gods are the major gods, deities of the sea, the storms, and the underworld, among many others. In the Greek religion, there were scores of them, major and minor.

In later times came the great dramas. There would be little reason to look for scenic description in them. We would, even today, have less expectation of it. And there would of course be no occasion for descriptions of perspective, especially in the sparse settings of the Greek plays. The role of the gods is equally as prominent in the tragedies of Aeschylus and Sophocles, the first two of the three great tragedians, as it is in Homer; somewhat less, however, in those of Euripides, the last of them. It remained for Aristophanes, author of comedies and contemporary of Euripides, to pillory them.

The obvious similarities in the literature and the art in this respect are thus quite pointed. Until at least the mid–fourth century, we see in both art and literature the same disinterest in scenic aspects of nature, the same view of each component of nature as representative of a god, or serving a specific purpose for human benefit. The view of each natural element as representative of a god is, furthermore, all too evident in

the Greek religion, at least until the end of the fifth century, and prob-
ably beyond.

Homer's epics were both first and last of that genre of enduring
consequence among the Greeks. As with paintings, we must await the
Romans before finding in epic narrative the spatial and scenic consider-
ations that seem substantially modern to modern minds.

VIII

Discovery of the Individual

Growth of sense of individuality in ancient Greece; scientific
evidence of human sense of "self" and contribution of right
hemisphere; evidence of such growth in Greek history, litera-
ture and politics; democracy and self-reflection in the tragic
drama.

It would be well now to step back a bit to get our own perspective.
We have seen in ancient Greece, to a degree that is not certain, the ten-
tative beginnings of three dimensional perspective. Intuitively, it seems
unlikely that it could have grown in a vacuum, and in fact it did not. As
we have previously noted, it was part of a bundle of other humanizing
trends, all of which seem intricately related to each other. Perspective
shows the world as seen by one person from one point in space and at
one moment in time, with an emphasis on the importance of the indi-
vidual. We see evidence of this same emphasis in later Greek portrai-
ture, which for the first time shows the subject, not as a type, but with
emotional expressiveness and human feeling, and with portrayal of the
subject's unique character and personality.

We see the same trend in the richness of metaphor in Greek litera-
ture, filled with novelty and innovation designed to delight the imagina-
tion, as opposed to the universal repetition of stereotyped words and
phrases in other literatures. It is also evident in the development of the
Greek tragedies with the expression of individual emotions, as opposed
to the odes glorifying heroes and kings and hymns to gods, and the "love"
poems which mention only the physical attributes of the ladies they con-
cern. We will in time look more closely at each of these developments.
As has already been noted, modern psychology sees all of these aspects
of human behavior as mediated in large degree by the right cerebral
hemisphere. It may all be coincidence, but more likely it is something else.

There appears to be an underlying attribute common to all of these
developments in ancient Greece, one that has been much discussed by

philosophers and historians. They refer to it as the sense of "self," or "individuality." It is the consciousness of oneself as unique and separate from the surrounding world. As with many other attributes it first arose, or advanced markedly, in Greece. It is so universal in most societies of present times that most of us assume it to have always been an integral part of the human psyche. Those who have studied such matters closely believe otherwise. Because it may be a cause of, or at least a phenomenon related to perspective, a closer look at its nature and growth is warranted.

Individualism, in the sense that it exists today as a factor in daily life, has through most of history been as absent as three dimensional perspective in art or true portraiture. It was, like other human behaviors we have seen, subject to growth spurts. The first such dramatic growth was in ancient Greece. It was propagated through the Roman Empire, and lasted through the end of classical times. For about one thousand years following the massive influx of northern populations into the Empire, that sense of self, as we know it today, was again markedly absent. The second growth spurt came with the European Renaissance and has continued. With some ebbs and flows, individuality has been increasingly prized ever since.

Philosophers have written at length seeking to analyze that human characteristic in abstract and all-embracing language, and some of their conclusions may have relevance to us. Psychologists also have much to say about it, some of which may at first seem far removed from our subject. There is a physiological underpinning to our sense of individuality. It is complex, and it appears that many different parts of the brain may mediate various aspects of it. We will start with one that may, at first, seem outlandishly far afield, but perhaps on reflection, its relevance will not appear totally lacking.

It has long been the assumption of psychologists and other scientists that among non-human animals, one—perhaps the primary—test of the concept of self has been the ability of the animal to recognize itself in a mirror. Psychologists have experimented by placing a small daub of bright paint on a prominent spot on the body of the animal and then placing a mirror in front of it. Only the great apes (that is, chimpanzees and gorillas, who are genetically most closely related to our own species) and a few other of the more intelligent non-human species have shown any signs of recognition that the spot is on their own bodies. Upon seeing the animal in the mirror, they will often turn their attention immediately to themselves, focusing attention on the corresponding part of their bodies until the spot is located.

This has been interpreted by scientists as indicative of a sense of the self as an individual creature separate from the world; some concept,

however primitive, of oneself as a organism independent from others. It is a giant advance from a mere reaction to stimuli, whether from outside of or from within the body. Most animal species show no such interest in the image in the mirror, apparently not relating the image to themselves. Significantly, it is only the chimpanzees and gorillas who share with us the most recently evolved portion of the brain, known as the "pre-frontal," consuming about one third of its entire volume.

Some experiments point to the right side of this structure as intricately involved in self awareness. Other experiments point to the left. Still others seem to involve a structure known as the "hippocampus," located in the temporal lobe, which lies between the frontal and the posterior portions of the brain. Input from both sides of this lobe has been detected, as has some input from the cerebellum (the lower rear and one of the oldest parts of the brain). These results are not necessarily contradictory, but are reconciled as showing different functions according to what aspect of self awareness is invoked.

It has been observed that some persons with damage to the right hemisphere are unable to recognize their own faces in a mirror. And in recent times, despite some contrary findings, psychologists have found the same lack of self knowledge through more sophisticated studies. These have involved, in one instance, patients suffering from epilepsy and preparing to undergo surgery. Preliminary tests required anaesthetization and suppression of each cerebral hemisphere in turn. During each of the two phases of suppression each patient was shown "morphed" pictures, the "morphing" consisting of digitally pairing two faces with each other. Each pairing included one picture of a famous person and one of the patient's own face. The patients were later asked what they had seen. With only the right hemisphere functional all patients remembered their own pictures; but with only the left working, four out of the five remembered the famous person. Variations of this experiment, with different procedures, some involving "normal" persons, have confirmed and buttressed the results of the morphing study.

The researcher Julian Keenan[1] states that the right front portion of the brain may give rise to a self awareness which could be a hallmark of the high order of consciousness of humans, and referred to its "bias for the processing of 'self.'" He pointed also to evidence from patients who suffered lesions in that right front portion as possibly experiencing a "cognitive detachment from self."

Another researcher, not involved in these studies, described them as similar to others indicative of the existence of a particular part of the brain that affects our ability to have a conception of ourselves. He spoke of observed deficiencies in the ability of schizophrenics and autistics to recognize themselves in mirrors, and also to make inferences about what

other people are thinking. The mention of a relationship between both deficiencies is significant. Psychologists have often found that recognition of one's own individuality and one's own views and feelings as unique is a prerequisite to recognizing the same individuality and uniqueness in others. It is the foundation of empathy, a quality decidedly lacking in most autistics, and to a lesser degree in some schizophrenics.[2]

A lesser development of that quality in entire populations may well have been a factor in some of the darkest aspects of human history, a history filled with human sacrifice and cruelty. Before looking at other evidence of individualism, and its possible physiological basis, it will be well to look at this aspect of history and the role of the Greeks as well as the Hebrews in bringing these inhuman practices to an end.

Human sacrifice in Greece has already been mentioned. It was in fact a universal practice, continued in some parts of the world to within the past hundred years. But it was in Greece, as well as in ancient Israel, that heated opposition to it first arose.

From Israel we have the account in Genesis of Abraham's aborted sacrifice of Isaac and the substitution of the luckless lamb. From Greece we have several accounts of heated questioning of the ancient practice. The Roman historian Plutarch, in the early second century A.D., described with revulsion two episodes from early Greek history.[3] On the eve of the battle of Salamis in 480 B.C., a prophet demanded the sacrifice of three prisoners to Dionysus. Themistocles, a Greek naval commander, was outraged, but not so much so as to resist the command of the prophet. As late as 371 B.C., just prior to the battle of Leuctra, a Theban general reported a dream in which he was told to sacrifice a red-haired virgin as the price of victory. After much heated high level-discussion, it was finally deemed sufficient to substitute a red-maned filly. The controversy involved in these incidents tells of a growing tension over the issue.

The profound significance of this show of repugnance becomes more evident upon an understanding of the prevalence of the practice, and how deep were its roots. For millennia, human sacrifice was accepted without serious question as part of the universal nature of things. The justification for it varied from one population to the next, but certain features of it are remarkably similar in almost all of them.

Sometimes the purpose was to have scapegoats relieve the masses of their collective sins. Other times it was to placate angry gods. For the Aztecs, who tore still beating hearts from their victims, it was to delay the fifth destruction of the world, the world already having undergone four such cataclysms. In many early kingdoms, Egypt and China included, the kings' harems and servants were buried alive with their masters to serve them in the next world. Victims often numbered in the

hundreds for a single ceremony. In southern India through the middle of the 19th century, persons raised from childhood for the purpose were cut up alive, and pieces of their flesh were buried in the fields to assure good crops. In Africa, in the kingdom of Benin, previously known as Dahomey, scores of victims were sacrificed every year to replicate in the next world the kingdom in this one. The sacrifice of thousands of Aztec victims in a single ceremony was witnessed in the 16th century by Europeans.

There was always a "reason" for the slaughter, but some anthropologists see the practice as a catharsis, intended as an outlet for the anger and fear that people were required to keep in check to maintain the cohesion of the group. It was said to symbolize the rebirth and communion that followed the sacrifice and rebirth of the god. It served as a regeneration of the community.

There seems much to support this view, in many cases. In various cultures the first victims were the kings. They ruled for a fixed term, following which they were sacrificed. (Soon or later, of course, they chose to bestow that final honor on others.) Also, certain prevalent elements seem to support the notion of rebirth. The sacrifices were almost always accompanied by religious ritual. In many of the cultures, neither anger nor ill will was directed toward the victims. Often they were obliged to perform an important part of the ceremony, and were treated with kindness and expressions of good will. Nonetheless, in populations throughout the length of the New World; from ancient Egypt, India and the Orient; and in the Pacific from Borneo to Hawaii; the gruesome methods were designed to continue the victims' agony for the longest possible time. The ceremonies often involved roasting the victim slowly over a fire, as in certain North American tribes; boiling in the Fiji Islands; inflicting hundreds of small cuts in the Philippines; or jabbing with long sharp needles in Borneo.

The end of the practice was preordained by a growing revulsion that came not from the intellect, but from the gut. It paralleled a growing sense of individuality, which some dominant members of society projected on to the victims, seeing them as fellow human beings with an individuality of their own. It is known as empathy, a vicarious feeling in an observer of the feeling directed experienced by another.[4] Empathy is a prevalent aspect of human emotion, even if insufficiently so, in most modern societies in modern times. Empathy was the antidote that virtually ended the hideous practice of human sacrifice. Beginning in the sixth or fifth century B.C., empathy underwent a growth spurt in Greece that was quantum in scope, and part and parcel of the burgeoning humanism in that land. And it was among the Greeks and the Jews, at about the same time, that human sacrifice began to diminish, though it never ended completely in either land in ancient times.

The term "catharsis," used by some to explain human sacrifice, was first used by Aristotle in the fourth century B.C. to explain the function of Greek drama. It implies the purging of emotions such as fear and pity by portraying fearful and pitiable incidents on the tragic stage. As much as any other aspect of classical civilization, the experience of catharsis by Greek audiences through observing tragic drama, as opposed to human sacrifice, bears witness to an unparalleled growth of humanism in that place and time.

To a certainty, the subject of individuality, in all of its aspects, is of vital importance to an understanding of the growth of humanism, and is closely related to it.

There is a large body of other study and experimentation involving our conception of self that should be noted. It includes that type of consciousness often referred to as episodic memory, our ability to travel backwards in time and to recall episodes that we experienced, either as actors or observers. This ability has sometimes been related to activity in the right side of the prefrontal lobe, other times, the left. This also appears to depend on the nature of the episodic memory involved. The right brain seems implicated more strongly in highly emotional memories as opposed to those more neutral in emotional content. Also, memories that must be searched out appear to involve more activity on the left side, while those more readily available, possibly because of involving more emotion, result in more activity on the right.

The left side, by much evidence, is primary in recalling facts through semantic memory as opposed to episodic memory. The difference between these two memory types is in the recall of words or facts that we have learned, as opposed to recalling the experience by which we learned them. Semantic memory may permit us to remember the names of the American presidents, the Roman emperors, or the annual rainfall in Namibia. The episodic memory is our recollection of memorizing the list of names or the inches of rainfall as required by our high school teacher. Semantic memory is evidenced by, for example, the state of our knowledge that the correct route to a certain place is by a particular road. Episodic memory is the recollection of the painful delays caused by taking the other route. Semantic memory is the knowledge of the date of someone's birth. Episodic memory may mean the retrieval of the memory of being told, or of attending a prior celebration. Normally we use both types of memory. We can undertake certain tasks and processes with semantic memory alone. More often we are better served by retrieval of the personal experience by which we learned the facts at issue.

The one results from knowing, says one psychologists, the other from knowing ourselves. Studies of blood flow in the brain indicate right frontal activity predominating when a subject is asked to think back to

a previous personal episode or experience. Retrieval from the semantic memory provides knowledge from the point of view of an observer of the world, according to some researchers; and even when involving autobiographical facts, "it is objective, impersonal and tied to the present moment." Episodic memory, by contrast, involves "remembering by re-experiencing and mentally traveling back in time," and it is rooted in an awareness that "the self doing the experiencing now is the same self that did it originally."[5]

It should be noted that the original "encoding of the experience," the storing or recording of it, is different from the retrieval of it, which is the recalling of it to consciousness. It does not appear that the prefrontal lobe plays a significant role in that process. It has also been found that despite the left mid-brain's generally more dominant role in the encoding process, novel or strange events more often result in increased encoding activity on the right side.

It sometimes happens that persons suffering injury to the right side of the brain suffer also from the inability to recognize their own body parts, and sometimes in verbal denial that a limb is their own. The medical term for this condition is "asomatognosia," Greek for lack of knowledge of the body. One frequent result of this is "hemispheric neglect," wherein the patient may shave only the right half of the face or dress only the right half of the body. Difficult as this may be to visualize, we have the word of apparently knowledgeable and respected physicians for it. Asked to draw a picture of a scene, these patients may omit the left field of vision entirely. Very rarely does it happen that injury to the left brain results in neglect of any part of the body. But often right-hemispheric patients will refer to a limb as "your hand" or "your arm." One patient referred to the limb as a breast and another called his hand his mother-in-law's hand. They suffer from what has been referred to as a cognitive detachment from oneself.[6]

Neither ancient Greeks nor any other ancient peoples had any trouble in recognizing their own body parts, nor in recognizing themselves in a reflecting surface, nor in recalling personal experiences. But the behavior of ancient populations does suggest that not only the right hemisphere in general but the sense of self in particular may have been less developed than those of modern ones. The evidence also suggests that the remarkable changes that occurred in Greece and Rome between the sixth century B.C. and the third or fourth centuries A.D. may have resulted from, or been accompanied by, a relatively sudden development of the right brain or perhaps a greater degree of lateralization. Such a development was advanced by Dr. Hufschmidt as the cause of the subtle

change, previously mentioned, involving the predominant orientation of portraits from right- to left-facing about 600 B.C. As we have also seen, the same cause was advanced by other researchers as a possible basis for the change in Greek script direction about a hundred years later.

Hence, it may be significant that certain changes in Greek thought and behavior arose concurrently with or shortly after the reversal in direction of profile and script, changes that have been capsulized by many writers with the term 'individualism.' The term has been defined in many ways, none completely adequate.

Perhaps one of the most satisfactory is that of Mark A. Wheeler and his colleagues, who describe it as "self awareness, the ability to introspect on one's own thoughts, and to realize the relationship of self to one's social environment."[7] Inherent in this and most other definitions is willingness to accept responsibility for decisions, and the duty to be true to oneself in matters of conscience as opposed to blind obedience to group or nationality. In medieval and ancient times, identification with the group, whether of city, village, religion or extended family, has been far more intense (sometimes to the exclusion of any other self-identification) than in classical or modern times. Individualism, in short, was no virtue.

The tension between the two obligations—to the self, and to the group—began with the Greeks, and has been the focus of philosophers and dramatists both in classical and modern times. But Greek thought was not a monolith. Some philosophers would probably not have subscribed wholeheartedly to this notion of self, their thoughts about individualism versus the obligation to the state being somewhat ambivalent.

When did this form of individualism first manifest itself? There is no consensus. It has been identified by various writers as occurring anywhere from the seventh century B.C. to the Hellenistic Age. Nor is there agreement as to just how individualistic the Greeks were. The fact that they may never have understood, in the way we claim to understand, what it means to be an individual, does not lessen the fact that it was they who gave birth to the concept. The same is true of three dimensional perspective, true portraiture, and the use of innovative, metaphorical language. These developments were all new with the Greeks, improved upon though they may have been in later times.

What were the changes in thought and behavior that point to the beginnings of individualism? They involve, first, the overt preoccupation of Greek dramatists, philosophers and other thinkers with notions of individual distinctiveness and uniqueness, personal identity and personhood itself. Christopher Gill, a scholar of Greek culture, has written extensively on this subject and finds support for penetrating Greek inquiry into such matters in many examples from the literature.[8]

It appears to be a centerpiece of Greek philosophy that consciousness

of others as rational agents, an awareness that stems from one's own rationality, is a crucial element in the development of altruistic motivation, a concept closely related to that which we today call empathy. The ultimate result is the extension of the individual's concern to all human beings, including others who are outside and beyond one's own group, whether tribe, culture, or country. This results from a recognition of the necessity for regard or care, in the words of Gill, "not only for the people who are specifically one's own, but for all rational agents as such, who share the core elements of one's own identity."[9] This notion is remarkably close to the teachings of modern psychology as to what the healthy psyche values and how the psychologically healthy person behaves.

The tragedies of the fifth-century dramatists Aeschylus, Sophocles and Euripides are filled with characters faced with the necessity for painful decisions. They are filled also with poetic outpourings of the burdens and agonies of those decisions, as well as of a cruel and unforgiving fate.

But Christopher Pelling and others are little impressed.[10] The Greeks, according to such critics, failed to grasp the true essence of a human being. The dramatic characters are observers, they say, and are detached and judgmental. They praise or blame instead of understanding and putting themselves in the place of the other. Both Pelling and his authorities decry the lack of development of character. The Greeks, they say, regard a man as something complete and entire, unmindful of the contradictions that comprise any personality or character of depth, and which in their totalities define the individual.

These critics compare the Greek literature with the Roman and, inferentially at least, with that of modern times. Such a comparison seems to miss the mark. The cultural differences between the fifth-century Athenians and modern peoples should not be disregarded in favor of some rubric of human nature, implying essential and unchanging truths. Love between men and women in the Western world, for example, has meant something different following the emergence of romanticism and courtly love in the 12th century from anything that preceded it. Until then, women were widely seen more as chattels than people. In those few ancient cultures where women were treated with respect, it was because they were regarded as people, and not as women, and romantic love, as we understand the term, was as absent from those cultures as elsewhere. This is a matter to be more properly discussed in connection with the so-called "advance Renaissance" of the 12th century; but it should be noted here that Greek women, at least until Hellenistic times, fared no better than women elsewhere, and that even then the improvement was not great.

What many critics see as a failing of Greek drama is in reality a reflection of the difference in the Greek mentality, a difference that may be hidden by so many remarkable similarities with our own. A more fruitful and more insightful assessment of Greek literature would come into focus upon an examination of where the Greeks had come from, rather than an irrelevant comparison with the works to which their innovations would lead. Theirs was an initial leap that would leave a mark on all of the fundamentals of Western thought that followed. It was Greek ideas, Greek concepts, or, perhaps more accurately, Greek feelings and emotions that ultimately conquered the West, even as they were expanded and refined by those they influenced. They are expanding today to all humanity, however slowly or rapidly. The concepts that form the cornerstone of Western civilization and that are spreading world-wide began with the Greeks; they did not end with them.

One of those concepts was the idea of democracy. This was another manifestation of the recognition of the individual, the self, and the concept that everyone, in his humanity, was the equal of everyone else (provided, in ancient Greece, that he was male and not a slave). It started, at least overtly, in the early sixth century B.C., with Solon. The rule of an entrenched aristocracy was undermined, and the power of the entire populace, of free men that is, became paramount. Athens had been governed by a board of officials, "archons," chosen by a select group comprised entirely of former archons. In 594 B.C., however, public opinion forced Solon's election as chief archon. Among other rather drastic reforms, he abolished slavery as a punishment for inability of debtors to pay, thus increasing the power of the ballot to the detriment of the aristocracy. He cancelled many debts outright, broadened the right to dispose of property by will, and provided for trial by jurors chosen at random. Further, he drastically weakened the power of the governing council.

It is difficult to believe that these advances, so novel and unique in the ancient world, were the sole result of the political prowess of one man. Jean Hatzfeld, one of the foremost historians of the ancient Greeks seems undoubtedly right, even without supporting evidence, in his belief that many of these reforms "were only the result of an evolution in public manners and opinion begun long before his time."[11] These reforms tell us something about the Greeks, not merely about Solon.

These changes in governance were not directly related to three dimensional perspective. Nor did the changes in expressiveness in literature or in portraiture cause, or result from, the movement toward democracy or the use of perspective. They may all well be, however, manifestations of the same change in the Greek psyche. If there is any single behavior that deserves to be called the cause of the changes in the

others, perhaps the notion of self, or individuality, may come closest to deserving the honor. Whatever the causation, each of the changes had far-reaching effects, well beyond the pleasure of literary or artistic enjoyment. Our concern here, in good time, will be with the effects of perspective.

IX

Novelty

Scientific evidence of right hemispheric contribution to plea-
sure in novelty; left hemispheric to propensity for habituation;
growth of novelty in Greece as opposed to changeless style
elsewhere; further scientific evidence for understanding of
metaphor; innovative use of language in Greece versus repet-
itive words and phrases in other ancient cultures.

There is evidence of another change in the Greek mentality for
which modern science may provide a physiological basis. We need, once
more, to turn from Greek political and artistic history to the area of psy-
chological and neurological research.

Work by scientists in recent decades has produced strong evidence
that it is largely through the right hemisphere that we derive pleasure
from new or novel experiences. This is not inconsistent with that hemi-
sphere's dominant role in both the interpretation and expression of emo-
tion in the face and voice. The function of the left brain appears to be
not only non-emotional, but one that provides control over the right side;
a counterbalance to its emotional responses, an inhibiting factor. Much
of the evidence comes from research into the behavior of certain neu-
rotransmitters, chemical agents that transmit nerve impulses from one
nerve cell of the brain to another. In the normal brain they balance the
desire for novelty and innovation with the tendency toward routine, famil-
iar and repetitive action. Those two major regulatory systems are termed
by neurologists "arousal," which responds to perceptions from outside,
and "activation," which maintains readiness for action. One of the lead-
ing researchers in this area, Don M. Tucker, claims that scientific evi-
dence supports the conclusion that the arousal system supports emotion,
and that the activation system supports motivation.[1]

Through the arousal system, the brain is drawn to novelty and inno-
vation, says Tucker. It enables responsiveness of the individual to stim-
ulation from the outside world and in turn is reinforced by the increasing

novelty or complexity it perceives. As the same input becomes repetitious, however, it produces "habituation"; it is no longer novel, and the system's activity lessens. The neurotransmitters that mediate arousal have been identified as norepinephrine and serotonin. In recent times, serotonin has been the subject of frequent public discussion, not the least cause of which has been its abuse through use of barbiturates. The two neurotransmitters operate by means of reciprocal pathways through the brain from the brainstem (the lowest rear portion of the brain), to seek and to produce a response to stimulation from outside.

"Activation" reinforces the activity of other neurons of the brain for a different purpose, namely a readiness for action. It is vital to physical movement and readiness of posture, and provides motivation for action. The attention that this system directs is one of vigilance, and it is more internally controlled. The neurotransmitters that control it are dopamine, which has also been much discussed of late, and acetylcholine. The primary effect of dopamine on behavior seems to be one of inhibition. Coordination between arousal and activation, or between novelty and inhibition, is necessary for normal functioning, but the two systems are distinct.

Rats, for example, with genetically high levels of norepinephrine (associated with arousal), show unusually high exploratory behavior, though they exhibit poor learning capacity for avoidance of dangerous behavior. With depletion of norepinephrine, however, rats continue repetitively to explore the same surroundings. With overstimulated pathways of dopamine (associated with activation), the animal progressively performs fewer acts, but each with greater frequency. Normally, the attentional control made possible by the dopamine system is essential in learning avoidance of danger, and is an intricate part of the flight or fight response.

The functioning of the two systems is not a simple division of effects on behavior. There is much overlapping of function, and a possible mutual relationship between the two that prevents harmfully excessive behavior in either direction. High levels of dopamine, for instance, may have the ultimately beneficial effect of producing inattention to stimulation that is unrewarding. It is a reward system in the brain, the exact operation of which is not at all certain, that rewards with a general feeling of well-being and contentment those stimuli and behaviors that are adaptive, that is, beneficial to the individual. Following excessive repetitiveness, the reward system motivates the individual to seek novelty and innovation. Pleasure results, but will again decrease in time as the habituation mediated by the dopamine system becomes paramount.

We are getting closer to the focus of our interest. The neurotransmitters mentioned are distributed differentially, or asymmetrically,

throughout the brain, and likewise function asymmetrically. The dopamine pathways are lateralized to the left hemisphere, mediating the individual's activation and complex operations resulting in movement of the individual. Among other operations, the dexterity of the right hand, controlled by the left brain, is of vital importance. Norepinephrine and serotonin are lateralized to pertinent portions of the right brain and cause the arousal that underlies emotional response to new stimuli, to novelty and to innovation. Because it minimizes repetitions and maximizes the focus on uniqueness of information, the right hemisphere has, through the course of evolution, developed the capacity to remain broadly receptive to the outside world. It has, as previously described, a parallel method of processing information, combining all perceptions from outside at once, instead of in a linear, one-step-at-a-time processing. Hence, it may have no access to any linguistic capability, controlled by the sequential mode of the left hemisphere, and one of the results of that right hemispheric method is what we consequently call intuition.

The right brain can grasp hidden patterns from a vast array of information, but its chief strength, according to Tucker, may arise from its contribution of novelty to the solving of problems. It does this by generating many different ways of ordering the available information, as opposed to a single, rigidly fixed one. Its advantage is thus imagination and flexibility. The tendency toward repetition by the activation system of the left hemisphere, on the other hand, restricts the range of methods of solving problems, but increases the amount of processing for each method, a type of operation that is the source of its analytic strength. Phrased differently, the right brain engages in fast and all-embracing arrangement of novel and unfamiliar information. But it is the left brain that thereupon develops structured, dependable and routine systems from it.

To further capsulize the results of these scientific studies: the right hemisphere sorts the novel pattern of information; the left organizes its processing into repeatable actions. So when we first imagine a novel idea, a new procedure in our daily activities, a new method of operation, or an innovative solution to a problem, it is the right hemisphere that is more active. When we repeat the procedure, method or solution often, when the novelty is gone, it is the left that is paramount in its control of the process, which is sometimes known as habit.

So, let us return to history. The march to humanity's present craving for originality, novelty, and innovation has been agonizingly slow. A search for new ways of doing things as an alternative to routine, new interests in the natural world, new ideas and new solutions to old problems, all

seem, until the last six hundred years, to have been the smallest part of the human condition, and until the last two hundred and fifty, to have been of still modest importance. The dizzying pace of scientific and industrial progress beginning in the late 18th century, in what is known as the industrial revolution, gives the impression of a virtual absence of progress, or any concept of it, in prior times. Ample evidence indicates, classical civilizations excepted, that permanence, stability, tradition, emulation of ancestors, the familiar and the routine, have been the hallmarks of human existence until the beginning of the European Renaissance, which, in the long march of human history, is like yesterday.

Members of a species known as *Homo erectus* (the immediate forebears of *Homo sapiens*), beginning about 1.8 million years ago, walked the earth for about a million and a half years, mostly in Africa, eastern Europe and Asia. For a million and a half years they probably slept in the open; there is no evidence that they inhabited caves. For a million and a half years they made stone tools of certain limited types; some were used as a spear points for killing animals, for butchering, or skinning carcasses; others for the pounding or breaking of other foods. About halfway along the course of their stay on earth they began shaping a bifaced tool rather than one with a single edge. During the last third of their existence, the tools become more symmetrical and more pleasing to the eye. But they were still essentially the same tools and had no more utility than the earlier ones. Two archaeologists, Kathy Schick and Nicholas Toth, who have spent their professional careers studying these stone implements, referred to the almost changeless continuity over millions of square miles and a million and a half years as "absolutely astounding."[2]

The paintings of the Palaeolithic people, mostly of southwest Europe but extending from eastern Russia across Europe including Italy and England, cover a period of over twenty thousand years, ending only about twelve thousand years ago. This art has previously been described, but it bears additional mention in this context. There are over 275 known sites, and over 15,000 paintings and engravings. They are almost all of animals: horses, bison, aurochs, lions, reindeer, elephants, and fish, among others. There may on occasion be different animals from one cave to another, and there may be minor differences in style, generally perceptible only to close students of the art, but the painted and engraved figures of animals comprise about 95 percent of the total. In some of the caves there are also abstract geometric forms and sometimes line drawings of humans, always without faces except for one site. In a cave at La Marche, in northern France, from almost the end of the Paleolithic period, there are over a hundred human faces engraved in limestone. Otherwise, the human face is conspicuous mainly by its absence.

It is no exaggeration to say that, fascinating though the many mys-

teries of this art, remarkable though the artistic genius on display, there is a deadly sameness to it all. There is little evidence of change in quality or style. Some of the finest specimens are among the oldest. Georges Henri Luquet, one of the earliest researchers of cave art, while acknowledging its skill and beauty, termed it also monotonous, and complained that "The eye is finally fatigued by this interminable procession of animals, which, save for a few exceptions, are always the same."[3]

Across the entire spectrum of ancient civilizations, classical ones excepted, we see little in the way of change except over many centuries, and even then little or no indicia of a concept of progress. Change in the lives of Egyptians, from the earliest records of about 3000 B.C. until the influx of Greeks and Romans in the last few hundred years before Christ, seen through the lens of recent history, is miniscule. In other ancient cultures, in later centuries, we see only here and there some new implements and tools, or improvements of old ones. For twenty-five hundred years, in Egypt, there was one style of painting; the frontal, the flat, the twisted perspective, a style that predominates throughout ancient cultures, but a style that seems everywhere to bear the name bestowed by art historians: Egyptian. Plato sang paeans of praise to the Egyptians for their "ten thousand" year history of fidelity to a single standard in art.

From the earliest days of civilization, humans traveled the seas by sailing ships, and the land by horse or, where the wheel had been invented, by horse-drawn wagons or carriages. In the new world the wheel had never been invented, or, better said, its use for transportation had not been known before the European conquest of the 16th century. A small wheel, part of what seems to be a child's toy from the west coast of Mexico, is the only oasis in that desert. The hauling of heavy stones for pyramids in Central and South America, of earth for mounds, and of goods and supplies throughout the Americas was done by a pack animal known as *Homo sapiens*, without help from wheels.

From our vantage point of the 21st century, the history of the world appears to be characterized by an accelerating increase of desire for novelty, new experience, and innovation. These, however, are all qualities that once were hardly in evidence, and were most unwanted. In recent centuries they have increased exponentially until they have, in recent decades, become almost an obsession. It may soon be time for habituation to kick in once more.

There is another highly significant human attribute that seems to have come to flower in relatively recent times, one that appears closely related to novelty and the pleasure that comes with the experience of it. It is that particular pleasure derived by many humans from the use of

innovative speech or writing, and from the perception of it when used by others. This may be an entirely different skill of the human brain, or perhaps simply a manifestation of that same change we have just seen.

It has been noted previously in these pages that the basics of speech, namely the lexicon (our mental dictionary of words) and the syntax (our use of the structure of language as in phrases and sentences) are controlled largely by the left cerebral hemisphere. But the right hemisphere also makes an important contribution to our understanding of language: It is the seat of what linguists call the "pragmatics" of language.

This refers to what is meant or implied as opposed to what is said. It includes our constant use of symbolism in speech, the use of one term to illustrate another, such as "eyes are the windows of the soul," or "billboards are warts on the landscape," more often called metaphoric speech. It often requires taking into account the context in which something is said. Pragmatics is the perception of what is between the lines as well as what is in them. It is understanding the figurative as well as the literal use of language, and includes not only metaphor but also idiomatic speech. These skills are often necessary also to the understanding of humor.

Patients with damage to the right hemisphere have been found through a number of studies to be deficient in understanding the pragmatics of speech, but it is not always necessary to make a formal study. A simple request—"Could you open the window," for instance—is not always understood by such patients to constitute a request. The patient has been known to answer "yes" and do nothing. One physician reports of an incident wherein he was told, in the presence of such a patient, that another physician would "hit the ceiling" when he learned of some unfortunate occurrence. A few moments later, the physician reports, he realized that the patient had taken the comment literally, apparently wondering how this third person was going to accomplish such a feat.

Anecdotes aside, much research confirms the pervasiveness of such a deficit in right-hemispheric patients. One research project involved presenting one group of left and one of right-hemispheric patients with sentences such as "He has a heavy heart." Each patient was then presented with a group of four pictures and was asked to select the one best illustrating the meaning of the sentence. One picture depicted the usual metaphoric meaning: a man crying. A second depicted the literal, but senseless, meaning: a man straining to carry an oversized heart in his hands. There were also pictures of a heart alone and of a lead weight alone. Most of the patients with left-hemisphere damage, but with functioning right brains, selected the metaphoric picture of a man crying, despite their problems with language resulting from left-brain damage. Some were seen to smile or giggle at the illustration of the literal

interpretation. On the other hand, most of the patients with damage to the right, but with functioning left brains, selected the literal interpretation showing the man struggling with the large heart. Even those that did not saw no humor in it.[4]

These results have been repeatedly confirmed by other tests and experiments. Hiram Brownell, in one such test, presented to two groups of patients, one with right- and one with left-hemisphere damage, eight carefully selected adjectives arranged in all possible combinations of threes.[5] With each triplet, each patient was asked to select the two that seemed to best belong together. One of the triplets was comprised of the adjectives "warm," "loving" and "cold." Pairing "warm" and "loving" would be indicative of use of the metaphoric use of warm. Pairing "warm" and "cold" would be indicative of the use of the literal meaning of warm as the opposite of cold. Consistently, the right-hemispheric patients, functioning with their left hemispheres, focused on the literal meaning of the word and showed no discernable conception of their metaphoric, or figurative, use. Conversely, the left-hemispheric patients, operating with the right, showed a clear affinity for metaphor, most frequently selecting the figurative use, warm and loving.

Other researchers have found that many right-brain–damaged persons are impaired in comprehending the overall structure of a story, fail to get the point of it, and misjudge the plausibility of individual segments. They have been found to have difficulty in understanding the point of a joke, and often seem to prefer irrelevant endings. Psychologist Nancy Foldi has claimed that these linguistic deficits dovetail with the reduced ability of right-hemispheric patients involving part to whole relationships.[6] Interpretation of speech, she claims, requires mental assembly of assorted pieces of information, and the simultaneous consideration of many cues. She believes that the inability of right-hemispheric patients to do this is related to their inability to assemble visual or spatial cues.

With these findings in mind, let us return once again to history, and to literature. It bears repeating that ancient and medieval peoples were not brain damaged and did not suffer the same disabilities as those of the patients we have discussed. It also can be claimed without embarrassment that (classical cultures excepted) their literatures, like their art and other behaviors, may evidence a lesser development of the right cerebral hemisphere. Those literatures have been described by many who have studied them closely, scholars of literature who would not ordinarily have much knowledge or even interest in cerebral asymmetry. Their descriptions show many similarities, although in a less pronounced way,

with the descriptions by psychologists and psychiatrists of symptoms of modern right-hemispheric patients.

Scholars have written extensively about the ancient Mesopotamians, Hebrews, Chinese, the Greeks prior to the fifth century B.C., many populations of medieval Europe, and Meso-America prior to the sixteenth century. They have described the use of metaphor, imagery and figurative language by these early authors, and have themselves used a number of very descriptive terms in doing so: perfunctory, platitudinous, repetitive, standardized, formulaic, artificial and stereotyped being among the most frequent. The literatures in question have often been called ones of clichés and conventionality. This is in marked contrast to present times, when no writer dares to use the same metaphor twice in the same novel, nor even the same descriptive word or phrase in the same paragraph, barring very particular reasons. Constant use of new phrases is, and for several centuries has been, mandatory for a successful writers. Repetition, even of descriptive words, has been the mark of the amateur.

Jeffrey Tigay has studied the literature of the ancient Near East, which includes the earliest written epic known, *Gilgamesh.*[7] Speaking of the entire literary style of that area in ancient times, he emphasizes its use of "standard formulas, similes, epithets, and the like." He points out further the habitual repetition of even larger components of standardized writing, such as motifs, groups of lines, and episodes. By Western standards, says Tigay, these practices would seem hackneyed and often be considered plagiarism.

Bedell Stanford states what many commentators have often observed about Homer, the great Greek poet, namely that he used metaphor and allegory very little in contrast with later Greek poets, an obvious reference to those of the fifth century.[8] That Homer was not lacking in the requisite vocabulary for them is clear from his use of similes. Because of the pervasiveness and richness of his similes, it is appropriate to contrast simile with metaphor to the extent that that difference bears on our point of focus: the difference in the mentality which each requires.

What is the difference between them? For those considering only the usual textbook definition of the two, there may be difficulty in grasping any significant difference. It is often written that simile says that one thing is *like* another, whereas metaphor says that the one thing *is* another. That simple contrast may adequately express the essence of the simile. For the metaphor it falls far short. Very often the metaphor says one thing and leaves it to the reader to determine what the other thing is that it refers to. The essence of metaphor is the challenge to the imagination, the challenge to grasp, from the one thing that is said, the other thing that is meant. The difficulty of the challenge, and our concomitant

satisfaction upon our intuitive grasp of it, will depend on the subtlety of the clues we are given.

Stanford explains the difference between simile and metaphor as essentially that between prose and poetry. Simile is "logical and judicious, metaphor illogical and dogmatic; simile reasons, metaphor apprehends by intuition." Simile, he says, expresses more, metaphor implies more. The metaphor can create something no simile can approach: "It can transcend the explicitness of paraphrase." It defies reason, he says, and yet prevails. Perhaps most importantly of all, "In metaphor there is always a pleasure giving as well as a useful function."

Another literary scholar, Deborah Steiner, says of metaphor that it arises when literal interpretation is inadequate, and that it exploits the gap between words and objects, "splintering the illusory bond" between the thing itself and its name,[9] a reference to the fact that in metaphor, we use the name of one thing to describe another. Paul Ricoeur adds the additional thought that the stimulation of the imagination is lost in simile by the fact that it is so explicit, and that it is just this that is the strength of metaphor for the agile mind, and its weakness for the inadequate one.[10] In simile there is, briefly said, no challenge. The hearer is consequently less interested in the idea.

True metaphor, of course, refers to new and original ones. Perpetual use turns them into clichés, often called tropes. It is remarkable how strikingly similar is the language of these scholars of literature, on the one hand, in distinguishing between these two usages of speech, to the language of psychologists, on the other hand, in distinguishing the functions of the two hemispheres of the brain.

Metaphor in Renaissance and post–Renaissance writing abounds to such an extent that selection of examples is almost superfluous. Three, all referring to old age and approaching death, should suffice.

In *Sonnet LXXIII*, Shakespeare wrote "That time of year thou mayst in me behold/ when yellow leaves, or none, or few, do hang/ upon the boughs which shake against the cold,/ Bare ruin'd choirs, where late the sweet bird sang."

T.S. Eliot, in *The Love Song of J. Alfred Prufrock*, uses a metaphor he never explicitly explains, and never needs to: "I have seen the moment of my greatness flicker,/ And I have seen the Eternal Footman hold my coat, and snicker,/ and in short I was afraid."

Metaphor is not only for poetry, or, better said, it can make poetry out of prose. Eugene O'Neill, in the last scene of his *Desire Under the Elms*, has the sturdy, crusty old farmer, Cabot, humiliated, betrayed by his sons, robbed by one of them of his one hope for happiness, and by the two others of his life savings, in a moment of weakness turn to his God: "—an' I'm gittin' old, Lord, ripe on the bough...." It is a metaphor

the old man has used before, but in this case, it is all the more effective because of it.

Thus, despite Homer's richness of simile, which is almost always used to compare something or some occurrence in nature to an action of a god or hero, there is much of substance to Stanford's description of Homer's use of metaphor. In quality, emphasis, vividness and imagination, he writes, "they are generally stilted, as well as formal, conventional, perfunctory, or platitudinous." As in *Gilgamesh,* what little imagery exists is dulled by repetition. Homer's often quoted "rosy fingered dawn" appears no less than seven times in the *Odyssey,* and once at least in the *Iliad.* The "wine dark sea" appears in the *Odyssey* at least five times.

Like the epics of Homer, the Old Testament is prized for its literary qualities. But, according to Biblical scholar Robert Alter, imagery and the use of metaphor are not among them.[11] Of the imagery used, he claims that innovative forms are the rarest, and that the conventionality of most Old Testament images is such that they barely have a life of their own. He terms most Biblical imagery minimal and conventional, and sees the words "pitfall," "stumbling" and "stronghold" occurring repeatedly, and always as a minor amplification of the idea that security depends upon God.

John Gabel and Charles Wheeler, who have written about the Bible as literature, agree: "Our modern horror of the cliché was probably not shared by the ancients, for whom the familiarity of the metaphor may have been the best thing about it."[12] Another writer on this subject, Mary Ellen Chase, sees a relatively sharp division of the Old Testament into two periods: the first, the classical, consisting of that part written between about 1000 to 550 B.C., followed by a "romantic" period.[13] Figures of speech are much less common in the earlier period, according to Chase, a small number of comparisons being used so often that they have become distinctive and peculiar to the age. Far richer is the later, or romantic, period in which both similes and metaphors become "rapt and various."

The history of Chinese literature, within the narrow focus of our interest, does not appear dramatically different from that of the Greeks or Hebrews. The content of Chinese poetry through the middle of the sixth century B.C.—roughly two hundred years after Homer, contemporaneous with the "romantic" period of the Hebrews, and perhaps a half century before the earliest of the great Greek poets—has been described by Wai-lim Yip: "From line to stanza, from stanza to stanzas; elementary procedures of reduplications, repetitions, variations, and symmetry; within the poems, ready made phrases, borrowed lines and even stanzas,

stock images, and situations."[14] Ann Birrell, describing Chinese poetry from about the time of Christ to the middle of the sixth century, says that metaphor did exist during that period, but that the pattern of imagery is often "roundabout, inconsequential and even abrupt."[15] The use of images, she says, is more contrived than logical, and the poets used a shared repertoire of imagery and meaning. Throughout later Chinese poetry, rich though its expressiveness, repetitions abound in poem after poem, among them, women's "jade faces" and "moth eyebrows," repeated almost ritually.

On occasion, the repetition has been ascribed by some scholars to a lack of vocabulary in the early authors. What these literatures exhibit, however, is not a lack of vocabulary, but a mentality that is comfortable with the customary, and that finds pleasure in the repetition of the familiar. It is the consensus of linguists and anthropologists alike that the speech of any culture is not bounded by its language; but that the language, rather, is a reflection of the culture, as is its art. Humans are almost always able to express what they feel the need to express. Language is a constantly changing and evolving organism, and if necessary, vocabulary is invented.

Lack of vocabulary, in any event, cannot be a cause for the lack of metaphor, nor is the use of a particularly rich vocabulary a requisite for it. What is required is not richness of words, but a richness of imagination. Good metaphor may require no description at all. It often uses but one word, or a few, for another word or another few. Similes can be accomplished by wordsmiths, but true metaphors, according to Stanford, are strokes of genius. Those in fine poetry undoubtedly are. In modern times, however, clever or colorful similes and metaphors are a part of everyday speech.

The earliest people to show the genius that Stanford mentions were the Greeks of classical times, those of the fifth century B.C.. In the works of the great tragedians, metaphors abound, if not so abundantly as in the Renaissance and later; enough so as to tell us something about the imaginative capacities of the authors and their audiences. A very few examples will suffice to give us an insight into the fertility of that imagination. All of the examples given are from Aeschylus, the earliest of the three greatest dramatic poets, and perhaps the best in the use of metaphor. All translations are by E.D.A. Morshead.[16]

From *Seven Against Thebes*, Eteocles replies (lines 395–398) to the spy's attempt to intimidate him with descriptions of the power of his enemy Tydeus:

> ... such pointed threats
> Are powerless to wound; his plumes and bells,
> Without a spear, are snakes without a sting.

From the chorus in the same drama, addressed to the two sisters bearing the bodies of their slain brothers, is an extended metaphor containing several shorter ones (lines 854–861). Acheron is one of the rivers of the underworld that must be crossed to obtain entry:

> Alas, my sisters! be your sighs the gale,
> The smiting of your brows the splash of oars,
> Wafting the boat, to Acheron's dim shores
> That passeth ever, with its darkened sail,
> On its uncharted voyage and sunless way,
> Far from thy beams, Apollo, god of day—
> The melancholy bark
> Bound for the common bourn, the harbour of the dark!

From *Agamemnon*, the herald describes the disaster at sea (lines 665–667):

> ... we sat and brooded deep,
> Shepherds forlorn of thoughts that wandered wild
> O'er this new woe; ...

From the *Choephori*, Elektra speaks to her brother Orestes about the murder of their father by their mother. Atè is the goddess that makes men do evil things (lines 242–245):

> Alas, the inborn curse that haunts our home
> Of Atè's bloodstained scourge the tuneless sound!
> Alas, the deep insufferable doom,
> The stanchless wound!

The senselessness of the bloodshed is thus "a tuneless sound"; the never-ending cycle of violence, "a stanchless wound."

These are not formulas, nor conventions nor commonplace phrases. They will not be found in any other poems or lines; they are, each of them, unique and molded to the dramatic occasion. Their authors are not challenging our analytic skill. They stimulate our imagination with their own inventive and resourceful intuitions. Their "strokes of genius," we may be sure, were not ones to be wasted on a blind audience that was obliged to be guided through them.

X

Portraiture

Expressiveness in portraiture and use of third dimension as
appearing and disappearing together in art history; universal
lack of expressiveness in ancient cultures; expressiveness in
social communication and its control by the right hemisphere;
intense expressiveness of portraits in Greek art of the Hel-
lenistic period.

Expressiveness in portraiture and three dimensional perspective have
traveled in tandem throughout history. They have come and gone like
inseparable twins, sometimes hand in hand, and when one appears, the
other cannot be far behind.

The paintings of the vibrantly expressive faces that we see today in
countless museums and in private homes are of a genre that has existed,
like three dimensional perspective and much else, only since the Renais-
sance, save for the output of Greece and Rome from roughly 350 B.C.
through A.D. 250. We have relatively few surviving examples of that out-
put, but enough from which to draw some firm conclusions about its
quality. What we have includes Greek sculptures, and Roman sculptures
and paintings, that seem almost alive, people with whom we could
empathize and speak.

Prior to the Hellenistic Greeks, true portraiture hardly existed. Facial
representations from earlier times were most often not intended to depict
individuals. They represented types, abstractions; and art historians and
critics have often called them romanticized or stylized, even spiritual. Yet
even when intended as representations of specific kings or other rulers,
the "portrait" was an idealization, rarely considered to be a true likeness.
They seem devoid of life or individuality, of character or personality, and
seem to be gazing into empty space, unfocused on anything in the world
around them. It is often explained that the vacuity of these faces is dic-
tated by the culture in which the artists lived, sometimes even com-
manded by the kings or priests. Unexplained is why all of the world's

ancient cultures and rulers should have dictated the same lifeless style. Matters that are culturally shaped, like language, dress and ceremony, generally differ from one culture to the other, particularly when contact between them has been lacking, as it necessarily was between so many of them in ancient times.

There are minor exceptions to this worldwide lack of expression, but even the best of them do not approach the lifelike qualities of the mass of representations of classical and modern times. King Chephren of Egypt held sway about 2500 years before Christ. A sculpture of him fashioned during his lifetime, staring emptily into space, is often described as typical of the Egyptian bust. A modern scholar of that art culture assures us that no one would presume that the king really looked like that.[1] The age of individualism, he explains, and with it the true portrait, would not come until much later.

An enlightened Egyptian monarch, Amenhotep IV (also known as Akhenaten), ruled in the 14th century B.C. for seventeen years. He was said to have allowed much freedom to artists to paint and sculpt what they saw and not to idealize his own face. This is apparently assumed by modern critics because of the idiosyncratic nature of the features of the sculpted busts and paintings in that short episode. But the expressionless faces and the twisted perspective remained, as they would for another thousand years. Apparently it was not the command of the king that caused them in the first place. The famed bust of Nerfertiti from the period of Akhenaten represents a very beautiful woman, though devoid of expression. Unlike the half smile of the Mona Lisa, it has aroused no body of speculation as to what she may be thinking. She seems to be thinking nothing at all, nor does her gaze seem to be fixed on anything but empty space. Most painted or sculpted Egyptian faces, like those of other contemporary cultures, seem to have no thought or feeling behind them.

From the scholars of almost every art culture until the Hellenistic Greeks, the message is the same. V. Gordon Childe refers to the portrait busts of the ancient Middle East as "stiff and expressionless types."[2] Werner Schmalenbach says of the masks and other facial representations of African artists, that at least through the 19th century, "Individual portraits are quite unthinkable," and that even among the most artistic populations of that continent, making a portrait was "inconceivable."[3] The treatment of the face by African carvers he describes as "non-dynamic, stereotypical, traditional and repetitive." Pál Kelemen claims that portrait statuary in the Americas, prior to the European conquest, "did not exist."[4] His statement is substantially true even if not literally so. In the art of the Maya, the Aztecs, the Inca and earlier groups from Central and South America, with few exceptions, facial expression or

even individualization seems never to have been given a thought. Among the paintings and carvings of humans from the native populations of North America, neither smile nor frown, thoughtfulness nor interest is to be discerned. Facial depictions among the Celtic populations seem barely human and apparently rate hardly a mention among scholars of that culture.

Portraiture in China seems to have closely paralleled the development of that art culture's use of perspective, a matter to be discussed later. Both developed in more linear fashion in China than in the West, but preoccupation of Chinese artists with neither portraiture nor perspective ever reached the intensity of western Europe.

Facial expression in art, the history of which parallels so closely the history of perspective, is also largely a right-hemispheric function. The modern human fascination with it need not be belabored. Psychologists tell us that more than 90 percent of the emotional content of communications between humans is non-verbal, meaning that it is conveyed by tone of voice, body language, and facial expressiveness (which must constitute the largest part of it). It is the face that has been the focus of study by poets and novelists, and by scientists of many disciplines. The scientists identify about twenty facial muscles which have nothing to do with chewing, but everything to do with expression. They also identify only a small number of innate, primitive expressions that are "hardwired" into our physiology, such as unrestrained fear, joy, anger, surprise, grief, or disgust. These expressions, in their pure form, are involuntary. They appear without any intent to display them, and in some circumstances can hardly be restrained. But in most cultures today, except under strong stress or unusual conditions, are they rarely displayed without some degree of voluntary restraint.

Of more importance in our everyday lives is the fact that with these same twenty or so muscles we can make an unlimited number of voluntary expressions that convey not only basic emotions, but utmost subtlety of feeling, and sometimes the mimicry of emotions, as in conveying the emotion of a past event as part of a narrative. Some are referred to as micro-expressions, and can come and go in a fraction of a second. The face can generate them almost continuously, some enduring as little as one twenty-fifth of a second. Nonetheless, viewers can readily interpret them without conscious thought, even those enduring for as little as twelve to twenty-five milliseconds.

Although the muscles used for these voluntary expressions are the same as those used for the innate, primitive ones, the network of nerves that connect with those muscles are not. The system controlling the invol-

untary expressions is the older one, called the "extra-pyramidal," which appeared earlier in our evolutionary history. The system controlling the voluntary ones, the "pyramidal," is more recent, though it evolved before humans. It exists in present-day non-human primates, namely monkeys and apes, hence probably in our most recent common ancestors. The involuntary expressions are universal and shared by all humans of whatever culture. The voluntary ones are learned and vary from one culture to the next, though in these days of rapid communication, differences may be fading. Then there are societal factors that may dictate the voluntary conveyance of an emotion that is not felt, a matter whose circumstances may vary from one culture to the next.

In humans the capacity for voluntary facial expressions is as prolific as the human speech with which it often works. Psychologists sometimes refer to such expressions as "conversational signals." Paul Ekman, a psychologist and one of the most prolific researchers into this area, has catalogued a large number of signals conveyed primarily by use of the eyebrows.[5] The movement of the brows can silently convey that a word is emphasized; that a question is being asked when words are insufficient to make that clear; or that the speaker is not finished but is searching for a word. With the brows, listeners can also convey silent signals such as agreement, skepticism, requests for clarification or for permission to speak.

Smiles are probably the most frequently used expressions. The genuinely felt smile is involuntary and requires only two muscles, fewer than any other expression, and can be seen from farther away and with a briefer glance. Often, however, smiles are voluntarily made, and they do not always signal pleasure or happiness. Ekman has catalogued eighteen types of them, but the number is probably infinite. Many are attempts to keep the expression of raw emotion, and at times the emotion itself, under control. The smile in modern societies is prevalent enough that it is its absence that is most noticeable.

Then there is the language of the eyes, something else that is taken so for granted in present times. The expression in the eyes is, in reality, not that of the eyes themselves, but of the fibers of the muscles around them. A glass eye, it has been said, is as expressive as a real one.[6] But the gaze of the eyes is something different. Simon Baron-Cohen has documented the existence of a human "eye direction detector" that with remarkable sensitivity can tell when another person's eyes are on us.[7] When we perceive that they are, heart rate soars and there is increased electrical activity in the brain stem. Baron-Cohen terms the lack of normal eye contact in human interaction "a social abnormality."

Neurologists find that identification of faces is also controlled largely by the right brain, and, like the interpretation of expression, is the product

of our spatial capacity. But the two functions are separate and apparently controlled by different portions of the right hemisphere. Failure of one does not mean failure of the other. Some persons suffering disease or damage to the right brain have lost the ability to identify faces, even those close to them such as family members (see also Chapter III), but can often still read facial expression. Others with different brain syndromes can identify faces but cannot read expression. They cannot tell a happy face from a sad face, or either from an angry one.

Often, however, normal persons use facial expression, including the unique expression on each face even in repose, as a means for immediate identification of the face. Some psychologists believe that identification may be effected even more quickly through recognition of expression than through the also-very-rapid synthesis of facial features and proportions. It is a common experience that we sometimes are tempted to confuse one person for another, but are halted by the fact that the expression is "just not the same."

Because both the expression of feeling and the understanding of expression are so intimately bound up with the functioning of the right cerebral hemisphere, there is some reason to believe that these skills are related to others that showed such sudden growth at the same approximate time. Scientists see this capacity for communication of facial expression as a function of our ability to make immediate sense, without conscious analysis, of this finely tuned movement of facial muscles.

The constant use of facial expressions leaves indelible marks that, according to Ekman, cannot be hidden, and even "in repose and in movement, in the moment of death as in life, in silence and in speech" are commanding sources of information.

Where were facial expressions in ancient and medieval art?

They began to appear about 500 B.C. in Greece, but they had been preceded by a century of progress in part-to-whole relationship in depiction of the human face. Prior to that time, like the Egyptian and other neighbors, the Greek sculptors saw an eye, an ear and a mouth; they did not see a face. Like the Egyptians, they still saw only frontal projections. Rhys Carpenter has written extensively about Greek art of that early period, and uses the ear as an example of the early Greek adherence to frontality.[8] The sculptor, says Carpenter, cut his stone around an outline of the organ, then grooved its interior shape into the stone. In short, the sculptor attached each part of the body or head to the main mass. Each was anchored to the surface but without spatial depth. Any interior detail was carved flat, and was projected on the block's surface. It recalls to us the insight of scientists into the functions of the two cerebral

ILLUSTRATION 16. *Charioteer*. Temple Terrace at Delphi, Museio Delphon, Delphi. Photograph credit: Alanari/Art Resource, N.Y. Votive offering for Victory, ca. 470 B.C.

hemispheres: seeing the trees versus seeing the forest; seeing the facial features versus seeing the face.

Beginning about the middle of the fifth century came a tremendous breakthrough in the concept of part-to-whole relationships. The human body, particularly the head, was now seen as an organic whole. Typical of this conceptual wholeness, though still lacking facial expressiveness, or any serious hint of character or personality, is the famed "Charioteer" from the temple terrace at Delphi; a dedication to victory, shown here as ILLUS. 16. It dates from about 470 B.C. The face of the Charioteer, like other Greek sculptures of that period, is marvelously human in its features and proportions, but is inscrutable, and tells us nothing of the subject's mood, emotion, or experience.

ILLUSTRATION 17. *Menander.* Dumbarton Oaks, Byzantine Photograph and Field-work Archives, Washington, D.C. Roman 1st century A.D. copy of 3rd century B.C. Greek original.

Only about a hundred years later, this had drastically changed. The great Greek elevation of humanity in art occurred in two giant leaps. First, they mastered the human body; then they showed us the inner person. The lifeless forms came to life. The features and the musculature of the face now betray feeling, sensations, and expressions of will. For the first time, the artists were exploring the nature of the human mind, an exploration already begun by the philosophers and dramatists. It was an exploration markedly lacking in other contemporary cultures, whatever their advances in technology.

Some of the finest specimens of this art come in the early third century. One is a portrait sculpture of Demosthenes, existing today only in Roman copy. The dramatic progress continues throughout the third and second Centuries B.C. Christine Havelock describes the sweeping changes.[9] The contours of the faces, she says, are not as regular. The skin is looser. Eyelids sometimes droop and the flesh seems heavier upon the forehead and the corners of the eyes, which are now more deeply recessed. The eyebrows curve more sharply and more independently either away from or toward the eyes. She speaks of shimmering flesh and dissolving forms,

ILLUSTRATION 18. *Athenian Kosmetes*, National Archaelogical Museum, Athens. Photograph credit: Dr. Nia Terazakis and Candice Parker. Highest officials of Athenian schools for upper class youths, 2nd to 3rd centuries A.D. Clockwise from upper left: inscribed bust, first half of 3rd century; unknown kosmete, second quarter of 3rd century; unknown kosmete, beginning of 3rd century; unknown kosmete, A.D. 200–240.

eyes that burn deep in their sockets, and of the extraordinary fervor and passion about them.

Two of the finest of the many specimens that justify Havelock's exuberance are a bronze head from Delos dating from about 100 B.C. and a Roman copy of a Greek original, probably of the dramatist Menander, from the early third century B.C. (ILLUS. 17). As opposed to the blank expressionless stare into nothingness, says Havelock, these subjects "look you straight in the eye."

It is not absolutely necessary however that a face, in order to show life, must look you in the eye. Long after the decline of Greece as a political and military power, long after its dominance by Rome, Greek art continued to progress; its artists to hone their skills. Among the finest portrait sculptures of ancient times, arguably surpassing even those of Hellenistic period, are a series of busts of "kosmetes," the highest officials of the Athenian schools for the children of the upper ranks of its citizens, known as "ephebes." These kosmetes taught philosophy, rhetoric and music. The costs of their busts, all from the second and third centuries A.D., were paid for by ephebes or by children of the kosmetes. For reasons unknown, these kosmetes are all shown with eyes raised, as though looking into the distance; but the upward gaze is too ubiquitous to be anything other than intentional.

Four of the busts, representatives of at least twenty that now reside in the National Archaeological Museum in Athens, are shown here as ILLUS. 18. Though the Roman sculptured busts may surpass the expressiveness of that of the Greeks of Hellenistic times, it is apparent from those of the kosmetes that the progress of the Greeks continued apace after the ascendance of Rome. It is apparent also that the expressiveness of the later Greek sculptors equaled or surpassed that of their Roman conquerors.

In sculptures of the human form, the new concept of space was thus first manifested in vastly improved part-to-whole relationships, including those of facial features. Only then could the Greeks give us that depiction of the finer movements of the facial musculature that we read as expression. As evidenced by the busts of the kosmetes, it was a perception and skill that continued to advance long after the focus of history had turned six hundred miles to the west.

XI

The Romans

Roman civilization as heir to the Greek; questioning of exis-
tence of gods and growth of appreciation of nature; growth of
perspective and representations of nature; "setting of scenes"
in Aeneas and other literature; expressiveness in portraiture.

The flowering of the Greek civilization passed, but its influence was
permanent. It was destined not only to survive, but for a few hundred
years thereafter, to thrive in fertile soil. Certain of the most artistically
viable aspects of the transplanted Greek culture did best in her own col-
onies or in cities first settled by her, such as Heraculeum and Pompeii,
both on the Italian peninsula near Rome. But the most vibrant stalk was
eventually Rome itself.

There was nothing dramatically new in the art or literature of Rome,
but what was old progressed. If the Greeks had, here and there, illus-
trated the illusionary relationships we see in space, the Romans alone
among their survivors saw them too, and carried them to further, if yet
unperfected, heights. Hellenistic Greek portraiture was the first in his-
tory to show us human beings with whom we of modern times feel we
could converse, and whose feelings, frozen in time, strike us as like our
own. But the painted and sculpted faces of the Romans are perhaps even
a bit closer to us, although, as proved by the busts of the kosmetes (ILLUS.
18), those Roman sculpted heads did not surpass those of their Greek
contemporaries.

It has too often been the practice of writers to make judgmental
comparisons between those two classical civilizations, always to the detri-
ment of the Roman. There is admittedly much about the Roman civi-
lization that suffers in the comparison, and seems perhaps a retrogression.
In the cruelties of the amphitheater and in much of its political and mil-
itary history, there seems at times a degeneracy of the heightened human-
ity of the civilization that preceded it. But nothing in its art or literature

can be fairly counted among those excrescences. In some respects they made what may indeed be considered significant humanistic advances. Early on, the Greek pantheon, with changes only in names and histories, was adopted by the Romans, their laws against the introduction of foreign gods notwithstanding. With it came the essentials of the Greek moral code and conception of the underworld. But where a nature controlled by gods was questioned by few Greek thinkers, and often only hesitatingly, from some enlightened Romans came a more vigorous and sustained cynicism.

Two of the most impious philosophies of the Greeks, both of the first century before Christ, found eloquent spokesmen on Roman soil. One, Lucretius, was a philosopher who sang in verse his support for the atheism of the Epicureans. The other, Cicero, best known as an orator, used his skills to advance the monotheism of the Stoics. In his *On the Nature of the Gods*, he attacked all other philosophies, especially that of the Epicureans. But both of these Roman spokesmen had much in common. Each rejected the notion of a multiplicity of gods, the persistence of which they found inimical to and inconsistent with the love and admiration of nature. Each saw a unity in nature and a harmonious interaction among its features. Cicero believed that there must have been an excellent and preeminent nature that first made, and then directed, the entire universe with all its parts. He saw the beauty of the world in the entirety and the order of all things in it.

Lucretius also saw both beauty and a unity in nature. If there were gods they could certainly take no part in worldly affairs, not in its wellbeing nor in its direction. Nature, he believed, acted in accordance with its own laws, free and uncontrolled by any gods. "Man is lord of himself," he wrote. He adhered to the beliefs of Democritus, that everything was comprised of atoms, including life, and that life ended with death, for the soul itself was made of atoms. The universe came about through the working of natural laws, not through godly machinations. It was nature, a creative nature, that alone decided what each of the parts of the world could do, and the laws that regulated those processes could not be rescinded or modified.

Whether the thoughts of these philosophers, however powerfully expressed, could have influenced the general Roman populace is questionable. But that it had some effect on Roman culture, and thus, even if only indirectly, on its citizens, seems more than likely, as their ideas undoubtedly had an impact on Roman art and literature. Or perhaps artists, writers and philosophers alike shared something that was "in the air," and perhaps each reinforced the creative impulse of the other. Our interest here is in their art: three dimensional art in general, landscape in particular.

The extent to which perspective and landscape are bound together in the modern psyche is reflected in the observation of Sir Archibald Geike, who, in the early 20th century, wrote extensively about the Roman feeling for nature. Speaking of the paintings of Pompeii, he remarked that "Landscape art, as we now understand it, can hardly be said to have any place in these paintings, for a knowledge of perspective was wanting."[1]

∞※∞

Landscape "as we now understand it" may have been lacking, but neither rich representation of nature nor perspective was entirely absent.

Beginning about 80 years before Christ, the interior walls of the luxurious homes of wealthy Romans living in Pompeii were often painted with scenes of various types, at times replete with human figures. One of the best known examples of figure-decorated walls is the "House of Mysteries," in which paintings encircle the room and abound with female figures. It points to the possible use of the room for religious ceremonies of a cult devoted to one of the gods. The advanced use of space and foreshortenings are most impressive for the time.

Other paintings are of the city; still others of the countryside. One example of a cityscape is the painting, mentioned previously in connection with perspective, in the villa in Boscoreale near Pompeii (ILLUS. 10). It seems a kaleidoscope of structures, each with its own perspective. Walls and cornices grow smaller as they recede into the distance, but with almost total disregard for the relationships between structures. The impression at first glance seems real, until we try to envision the relationships between buildings, and find the task hopeless. We realize this even before we see the cause, the existence of many vanishing points instead of one.

Likewise previously mentioned was the Alexander mosaic (ILLUS. 12), an advanced example of intuitive perspective. If it is a copy of a fourth-century B.C. Greek original, as is widely suspected, it tells us much about use of perspective at that early date. If an original, it represents a signal advance by the Romans. None of these works, as can be seen, involves any representation of nature, save for a solitary tree in the Alexander mosaic.

But nature has not been neglected. From a villa at Primaporta near Rome, just a few years before the time of Christ, there comes a wall painting, not of nature in the wild, but of a garden scene (ILLUS. 19). The garden contains no humans, but it is the handiwork of humans: an orchard of fruit trees and shrubbery, complemented by birds.

A hundred or so years later comes, from Pompeii, a wall painting sandwiched in time between two eruptions of Mt. Vesuvius, the earlier

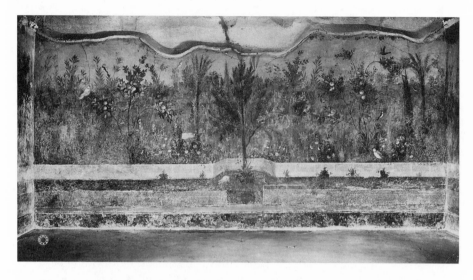

ILLUSTRATION 19. *View of a Garden.* Museo Nazionale Romano delle Terme, Rome. Photograph credit: Alanari/Art Resource, N.Y. Detail of Roman fresco from the Villa of Livia at Primaporta, ca. 20 B.C.

one in A.D. 62, the devastatingly final one in the year 79. It is a special type of landscape known as "sacred," abounding with statues and shrines in addition to humans, animals, and natural features such as trees and rocks (ILLUS. 20). This scene is set on rocky terrain. Hills and trees, altars and shrines dot the landscape. A shepherd and ram are approaching an altar at the crest of the hill while a goat watches from slightly below. The years have not treated this work too kindly, but it seems, nonetheless, one of the finest specimens from classical times, with respect to both landscape and perspective. It is called *The Lost Ram,* or *Mountain Sanctuary.*

Somewhat earlier than these are a series of paintings from a home on the Esquiline in Rome (one of the seven hills on which the original city was built, according to legend, in the eighth century B.C.). The paintings are believed to be first-century B.C. copies of originals from the previous century, and depict scenes from the *Odyssey.* Four represent, with some poetic license, the adventures of Odysseus with the Laestrygones. As related in the epic, Odysseus sends three men to speak to the inhabitants of the island on which they have chanced to land, whereupon they meet the daughter of the king of the Laestrygones. A nymph, two gods and an animal adorn the picture, but, compared to most Greek sculptures and vase paintings, the human and animal figures are less dominant. Rocks and trees predominate.

In another of the paintings, shown here as ILLUS. 21, the king has

ILLUSTRATION 20. *The Lost Ram,* or *Mountain Sanctuary.* 1st century A.D. Museo Archeologico Nazionale, Naples, Italy. Photograph credit: Alanari/Art Resource, N.Y. Masterpiece of landscape and perspective, Pompeii.

his Laestrygones attack the Greek ships with huge rocks. Trees and boulders are again a mighty presence, and though the people, the Laestrygones, are more intensely active, they dominate the scene even less, and the realism of the portrayal of nature excels. Distance is portrayed by atmospheric perspective as well as by diminution in size of the more distant ships. Unlike the earlier painting, it is more obviously intended as something other than an overtly idyllic scene. If this is not true landscape, it is something quite close, even by modern standards. The portrayal of

ILLUSTRATION 21. *The Laestrygonians Hurling Rocks at the Fleet of Odysseus.*
Museo Gregoriano Profano, Vatican Museums, Vatican State. Photograph credit:
Alanari/Art Resource, N.Y. Wall painting from a house on the Esquiline. Late 1st
century B.C.

the coast is considerably more detailed than we would read in the epic
of Homer, who, as author T.B.L. Webster puts it, "is only concerned with
its convenience for shipping."[2]

Another fine specimen of both perspective and landscape is a mosaic
from Hadrian's Villa, hence probably from the early second century A.D..
It depicts a rugged, rocky landscape, populated by five skillfully repre-
sented goats and one unobtrusive, but well-sketched goatherd (ILLUS.
22). Both the distant scenery and distant goats are realistically smaller,
if just barely so, and even atmospheric perspective is effectively used.
Because of the simplicity of the composition, the pleasing effect of the
unity that results from such perspective is quite pronounced. It may be
among the most modern of all examples of landscapes from classical
times.

These, it must be acknowledged, are exceptions. Concerning per-
spective, the necessity that all objects must be viewed from one point of
sight, and that one vanishing point exist for all receding lines, seems to
have been grasped only intuitively, and then by only a few. Careful obser-

ILLUSTRATION 22. *Rocky Landscape.* Vatican Museums, Vatican State. Photograph credit: Alanari/Art Resource, N.Y. Mosaic, Hadrians villa.

vation, rather than conceptual understanding, seems to have been more at work.

As with the Greeks, the interest of most of the Romans was in the small, the charming and the cultivated. It is as true of the Roman literature as of Roman art. As Sir Archhibald Geike describes it, "Appreciation of the solemn majesty of the mountains and of the infinite beauty and grandeur of the ocean is of comparatively recent growth. The Romans as a people were insensible to it, though by some of their finer spirits, its early stirrings were felt."[3] In both Greek and Roman art, we will look in vain for representations of high mountains or a wide expanse of the seas. Geike mentions both Virgil and Horace, renowned Latin poets of the last century before Christ. Neither, he points out, despite their nearness to great mountain ranges, paid more than scant attention to them, in poetry or prose. Horace took more delight in "the peaceful fertility of his landscape with its woods and fields, its vines and olives,

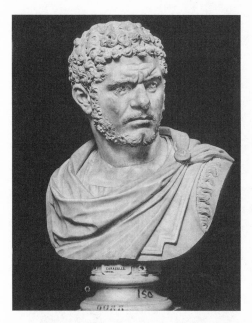

ILLUSTRATION 23. *Emperor Caracalla.* Museo Archeologico Nazionale, Naples, Italy. Photograph credit: Alanari/Art Resource, N.Y. Bust from the Farnese Collection. Ca. A.D. 215. Marble, 51 cm.

its fountain and stream." Though Virgil lived between and quite near the Alps and the Apennines, "neither range draws from him any description or encomium."

Of all the poets of that golden age of literature, there appears to have been only one who climbed mountains solely for the pleasure of it. How unsurprising that it should have been Lucretius, the Stoic, the cynic, the philosopher who held in contempt the notion of a multiplicity of gods controlling human destiny. His fascination with the elemental forces of nature, and the unity and interaction between them, led him to explore the most terrifying of them, to write of his exhilaration, and to describe the view below and the movement of clouds around him. Until the very late 17th century, it is quite noteworthy how few had shared that experience. Even more so is the fact that of those who wrote of their mountainous ascents, even fewer, including Dante, found anything aesthetically pleasing in them. According to John Ruskin, the 19th-century English critic, writing more than five hundred years after the great poet's death, Dante's feeling of repugnance for mountains, a number of which he had climbed, was manifest, and he saw in them only broken stones and crags.

Yet, the advances in spatial awareness come in many forms. Recognition of the beauty in rugged mountain scenery is one. But the appreciation of the rolling sea and the interaction between the water and the jagged coast line is another. Virgil, of the first century A.D., could paint a word picture of such scenes in all of their totality. In his epic poem *The Aeneid* he gives us a number of them.

In the *Aeneid*, as in Homer's *Odyssey*, Virgil tells of the wanderings of a hero following the Trojan war. Virgil's hero is not a victorious Greek, but a defeated Trojan, who ultimately settled in Italy, where his descendants founded the city of Rome. In his poem, we see the swells racing toward the shore, then smashing futilely on the indomitable cliffs. There

are the advancing and retreating waves breaking against rocky ledges, and descriptions of the cliff-lined bays of North Africa. His descriptions, says Geike, have the breadth of a skillfully executed painting and the faithful detail of a photograph.[4] This, as we have seen, was something that had been lacking in Homer, for all of his genius of narrative and of poetic expression.

We turn again to Andersson, who pointed out so vividly the absence of background or setting for any of the adventures of Odysseus or of the events of the earlier *Iliad*. As Andersson tells us, it is quite different with Virgil.[5] His awareness of space is more highly developed. His action takes place in a visible scene. The Roman poet gives the reader a new dimension to the action by backing off to "observe the scene from every angle and level." As Aeneas, for example, approaches the coast of Africa, Virgil creates a "spatial totality" by describing the entire area between the mountain backdrop and the distant horizon. Virgil's spatial attributes, as described by Andersson, include scenic visualization, deliberate plotting of space and terrain, and the creation of mood through the use of perspective. It is similar, in short, to the tentative advances in spatial mastery that were evident in Roman painting of the time.

The Romans thus continued the Greek innovations in depth in art. The same may be said of portraiture. Derivative though Roman portraiture may have been, it contains specimens that undoubtedly equal, and probably excel the finest of the Hellenistic works. It began in the middle of the first century with a bust of Emperor Claudius, and the highlighting of inner human qualities increased throughout the following century. One splendid example is the "Head from the Bust of a General," executed about A.D. 120, now at the Schloss Fasanerie, near Fulda, Germany. Almost a century later came a bust of the Emperor Caracalla, which is typical of the increasingly fine character portraits by the Roman artists (ILLUS. 23). Many other Roman busts are copies of Greek originals. They are carefully and sensitively done. Both these copies and the original Roman sculpture portraits, such as those of the emperors, demonstrate that in this area also the Romans were excellent students and responsible heirs of their Greek progenitors. Further, their painted portraits copied from Greek originals, such as may be the case with the *Cithirist*, described earlier, may give us a rare glimpse of lost Greek portrait painting.

XII

The Middle Ages and the Retreat of Nature

Influx of northern population into Roman Empire in third century; disappearance of aesthetic consciousness, of perspective, of the sense of nature as an independent entity; lack of "setting of scene" or description of nature in literature.

In perspective, in landscape and in portrait sculpture, Roman artists reached the pinnacle of the art of classical times. But in the third century A.D., a retrogression began. It did so very shortly after the growing waves of invasions and migrations of northern tribes, who ultimately engulfed the entire area of the Roman Empire. The concurrence of these developments is not coincidental. The invaders were from many parts of the uncivilized, or less humanized, world; from places as diverse as western Europe and the steppes of Russia; and they included Germanics, Sarmatians and Huns. Their art has been described by historians variously as ornamental, decorative, and stylized.

By the latter part of the third century, prisoners from the Germanic tribes were settling permanently on Roman soil. Ultimately they accepted the Christian religion, which by the early fourth century was recognized by the Emperor Constantine I. But for them to accept the Roman world view, the Roman sense of aesthetics, conception of space, and response to three dimensional perspective, was not a matter for simple choice. These features of Roman art and the Roman psyche lay beyond their reach, and their inability to grasp them was the most noticeable effect on art to flow from their influx. "The aesthetic consciousness gradually disappeared," says Frank Chambers, and "by Medieval times it had gone."[1]

As early as the late second century, on the Column of Emperor Antonius Pius, there is an odd mixture of styles on different sides of the base. On one we see the perspective of the classical tradition, with reasonable unity of space; on the other, abstraction and total disregard of

spatial relationships between the various elements, a harbinger of things to come.

It is sometimes claimed that the change in artistic portrayal came as a result of the dictates of the Christian church, the flatness of the paintings being an intentional effort to convey the complex symbolism of the new Christian dogma.[2] The chronology of the relevant history refutes such an explanation. It has been well documented that the noticeable change, from the portrayal of depth to flatness, came before there was significant Christian art. The new religion was not the cause of the artistic change. When the Christian faith ascended to dominance in the empire in place of that of its pagan contemporaries, the pagan artistic style, including facial depiction, was already that of the Middle Ages. Flatness in the portrayal of perspective and emptiness in the human gaze returned as they had left several centuries earlier, in tandem.

That classical use of perspective, that unity of space, was to disappear for a thousand years, and in art, poetry and prose alike, the visible world of nature was ignored. With rare and trivial exception, features of the landscape were neither painted nor described except as religious symbols, or as necessary to set a scene. Though neither the death of perspective nor its rebirth could have been quite so sudden as it seems from the vantage point of the 21st century, it can be but little exaggeration to say that between the fourth and 14th centuries, it did not exist. There were splendid artists throughout this period, often nameless, but they hardly seemed to notice that the world existed in three dimensions, or if they did, that there was any aesthetic value in it. Where artists of the classical world had depicted depth and volume, those of the Middle Ages were content to see the world as flat and two dimensional, and so they painted it. The medieval artist, like his ancient and prehistoric predecessors, painted what he knew and not what he saw, an example of which is the miniature from a Syriac Codex of the 12th century (ILLUS. 4). It depicts the *Last Supper* but reveals, not what could be seen from one point, but what the artist considered important: namely the table and its roundness, viewed from above, but with Christ and all of the apostles shown in full face, and at any angle from the table that best revealed them.

In the early Middle Ages, figures were distorted and backgrounds conventionalized and disjointed. According to some art historians, this too, just as in the art of the late empire, was for the purpose of fractionating the visible world to disclose the "deeper" Christian truth. It is to be doubted here also that it was a consciously chosen path, or that the style employed (as opposed to the subject matter), was intended to convey anything at all. There is nothing in the contemporary literature to support the proposition that it was, and it seems doubly odd that this

manner of conveying Christian truth should coincide so precisely with
the prehistoric and ancient heathen style. As in ancient times, there was
little attempt to convey a sense of perspective or of spatial relationship.
Objects were larger or smaller according to their importance, not accord-
ing to distance from the observer. The flat perspective is starkly similar
to the early Greek krater, or a Mayan or Egyptian wall painting, and
explanation of neither the Christian nor any other creed seems to have
been intended by it. What was at work seems to have been something
less purposeful: a different mind-set, and perhaps a different part of the
mind predominating.

A.J. Gurevich has studied and written extensively about all aspects
of medieval civilization and culture. He has aptly capsulized medieval
painting, which he refers to as Neo-Platonism: the separate sections are
not related to each other; the picture lacks depth and is entirely on one
plane; key figures are given in full, thus standing out from their setting,
which becomes a decorative background only; a house is disproportion-
ately small in order to show all of its constructional details; and every-
where there is a palpable lack of proportion.[3] An example is ILLUS. 24,
entitled *Blessing the Lendit Fair at St. Denis,* from the year 962. Gurevich
confirms what seems apparent from a study of medieval art itself:

> We can hardly doubt that, like ourselves, medieval man was able to distin-
> guish between close and distant objects and was aware of their real
> dimensions. But these purely empirical observations were not transferred
> to painting and no aesthetic value was placed upon them.... The picture
> assumes the presence not of one but of some or many observation points.

The picture, says Gurevich, is organized on an "associative" basis,
not by any rules of unity. Space is not measured by the perceptions of
the individual, and the picture does not draw the spectator into it, but
"expels" him from it.

As might be expected from this absence of perspective, nature as
an independent entity is almost entirely lacking. Its absence is felt quite
keenly upon viewing any significant portion of the thousands of speci-
mens that adorn museums the world over. Settings are unimportant
except to identify a figure or explain an action. A tree or a rock is used,
as in ancient times, to indicate an outdoor scene, natural objects other-
wise being intended as religious symbols.

There were many artists of genius, but any aspect of nature in their
work is most noticeable by its perfunctory treatment. The landscape in
medieval paintings is most often an abstraction. It seems clear that people
of the Middle Ages were absorbed with their immediate surroundings to

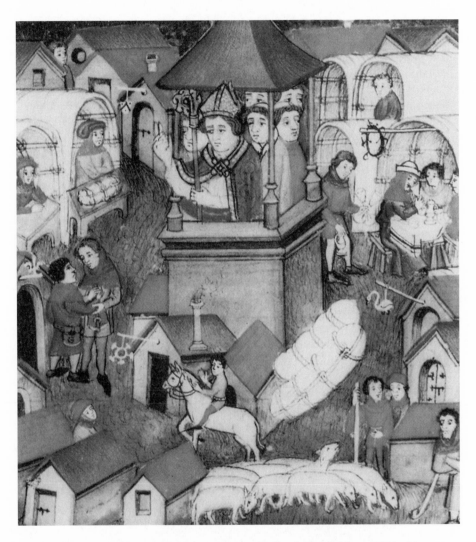

ILLUSTRATION 24. *Blessing the Lendit Fair at St. Denis*. D. Matthew. Bibliothèque Nationale de France, Paris. Photograph: Sonia Halliday, Weston Tuville. A fair held in the late Middle Ages throughout the plain of St. Denis in France to bless commerce.

the extent that they were very little aware of the landscape and no keen feeling for nature as something separate from their own needs. The absorbing features of the paintings of the Middle Ages are the religious, the spiritual, the transcendental. Compared to the pervasive religious focus of such works, scenes of secular life are scarce; of landscapes as such, non-existent.

O.M. Dalton gives an illuminating description of the paintings of the Byzantine, or eastern, part of the old Roman Empire during the early middle ages.[4] The most characteristic features of the Byzantine "landscape," he writes, are hills symmetrically disposed in pairs; trees and plants sometimes dotted over the surface so as to resemble a continuous pattern. The hills are composed of prism-shaped rocks. The trees are "mere schematic forms of the 'mushroom' and other types, copied and recopied until all connection with nature is lost."

The change in portraiture was equally as dramatic. Whether or not they are timeless or idealized, as sometimes termed by art historians, these expressionless, vacuous and impersonal faces and flat, two-dimensional backgrounds stand in sharp contrast with what preceded them in classical Greece and Rome, and what was to follow in still–Christian Europe. It becomes clear from medieval art, without necessity for further evidence, that these were people who lived not for the present world, but for the rewards to come in the next.

Alfred Biese, whose writings we have mentioned in connection with the feeling for nature among the Greeks, has written also of the Middle Ages. His concern is primarily with such feeling as may be evidenced in poetry and other literature. He concludes that the charm of nature apart from other considerations, that is, "delight for her own sake alone," was unknown in the Middle Ages. Further, believing that "the mind of a people is one united organism," he feels that poetry and painting enlarge, explain, and condition each other.[5] Hence, he sees the lack of landscape painting in the Middle Ages as a correlate of the absence of landscape description in literature:

> It may be taken as a universal rule that landscape-painting only develops when Nature is sought for her own sake, and that so long as scenery merely serves the purpose of ornament in literature, so long it merely serves as accessory and background in painting; whereas, when Nature takes a wider space in prose and poetry, and becomes an end of representation in herself, the moment of landscape-painting has come.

Throughout history, the literature of a people stands as proof that lack of landscape painting results, not from artistic inability as is sometimes claimed, nor from royal or religious command, but from a lack of feeling for nature. Where the one form of aesthetic expression is bereft of admiration of it for its own inherent beauty, likewise is the expression of the other.

Nowhere is this universal rule more evident than in the literature of the Middle Ages. Biese and others have marshaled much evidence. As

with paintings, the lack of both perspective and description of nature can be seen in a perusal of any significant part of the vast literature of the time. The lack of perspective is, once more, the key focus of Theodore Andersson.

His searching analysis previously highlighted for us dramatic differences between the lack of scenic and spatial description in the epics of Homer, and the mastery of it in Virgil's *Aeneid*. He finds a marked degeneration of it in medieval epics, referring primarily to the English *Beowulf* and to the French *Roman d'Eneas*, an adaptation of the *Aeneid*. In both of these he finds a pronounced absence of scenic visualization, plotting of space and landscape, and of mood, all through lack of perspective for the reader. Both epics are of the 12th century, but little advance is noted from those of the earlier Carolingian times. The sense of scene was thus still dead in the 12th century.

Because *Eneas* is an adaptation directly from the *Aeneid*, Andersson finds comparison of it, rather than Beowulf, with the earlier Roman work more fruitful and relevant. Most glaring in the French *Eneas* is the absence of a pre-established natural setting. He compares the great storm episode in the two epics. Where Virgil suggests the vastness of the sea and sky so as to reduce the ships and crews to utter helplessness and insignificance before the storm's onslaught, the French epic, as with the much earlier style of Homer, focuses only on Eneas. The result is a sacrifice of most of the terrorizing quality of the storm and the emotional drain on the hero. As they approach Libya, the crew sees nothing of consequence nor does the reader, until aspects of the scene become important to them for some specific purpose. There is no advance setting of the scene. The parallel with medieval paintings is apparent. As with Homer, the French poet visualizes the sea voyage "largely in terms of rigging."

A similar style is evident in the 13th-century *Tristan,* by the German poet Gottfried von Strassburg. There is a storm scene in this epic too, but no description of its massing and breaking, and no attempt to depict the ship or its company against a scenic background. We see neither sea nor sky. Landscape is never represented in any coherent fashion beforehand, nor until Tristan has experienced some aspect of it. Space is established only in pieces, and only as each piece becomes necessary. As with the painters of the time, nature is only important insofar as it has effects on humans, and space itself is without unity. It is the same throughout medieval literature. There is neither cohesion of space, nor description of nature except as it is necessary.

According to Gurevich also, epics by medieval authors are purely conventional and laced with clichés. He cites as an example *Chanson de Roland,* dating from the 12th century, one of the oldest and finest of the

so-called "songs of deeds," epic poems of medieval France.[6] This one celebrates the deeds of the hero Roland in the time of Charlemagne, the ninth century. What mention there is in this epic of heavenly bodies is most often a cliché; natural features of the land are only a setting for the deeds of knights; and extreme weather, storms, lightening or thunder, are signs or portents of upheaval or death. Nature plays no independent role, and the heroes of the epic are "figures in empty space." Gurevich, like Biese and others, says that as an independent entity of value, nature has no place in medieval painting or literature.

Many Icelandic sagas were written down in the 12th and 13th centuries. They tell—with perhaps much poetic license—of deeds and tales, that occurred as long as eight hundred years previously. The same elements are lacking in these sagas as in the epics from England and continental Europe.

In the *Volsunga saga*, for example, we see what, to the modern reader, is an impossible lack of setting or spatial cohesion.[7] A climactic moment occurs when Sigmund, a hero of this saga, and his son invade, then set fire to the hall of their enemy, King Siggeir. The king's wife is Signy, the sister of Sigmund. When the king demands to know who set fire to the hall, Sigmund replies, narrating at length the tortured history of the main characters, involving murder, incest and revenge and the motivation for the fire. Signy thereupon, after delivery of her own narrative, kisses her husband and her brother, then walks into the fire to die. It is almost impossible to visualize this scene in any realistic manner, either the location of the fire or the relative positions of the characters to it or to each other. We are told nothing of the layout of the castle, the means of entrance or exit of the avenging pair, or the scene of the action. This is not to say that the saga holds no human interest or that it lacks literary value. The consistent absence of intelligible setting, however, bespeaks a different aesthetic, a different perceptual organization, and perhaps a different mentality, one to which visualization is unimportant.

The lack of perspective in medieval literature is accompanied by a similar lack of description of nature. One of the best known, and reputedly the finest, of the Icelandic sagas is *Njáls saga*.[8] Another, the *Laxdaela Saga*,[9] has been called the most imaginative and perhaps rivals the other in popularity. The *Njáls* is, in English translation, 315 pages; the *Laxdaela*, 198 pages. Both are filled with tales of murder, revenge, exile, and frequent travel between Iceland and various points along the western coast of Norway.

As any modern person who has seen those lands will attest, it is impossible to remain unmoved by the scenery. Iceland's rolling hills, ice-

covered volcanoes, and rugged coastlines cannot fail to impress. The west coast of Norway is laced with the overpowering beauty of towering mountains that frame seemingly endless narrow fjords. Authors of even the most prosaic non-fictional narratives of modern times seem unable to ignore the grandeur of the settings.

Yet one can read these two sagas (by accounts of those who claim to know, we may read all of them) and be totally unaware that there are mountains or fjords on the west coast of Norway, or hills or volcanoes or any mountains at all in Iceland. There is but one passage in either of the sagas that informs us that there is the slightest awareness of the landscape. That passage pertains to a single moment in *Njáls saga*, when one of the major actors, Gunnar, leaving his home in Iceland on a voluntary exile, trips, looks back and sees his home on the slopes. "How lovely the slopes are," he remarks; "more lovely than they have ever seemed to me before, golden cornfields and new mown hay. I am going back home, and I will not go away."

Gurevich notes this passage, and says that it is perhaps the only example of emotional relationship with nature in any of the Icelandic sagas.[10] But, he says, it can be more likely be explained in terms of Gunnar's attachment to his native soil, his farm and homestead, and his determination not to give in to his enemies, rather than as an expression of admiration for nature. Considering that it is the only expression of its kind in this saga, or perhaps any of the sagas, Gurevich's analysis seems indisputable. It is similar to the shorter and somewhat pithier comment by Soutar about the chorus of Spartans in the *Lysistrata* of Aristophanes and its expression of admiration for a mountain they have left behind.[11] Says Soutar: "This home-feeling is a different thing from an independent, reasoned love of nature. It has no aesthetic basis. But it is felt by the dullest clown."

Biese has studied the accounts of the European Christian crusaders to the Holy Land between the 11th and 14th centuries.[12] He takes full account of the difficulties of expression of many of the crusaders, confronted as they were with overwhelming novelties of scenic beauty. He acknowledges that of prime importance were practical matters: the fertility of the land, its water supply, the dangers and discomforts of the journey. But, says Biese, when all this has been weighed and admitted, and allowing for possible lack of descriptive powers, the fact remains that in the accounts of the crusades, "There is great poverty of description of scenery, and lack of much feeling for nature." The modern reader, he continues, is "astonished to see how little impression the scenery of the Holy Land made."

He finds instead only matter-of-fact geographical and sometimes mythological information. William of Tours, for instance, described the

Bosphorus as "fruitful" and "pleasant," but wastes not a word over its beauty. The city of Tyre was described as "conspicuous for the fertility of its soil and charm of its position," but the mountains were described only as "very high." There was nothing in his writings about the beauty of the mountains or any other aspect of the city or any other landscape, except as it may be cultivated and useful. As a rule there is little besides matter-of-fact discussion of practical utility. Of La Boneia he wrote that it had many homesteads and beautiful groves of olives and figs. Another crusader, Perdiccas, described Sion as beautiful to behold, "owing to a number of vines and flower gardens and pleasant spots." To a German crusader, Candia "is a beautiful town in the sea, well built; but also a very fruitful island with all sorts of things that men need for living." Naples was "very pretty and big." As to the Alps, says Biese, there was no enjoyment of its beauties.

While Biese generously allowed for possible lack of descriptive powers in the crusaders, there certainly does not seem to be any such lack in the skills of Marco Polo. His travels to the Far East were meticulously recorded and were published many times. He obviously possessed sufficient vocabulary to adequately describe whatever he wished. But this did not include hills, or forests, or mountains, which he usually mentioned without comment, or described only as "high," or at most "lofty." Praise, however, was lavished on the courts of rulers, palaces, gardens, valleys when cultivated, precious stones, trees and crops, and women's dress. Even when not lavishing superlatives on the beauty of such objects, he describes them in the greatest detail, as he does the appearance of the people, their dress and the cities themselves.

A "beautiful palace" belonging to a King Mangalai is embellished with many fountains, and the spacious structure itself "cannot be surpassed for symmetry and beauty." Another kingdom manufactures the "most beautiful cottons," and its palace, described in painstaking detail, contains chambers "all highly beautiful and so admirably located" that no improvement seems possible. We are told also of its "handsome" balustrade with pillars, and its "beautiful evergreen trees." The palace of Kublai Khan was erected of "marble and other handsome stones, admirable for the elegance of its design and the skill of its execution." In the park were "rich and beautiful meadows," and a pavilion supported by "handsome pillars, gilt and varnished," meticulously described. He elsewhere paints word pictures of other beautiful gardens, but seems most rapturous about the precious stones. One section of the land he describes as very beautiful, although the beauty apparently consists of its abundance of fruit, corn and vines. In a mountain are found veins of lapis lazuli. The stones are very beautiful; about the mountains we hear not a thing. Certain hills are large and lofty, their main attraction being

the white salt they hold. The salt, its huge quantity, and the means of removing it are described abundantly; the hills rate no further mention.

In the province of Vokhan are summits that seem to be the highest in the world. It required Polo's party three days of steady ascent to attain the point from which they were seen. We are treated to no description of the view, either of the peaks from the valley, or of the land below from the heights. We hear only that along a stream between two ranges, there is the "richest verdure." Another mountain is so high that no birds were seen near the summit. Other than that we hear only of the difficulty in cooking food at that height.

It seems the same the wide world over. Concerning the northern literature of the time, for example, Biese says that in the *Nibelungenlied*, the best known of the Germanic epics, "hardly a plant grew." Why did it not? Why were the ancients and people of the Middle Ages so lacking in feeling for nature? From both the literature and the painting, as well as from other factors reflected in contemporary writings, it seems that they saw nature as extensions of themselves. They were one with nature, which existed only for them, and was of import only as it affected them. As Gurevich puts it, each carried his or her own spatial sphere of action and gauged the world from that narrow corner. So, he asks rhetorically, is there not a contradiction here?

He answers that there is not. His explanation is not novel or unique. It is the same as has been given by many others. But perhaps he says it best:

> Not entirely separated from the natural locus, remaining a part of it, man—precisely for this reason—did not convert nature into the object of his observation "from without"; before he could do that, the distance between him and the natural environment would have to increase.[13]

Humans, in short, must step back from nature and see it from outside. We cannot, as part of it, see its beauty. This separation is, of course, an illusion. We are indeed part of nature, but until we began to see nature as something separate from ourselves, independent and existing apart from humanity, we found nothing sublime in it.

XIII

Metaphor, Individuality and Facial Representation in the Middle Ages

Repetitious, stereotypic use of words and phrases in literature;
return of the blank expression and empty stare in portraiture;
identification with group in place of sense of individuality;
beginnings of courtly love.

Thus descriptions of nature and three dimensional perspective died together in the Middle Ages. What of the other literary or artistic characteristics that first blossomed in classical times: use of figurative language and metaphor? Facial expression in art? The concept of individuality, of self?

Let us look first at the subject of metaphor. Did people of the Middle Ages seek and respond to novelty and innovation in language as did the Greeks and Romans, or did they find more comfort in the usual, the familiar, the routine? Gurevich addresses this subject also.

In the Middle Ages repetition of thought by authors, he says, was laudable, while the expression of novel ideas was frowned upon; plagiarism was not an offense, but originality might be heresy. Stereotypes were the stock in trade of poets. Authors were masters of the commonplace; set-phrases and clichés were everything, originality nothing. This was the literary tradition of the Germanic settlers and invaders, beginning in the third century. Those traditions are exemplified in the "kennings" and "heiti" of Scandinavia. But the epics of all Germanic peoples, including the Scandinavians, share a common source of formulaic expressions, a tradition of use of commonplace phrases, and clear predominance of the typical over the individual.

Both the kennings and the heiti that Gurevich refers to were canned, stereotyped metaphors. A heiti is a single-noun metaphor, if such it can

be called; for example, "steed" for horse; "bride" for woman, "surf" for the sea. Each of those and many others were used endlessly. A kenning consisted of two elements. A man, for instance, might be defined according to his origin, his property or his work. "Son of Odin" (king of the gods) might refer to any man; "breaker of rings," a generous man. "Sword liquid" was blood. These combinations also were used repetitively throughout the literature.

A more complex common usage was "heather fish" for snake, as it goes across heather like a fish in the sea. Haki was a well known pirate, and the "blue land of Haki" was a term for the sea. A "wave horse" was a ship riding the waves as a horse does the land. Then we might have one of the two elements compounded into two other ones, such as "horse of the land of Haki."

Many such stereotypes are seen repeatedly in the *Icelandic Eddas,* which date from between A.D. 800 and 1200 and were probably first written down in the 13th century from this long oral tradition. They are often in the nature of riddles, the solution to which depends not on poetic imagination, but upon ingenuity and sometimes on knowledge of the mythology and legends. Because the god Odin once hanged himself, he is often called "gallows load." Because of the custom of wearing bracelets, glittering gold is often called "fire of the arm." "Feeder of the Raven" is a warrior. The "troll of the shield" is a sword. "Horse of the boatsheds" is another term for a ship.

Many other stock words and phrases were used repeatedly, usually for expressing sharp changes or abrupt shifts in time or space. These expressions, known as "topoi," usually signified a change, such as from present to mythical time, or a change in fortune.

Across the ocean, almost contemporaneous in time with the first transcriptions of the epics of northern Europe, another culture was writing poetry. The possibility of influence between these two cultures, in either direction, can be safely disregarded. Yet it is difficult to examine the literature of one without drawing comparisons to the other.

The Aztecs, whose civilization was centered in what is today Mexico City, spoke and wrote Náhuatl. Its poets employed extended metaphors which are comparable to the Norse kennings. José Luis Martínez compares these metaphors not only to the kennings, but also, in the repetition of the phrases, verses, strophes, and standard epithets, to all ancient epic poetry, and particularly to that of Homer.[1] He has prepared an inventory of metaphors and epithets used by the Náhuatl poets to describe gods, places, heroes, prisoners, actions and ideas such as death in combat and the human heart.

Among others he cites: the capital city of the Aztecs, Tenochtitlan, as "the place where darts are made" or "the place of the eagle and the

cactus"; Huitzilopochtli, the sun god, was "the blue heron"; war was the "song of the shields"; the heaven of soldiers was "the garden of sunrise"; the most valued and appreciated objects, regardless of type, were "precious stones," "jade," "flowers" or "gold." There were many scores of such repeatedly used stereotyped references.

Miguel Leon-Pórtilla[2] has studied the literature not only of the Aztecs but of many Pre-Columbian literatures of Mexico. He finds that all of them have certain stylistic similarities to each other, as well as to other ancient writings, such as the Bible and other texts from the Eastern cultures. One cannot fail to notice, he says, the repetition of ideas and the

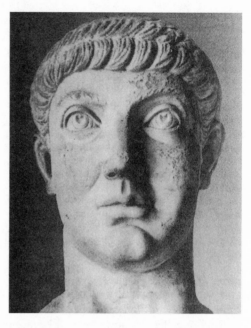

ILLUSTRATION 25. *Emperor Constantine II*. Museo Archeologico Nazionale, Naples, Italy. Ca. 337. Marble. Height, 1 meter.

expression of sentiment in parallel form. He refers also to the "recurring phrase, the key words," which are used in all literature, not only in poetry.

In medieval art, facial expression all but disappeared. Gone were the lifelike expressions of Hellenistic and Roman faces that gaze directly at us. We see few, if any, faces of medieval people with whom we feel we could converse or empathize. The change can be seen as early as about the year A.D. 250 in the portrait of the emperor Trajanus Decius, and with it the return of the blank stare, directed uncertainly into nothingness. It seems to be the same empty, vacuous stare that was so prevalent in ancient art prior to Hellenistic Greece. Portraiture had been almost unknown to the northern tribes that poured into the empire in the mid–third century and later. Their tradition was the animal style, similar to that of Sumerian art seen almost three thousand years earlier. The regression in Roman portraiture is evident in the sculptured bust of *Emperor Constantine II*, ILLUS. 25, executed about 337. In stark contrast with the portraits of earlier emperors, such as *Emperor Caracalla*, ILLUS. 23, this one seems vacuous.

Like the reversion from three to two-dimensional perspective, this change predated the recognition and spread of Christianity. The lack of expression in the sculpted faces is evident from as early as the second century. Even in earlier Roman times, on the fringes of the empire, native artists attempting to copy Roman models failed utterly to capture the individuality or the expressiveness of their models' faces. Ernst Kizinger describes third- and fourth-century portraiture as exemplified by the "motionless impersonal faces arrayed monotonously" in the ivory panel known as the "Apotheosis of an Emperor."[3] He writes of the complete neglect of the third dimension, as can be seen in ILLUS. 24, *Blessing the Lindit,* and the absence of "individual characteristics in the faces, the rigid staring eyes," characteristics of portraiture that would remain for another thousand years.

What changed with Christianity was subject matter, not facial expression nor perspective. And as with perspective, facial expressiveness returned a thousand years later with no objection from the church. It returned because of a change in the psyche of the artists and those for whom they painted, a change that came from within. Whether the end of portraiture was a partial cause of the degraded emphasis on individualism, or merely a symptom of it, is an interesting but academic question. They went together, and together they returned, a millennium later.

Much of what is said about the diminution of individualism during the Middle Ages, its causes, and its effects on everyday life (matters that are often difficult to distinguish), is found in descriptions of its flowering in the Renaissance. The relatively sudden growth of individualism at that time, understandably, cannot be fully appreciated without a reference to the lesser sense of self that preceded it. The necessity for such a comparison is exemplified by Jacob Burckhardt, the Swiss historian, one of the most prolific and often-cited authorities on the Renaissance. He saw that epoch as the liberation of the individual, a discovery of himself and of the world around him. Writing at the end of the 19th century, he tells us that during the Middle Ages human consciousness lay only half awake beneath a common veil woven of "faith, illusion and childish prepossession." It was a veil that first melted in Italy and it was there that man first became, and recognized himself as, a "spiritual individual."[4]

Even in much earlier times, says Burckhardt, there may have been in Italy a sporadic development of free personality, something which in northern Europe either did not occur at all or could not display itself in the same recognizable way. But by the close of the 13th century, Italy was swarming with personality.

The Renaissance resulted in the first discovery and display of the "whole full nature of man." It was the Renaissance, Burckhardt continues, that

> ... first gave the highest development to individuality, and then led the individual to the most zealous and thorough study of himself in all forms and under all conditions. Indeed, the development of personality is essentially involved in the recognition of it in oneself and in others.

And, he might have added, it is essentially involved in the recognition of the separate identity of nature. It is another formulation of Biese's observation that only to the fully developed man or woman does nature fully disclose herself. Others expressed similar thoughts. To the 20th-century German philosopher Ernst Cassirer,[5] the Renaissance was characterized by the "discovery of the individual in intellectual, personal and social life." As with Burckhardt, this is an inferential declaration of its lack in the Middle Ages.

Few who write about the Middle Ages deal directly with the diminished sense of self. Among those few is Gurevich. Though he may say little of life during that period that is not said by others, he, substantially more than others, relates those facts to the diminished sense of individualism. Intentionally or otherwise, he and others who address the matter reveal the close affinity between this loss of sense of self, and a lack of differentiation between self and nature, a correlation that is starkly evident.

According to Gurevich, the cosmic world-view of the Germanic tribes was similar to that of other "barbarian" peoples. Though it differed from the Christian view in some respects, it appears to be the source of certain aspects of the perception of space in the Christian Middle Ages. The most important aspect involved the incomplete separation from nature, an undifferentiated relationship between individuals and groups on the one hand and the earth on the other. Evidence of this fusion of identity of man with nature exists in the image of the "grotesque body" which found expression in the graphic arts, literature, folklore, extravagant festivals and carnivals, all depicting man as part of nature. Recurring repeatedly, as it did in antiquity, were images of animal-men, plant-men, trees with human heads, mountains in the shapes of men, and beings with many hands or legs.

M.M. Bakhtin has also dealt directly with this man-nature fusion and the concomitant lack of individuality. He has described how the protuberances and orifices of these weird depictions of man link it with the rest of nature, such as by exaggeration of the anal-erotic and gastric functions.[6] There is emphasis on the passages of birth, death, aging and rejuvenation, fertility and the productive forces of nature. What in

classical times had been lofty and ideal was thus demoted to what was earthy and material. Significantly, and reflecting anew the affinity between oneness with nature and the absence of individuality, Bakhtin says that the grotesque body thus represented was non-individualized, incomplete and intertwined with the earth, which bears it up only to swallow it up again. On the one hand the grotesque body exemplified cosmic elements, while on the other, the earth itself took on the form of the body, usually the grotesque body. This absence of barriers between the body and the world was a characteristic trait of medieval popular culture and imagination.

Gurevich sees no clear boundaries separating humanity from the world in such a view. On the contrary, man found in the world only an extension of himself. What was missing was the link that would have enabled humans to use nature and at the same time to exclude themselves from her embrace.

This identification of man with nature was closely bound to his identification with a group. From the highest to the lowest levels of society, medieval life was in essence corporate. Life was ever entwined with some group: associations of vassals, knightly orders, monastic brotherhoods, Catholic clergy, town communes, merchant or trade guilds, defensive unions, religious brotherhoods, village communities, or individual or extended family groups. The members gave each other protection and help. Some groups also gave the member his occupation and guaranteed him a certain material existence. Each had its own code of behavior and prescribed the way its members thought and behaved, and the way they were to react to circumstances. Mental conformism was its essence.

Non-traditional behavior resulted in censure, punishment, or expulsion. Deviation from accepted standards, in any direction, was not tolerated. The craftsman who produced a better-quality product, or produced it quicker or more efficiently than his fellows, was punished no less than the negligent or incompetent. The nature of corporate existence itself prevented the development of human individuality, according to Gurevich. But it appears also likely that the lack of individuality he describes did itself enable such a corporate existence. It did, in all events, subject the individual mind to the collective mind of the group.

The behavior of the burghers, citizens of the towns, was as restricted as was that of their rural counterparts. Codes and rules of the town dictated processes of production and almost all other aspects of economic life, the care of the poor, rules for the baptismal service, the authorized dress for apprentices, lists of vulgarities and the fines for uttering them, the number of guests that might be invited to a wedding, the details of dress and the procession at the wedding, and generally the most seemingly insignificant details of daily life and ritual.

The personal self was thus not seen as an integrated whole in the Middle Ages. The individual did not see his faculties and attributes inwardly and indissolubly bound together. Nor was he valued because of his individual qualities, but only insofar as he partook of what was typical and recurrent. Change was no virtue; man did not develop, nor was he expected to.

A matter of interest, and possible significance, is that highlighted by Gurevich in a comparison between the Greek tragedy and the Germanic epic. The Greek hero has choices; the hero of the Germanic epic has none, however much it may initially seem to the contrary. In the Greek drama the possibility of choice generates the tragedy. In the Germanic epic, the hero's actions only reveal the content of fate. The result is pre-ordained. The Germanic epic thus seems to hark back to Homer and the *Iliad*, where the gods control the destiny of the battle and of life and death; the humans are but pawns in the rivalries and jealousies of the gods.

Ultimately, it becomes clear that medieval man saw the world, but not nature, as a unity. But that unity existed on a metaphysical plane only. The unity, that is, did not arise from the worldly things themselves; it was rooted in God. Medieval concepts of man and his place in the world, fragmentary and unconnected though they were on the worldly plane, became unified and ordered in the unearthly realm of God. Such concepts became irresistible from the consistently religious thematic material that exudes from almost every work of medieval art and literature. The world was seen as a spiritual entity and neither nature nor earthly matters played a very significant role.

But there are always precursors. As early as the end of the 11th century, over three hundred years before Brunelleschi, and a full three centuries before Giotto, clearly in that epoch known as medieval, there was a tremendous advance in another form of humanism. It was a change in the relationship between men and women, one barely hinted at by Roman society and even less so in the Greek. It is evident in a form of poetry known as *amour courtois*, or courtly love.

It is easy to fall in with the comforting belief, so often bandied about, that romantic love as we know and understand it has always existed, one of the few things (like human nature) that has been permanent and unchanging. It is as it has always been, as is repeatedly said, and will always be. But by all available evidence, and by the opinion of almost all who have seriously studied the matter, romanticized fiction notwithstanding, it is not so. It is, rather, a feeling, a behavior, or concept—call it what you will—that came into existence as part of an "advance Renaissance individualism" in the 12th century, a development that Denis de Rougemont called a "complete revolution of the western psyche."[7] The

word "love," or its equivalent, has been around almost forever. It can mean many things, friendship, sexual attraction, or need, to name a few of the most obvious. The Greeks had many words for love, but none for romantic love as we understand the term.

Like so much else that developed in Western thought and behavior, then and several centuries later, it has continued to spread and may be on its way to becoming universal. Attraction between the sexes has been with us since the beginning, and the word love has often been used to describe it. What was new in the 12th century, and in the poetry of the troubadours of France and the Minnesingers of Germany, was the notion of placing their ladies on a pedestal, a place of superiority above the lover, finding fulfillment in the act of giving, and in controlling oneself instead of controlling the other. What courtly love replaced was once as universal as human sacrifice.

Women, almost everywhere, were completely subservient, bargained for and bartered for like chattels, important chattels though they were. Almost nowhere did women have any say in the choice of a mate. Where they did, romantic love, as we know it, played no role. In a large swath of the earth's surface, from eastern Siberia to Assam, and from India to New Caledonia, marriage was governed by centuries-old cultural strictures, the details of their application determined by male relations of both bride and groom. In Burmese culture, the woman was married more to the clan to which she was given than to the nominal husband. Upon widowhood she was given to another member of the clan. And from one end of the Americas to the other, marriages in the indigenous tribes were fixed by the families and sometimes by purchase by the groom. Love, in any event, played no role. For the suitability of a marriage, the Aztecs sought confirmation in the stars, but the young couple were not consulted.

In Europe, marriages were arranged based almost entirely on economic or other practical matters. In parts of the Middle East, a man could change a daughter for another wife. In some Germanic tribes, women were bought like slaves and prohibited from sitting at the table of their husbands. In ancient Greece, at least until the third century B.C., things were no better. Both in Hellenistic times and in Roman society, there was definite improvement, but only in the sense that women were treated better because they were viewed as people, not as women.

Literatures the world over are notable for the absence of any description that would meet our standards as romantic love, a theme that is pervasive in modern fiction. Of the thirty-two surviving Greek tragedies, not one deals with that subject. The many poems of ancient Egypt are consumed mainly with paeans of praise to kings and with hymns, prayers and myths. Their "love poetry" is confined to descriptions of the lady's

physical attributes. Alfred Wiedemann, a scholar of Eastern literature, compares Egyptian to other Eastern treatments of love, as rarely containing even a sentimental feeling, usually being a "passion finding for itself intense and realistic utterance."[8]

The poetry that was new in the 12th century was often absorbed with something that did not seem to concern earlier poets: the face and facial expression of the beloved. The poet of *amour courtois* was often "transported aloft by her smile, reduced to tears by her frown." Most often mentioned was the glance, or the "deadly glance" that completely captivated the lover; this sometimes was couched in the language of the myth of Narcissus, the poet seeing himself in his lady's eyes. Frederick Goldin has convincingly made the case for this connection as one of the essences of courtly love in his volume on *The Mirror of Narcissus in the Courtly Love Lyric.*[9] This is a form, a rather intense one, of empathy, namely, seeing oneself in another person, as opposed to a reflecting surface. It is a precursor to the more generalized growth of that quality that blossomed in the Renaissance, a few centuries later. It was to show itself, not only in the continued life of romantic poetry, but in the splendid portraiture that flowed from the workshops of hundreds of artists. As always, there are, in Chinese and Islamic literature especially, a few progenitors here and there. But descriptions of the look, or the glance, are very few and rarely of an intensity to compare with those of the poetry of the 12th century and beyond in France and Germany.

Though that form of poetry has long since disappeared, the development of the feelings it described was no passing fancy. The human emotions and behaviors to which it gave birth are with us today and continue to dominate much of the relationship between the sexes. It—like the changes occurring in the Renaissance in portraiture, use of language, individuality, and three dimensional perspective—has become a permanent fixture of Western and other social thought and behavior.

XIV

Chinese Landscape

Power of Chinese landscapes despite lack of vanishing point;
different perspective of Chinese art, looking to infinite space
beyond the painting; abstract concepts and unparticularized
representation; symbolism and spirituality rather than nature
for its own sake as incompatible with scientific outlook.

Three dimensional perspective, love of nature for its own beauty,
portraiture, and individualism all seem to interact in human cultural his-
tory, and to rise and fall concurrently and very smoothly. But there always
seems to be in nature and in history, some phenomenon to disturb invari-
able rules. The spoiler in this case appears, at least at first blush, to be
the art of China: There is love of nature, but not three dimensional per-
spective. On deeper inspection, however, the awesome Chinese land-
scapes may not be so anomalous.

One must take care not to overemphasize the continuity of her art
tradition, which spans 3,400 years. Nothing is so static; everything in life
changes. Nonetheless, set against the backdrop of the turbulent art his-
tory of the Western world, it appears as an almost changeless, unbroken,
seamless organism, running from its beginnings about 1600 B.C. until
some time in the late 19th or early 20th century. There were of course
individual differences in the styles of the great Chinese painters, but in
comparison with their counterparts in the West, those differences seem
insignificant indeed. There were slight changes in emphasis in subject
matter, changes that fade into nothingness in comparison with the dra-
matic shifts in the art of Europe. There was no "dark age" in China to
compare to that of medieval Europe; but there was likewise no Renais-
sance. No doubt, China's isolation and the fact that she was spared the
tremendous influx of foreign populations, the constant churning involv-
ing different and long-separated peoples, was a contributing factor to the
stability of her artistic tradition.

Chinese artists never developed three dimensional perspective, at

least not the one-point perspective of the Renaissance. Yet beginning
several centuries before Christ, landscape and the Chinese love of nature
dominate their art. The rules by which Chinese artists worked were con-
ceptualized centuries before Christ, and articulated in the sixth century
of the Christian Era. Some revolutionary ideas notwithstanding, they
were faithfully followed through the 19th century. None of these cir-
cumstances, however, can detract from the sublime beauty, the emotional
impact, or the power of the countless landscapes that seem to have
sprouted from the brushes of Chinese artists, most particularly in the
14th through the 18th centuries.

No less than their counterparts in the West, Chinese landscape
painters over the millennia have written about their art. Their writings
explain much about the differences we see in the landscapes of the two
art cultures. Their words contrast markedly with those of Alberti and
other Western artists.

One of those differences is the comparative emphasis on perspec-
tive in the West; its lack of emphasis in the East. Throughout its history,
Chinese art reflects mainly a juxtaposition of landscape elements, hills,
rocks and trees, without concern for placement in space or relative size.
Depth is sometimes shown by placement of two dimensional planes, one
behind another, like stage scenery. George Kuwayama, writing from the
Eastern point of view, tells us that the Eastern artists defined space sym-
bolically.[1] Their landscapes, he explains, were divided into three layers
of depth, separations between them defined by "mist laden passages."
Even by A.D. 400 the Chinese art showed less concern with perspective
than that executed by Romans several hundred years earlier.

But the Chinese artist was not completely lacking in a sense of three
dimensional perspective. Many three dimensional effects are captured in
Chinese landscapes from at least the early Han period, beginning about
200 B.C. There is, here and there, diminution of objects in the distance.
There is sometimes overlapping. But whatever similarities may at times
be evident, there is one feature of European Renaissance art that is not
to be found in the that of the Chinese: There is no vanishing point.

The Chinese have shown no concept of it; their concern is for the
infinite. There is never one perspective, nor any thought to show a view
of the world as seen by one person from one point in space at one
moment in time. This fact is not unrelated to the circumstance that indi-
viduality, in the sense that it was prized in the classical civilizations of
Europe and in that continent's Renaissance, was, in China, almost
unknown.

We do not look at the Chinese landscape as a viewer from without.
We are in it and we are led along a path. Lawrence Wright, in his trea-
tise on perspective, says that the Chinese preferred the bird's-eye views,

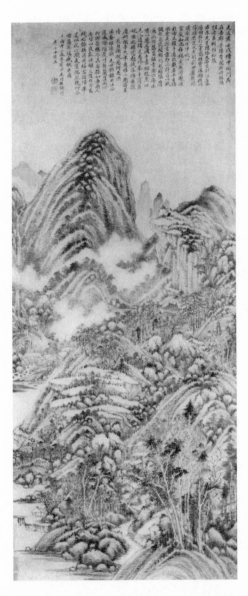

ILLUSTRATION 26. *Chinese Landscape in the Style of Huang Kung-wang*, by Wang Shih-min (1592–1680). After Lee, Herman, *Chinese Landscape Painting* (Cleveland: The Cleveland Museum of Art, n.d.). Credit: The Bamboo Studio, New York. Hanging scroll. Ink on paper, 53" × 22". Inscription by artist dated 1666.

conceived with no particular viewpoint in mind. "The eye is led from incident to incident as though a story were being told."[2] In many of the finest examples of Chinese art, we view each part of the terrain from close up, and often from different angles. Rather than depicting the limits of human vision, the Chinese seek to give an impression of the boundless and infinite space beyond the picture. Hence their lines of sight often go outward from the viewer, not inward as in Western art. The horizon, that flat boundary line, was apparently anathema to the Chinese artists, and theirs flowed in curved lines outward and seemingly beyond the bounds of the picture. They compared it to the "undulations of the dragon." The landscape from the hanging scroll shown in ILLUS. 26 dates from 1666, a high point in Chinese landscape art.

There is a unity in the Chinese landscape, but it is not merely, as in Western art since the Renaissance, a unity in what is seen. The unity, rather, is in all of nature, the entire world. According to Laurence Binyon, "the spectator was lifted up, to see as from a tower; his eye was enmeshed in no tangle of foreground, but was led across great tracts of country to the distant mountains, shadowy range beyond range, or waters mingling at last with the vapours of the sky."[3]

What could be seen in life was to the Chinese landscape artist no barrier or restraint. In the 11th century, one of them, Shên Kua, explained that if people looked at painted hills in the same way they look at real hills (that is, looking up from the base to the summit), one could only see one range at a time. He would be able to see neither the ranges beyond nor their ravines and valleys.[4] But that did not prevent the artist from showing, in much detail, the rocks and shrubbery at the base of that nearest range. Thus did the Chinese unapologetically paint what they knew, not what they saw, and not from one perspective, but from several or many.

Nor was the viewer of that art to be limited to a moment in time. According to Binyon, the artist was obliged to "pierce beneath the mere aspect of the world to seize and himself to be possessed by that great cosmic rhythm of the spirit which sets the currents of life in motion."[5] Those phrases are not Binyon's inventions. The first and most important of six great principles, laid down in the sixth century by Hsieh Ho, a name that looms large in the history of Chinese art, enjoins the artist, according to some interpretations, to portray the "rhythmic vitality, or spiritual rhythm expressed in the movement of life." The recurring and endless patterns of nature have permeated the life and thought of this largely agricultural people from the earliest times. The feeling of the movement of life is inherent in the orderly or symmetrically flowing lines of the landscapes, a sometimes beautifully executed device, though not something seen in nature.

Religions have come and gone in China, but the changes in the rock-ribbed principles of art have been minuscule. The religions, like elements of foreign art cultures, have entered China only to be subsumed in her almost timeless rule-oriented artistic edifice. Even in the 14th century, the period of the Yüan Dynasty, according to Osvald Sirén, painting was something sacred, "almost like a religion. They were afraid of profaning it by exhibiting skill or accumulating personal fame."[6]

Of the Chinese love of nature in general, mountains in particular, there can be no question. Their landscapes, though not evidence of three dimensional perspective, preceded landscapes in western art by centuries. Even as landscape art perished in the late Roman Empire and during the Middle Ages in Europe, that of the Chinese flourished. But a more difficult question is wherein lay the beauty that the Chinese saw, both in nature and in art.

The landscape painting that arose in Europe in the 16th century sought beauty in and of itself. No longer was the sole preoccupation of artists the religious or spiritual event or figure. Gone was the view of

nature as a reflection of human deeds, thoughts, or spiritual beliefs, or as a background for human events. European painters from the 16th century on looked to the mountains and other scenic wonders, and found indescribable beauty in the shapes of things as they were. We will look more closely at that development shortly. In the meantime, a look at Chinese art can tell us much about that of the West. There are times when one's own traits and characteristics, and their significance, can be seen more clearly from without than from within.

The laws of optics, of projection and section, or of projective geometry, are of no moment to the Chinese artists, and have had no influence on them. Any similarities of their perspectives to those of the West have been purely intuitive and used only to the extent that it suited the purpose of the artist. What dominates is symbolism; Chinese landscapes speak a language of visual symbols that has its roots in an attitude of mind uniquely Chinese. This attitude is represented by the *pa-kua*, consisting of eight epigrams and the 64 hexagrams that can be produced by combining them. The source of the epigrams, according to the *I-ching*, the Book of Changes, is the "Great Ultimate," the creator of all existence, which produces two forms, then four emblems, then the eight epigrams that were made manifest on earth. The four emblems are collectively known as the *hsiang*, an important concept in Chinese thought and art. In ancient China, the tenets of philosophy and events of the heavens were often symbolized by the emblems of the *hsiang*. Under this religious or philosophic system, the *hsiang* are the pure abstraction. The *pa-kua* are their visible phenomena. The *hsiang* is thus comparable to the thought system of Plato, an ethereal essence, not accessible to the senses; the earthly objects, the *pa-kua*, being mere manifestations of the abstract concept.

What has been the effect of a system of art and of thought rooted in these beliefs? As Michael Sullivan summarizes the Chinese view,

> Pictorial representation is not for the purpose of describing a particular object, since individual objects have no significance in themselves, but in order to express the ideal or norm which exists eternally beyond the limits of temporal existence and is manifest in natural forms. The more abstract and unparticularized the pictorial forms, the nearer they approach the true form.[7]

Plato's view of art and of the world in general could not have been better capsulized by Plato himself. Sullivan describes this profound idealism as playing a crucial role in the emergence of the Chinese philosophy of art, and believes that an understanding of this factor brings us closer to understanding the attitude toward nature that is revealed in the landscapes. Although the origins of the early forms of Chinese painting

are obscure, the symbolism and generalized, relatively abstract forms throughout Chinese art history, according to Sullivan, are closely related to them. Nor does it detract from the power of these works that Chinese landscape is in truth primarily "a complex of brush symbols for nature."[8]

It should be no surprise then to see that Chinese landscapes are highly abstract line drawings, lacking in the detail of many of the finest specimens of Western artists, nor that the scenes of the Eastern genre, as compared to those of the West, are less specific and more impressionistic, though not in the sense that the term is used in Western art. The Chinese artists look within themselves and their own spirituality for expression of what they see in nature. The European artists of recent centuries look to the scene itself; for them, the motivation is more completely aesthetic, less a matter of religion or spirituality.

In the West there was thus a greater interest in representing the scene as it was. Even with the Impressionists of 19th century Europe, three dimensional perspective was still rigorously used. It was supplemented, not replaced, by intense use of atmospheric perspective and other devices. Of course, no painted scene is ever a photograph. But the general shapes of the mountains and other features of the landscape are themselves the sources of the inspiration of the European artists, more purely and to a greater degree than is true of those of the East, who follow the dictates of a hallowed spiritual and symbolic tradition for which they are trained from early life.

The Chinese use of symbolic abstraction in landscape painting, and the use of that genre as a vehicle for metaphysical ideas, took strong root early on and was probably firmly embedded by the sixth century of the Christian Era. But even though constantly modified and elaborated it remained essentially intact through the course of Chinese art history, including most of the 19th century.

When the ultimate focus of an art culture is not on natural features themselves, but on the spiritual, religious or metaphysical ideas they invoke, what significant differences might result between other aspects of that culture, and those of one concerned more directly with aesthetics? Again, Sullivan:

> When every aspect of the nature, both transcendental and phenomenal, could be represented by a combination of the conventional symbols of the pa-kua, it became unnecessary to examine these things as external events capable of analysis and of yielding, by induction, general laws regarding the behavior of the universe.[9]

Indeed, says Sullivan, the existence of such a system made "difficult, if not impossible, the development of a scientific attitude." No event or object could be particularized or studied in isolation, as each was but

part of a totality that lay beyond logical comprehension. "Nothing existed or had meaning apart from that pattern."

Sullivan's analysis is apt; his insight seems sound. But the question remains as to what extent that system results from a mind-set that is itself less disposed to scientific inquiry. To what extent, in short, are both the system and the lack of scientific analysis the result of the world-view prevailing in the culture? Is there perhaps a symbiotic relationship at work? It is, in all events, an interesting backdrop for a look at developments in the West, where first perspective, and later landscape painting, were to reach their pinnacles during the same period, it so happens, as the flowering of the Chinese landscape genre. A comparison of the artworks of the two cultures lends credence and body to the statement of Harries that "perspective has meant secularization of the visible." In Western art the visible was secularized. In China it was not.

XV

One Point in Space, One Moment in Time

Cimbue and Giotto, and the beginning of "intuitive" perspective; Masaccio and *The Trinity*, and Donatello as continuing the rigorous use of the perspective of Brunelleschi.

There was civil strife in Florence in the late 13th century. The ultimate contestants were the Papacy and the secular authority of the princely family of Hohenstaufens. This line of Hohenstaufens was the successor of part of the late and unlamented Holy Roman Empire, that amorphous entity that was once described so incisively by Voltaire as being neither holy, nor Roman, nor an empire. More immediately involved in the bloody struggle were the Gulephs, representing the Papacy, and the Ghibellines, carrying the banner of the Hohenstaufens. By the late part of the century the Gulephs had prevailed, but, as is not at all unusual with victorious forces, two factions of it fell to fighting with each other. These had the somewhat more memorable names of Blacks, composed in the main of the nobility, and Whites, the party of the populace, including many of the finest of the city's artists and writers. Among their number was the great poet Dante. The Blacks were the more tenacious in their partisanship in behalf of the Papacy, finding the Whites too similar to the defeated Ghibellines for their tastes. Fighting in the streets of Florence was savage and bloody, and the city was torn asunder. As the fortunes of each party temporarily ascended, many of their enemy were banished. Ultimately, one day in 1301, through treachery, many of the Whites were slaughtered, and most of the survivors, including Dante, were exiled from the city.

But commerce boomed. The war had indeed been good for business, and both the city and her inhabitants, especially bankers and merchants, prospered. Silks, tapestries and jewelry were among the most

156

important items of commerce. Nor did it hurt that Florence had absorbed some of the neighboring towns in the course of the conflicts, nor that the Papacy looked now to the bankers of Florence for financial assistance. The city, home to only 45,000 just a few decades earlier, was soon bursting at its seams.

Within a little more than a hundred years, it would be the birthplace for the most dramatic flowering of artistic and literary endeavor, and for the greatest general growth of humanism, that the world had witnessed in almost eighteen hundred years. It is not possible to define an exact moment that the ground moved beneath the feet of its inhabitants. Such momentous changes are never so sudden as they appear from the vantage point of six or seven hundred years. It can hardly be said to have begun in the 13th century, nor in the 14th. There were some tremors during those centuries, but they were mere precursors of what was to come, both in art and in humanism, and in aspects of that amorphous quality we call individualism.

In art, one of the most dramatic and (at least in retrospect) surest portents of what lay ahead is found in the work of Giotto di Bondone, now known to the world of art as Giotto. He was born, most probably in 1267, in a small village near Florence. The winds of change were already aloft. Europe, and Florence itself, was still more medieval than modern in its thinking, but almost a thousand years of immobility in the patterns of life was starting to give way. By the time of Giotto the art world of Florence had already witnessed a significant break from the hide-bound tradition of Byzantine painting with the frescoes of a Florentine artist named Cimbue.

Though hardly revolutionary, nor expanding markedly the traditional religious subject matter, Cimbue's art added new dimensions of expressiveness, volume and naturalism to human figures. At some point in his mature life he met the boy Giotto and took the lad under his wing and his tutelage. Whether Cimbue's interest in him at age twelve arose from watching him sketch a goat in the field of his peasant father, or from the youth's continual visits to Cimbue's studio in Florence, depends on which source one chooses to believe. In either event, and whether or not Cimbue could have guessed that the youngster's fame would far surpass his own, he persuaded the elder di Bondone to permit the apprenticeship.

In time, Giotto the man was to witness much of the depravity of the internecine warfare of Florence, a matter he accepted with apparent equanimity, as he did most other of life's vicissitudes. In fact he did more. The pragmatic artist rented looms to weavers at healthy prices, and profited handily from the prevailing sorry state of the Florentine wartime economy. Other opportunities followed. Pope Boniface VIII, within a few

years of his consecration in 1295, formulated plans for the redecoration of Rome, by all accounts a badly needed one. Giotto's fame had already spread, and, along with the services of that city's already ample supply of native artists and artisans, his talents were eagerly sought. His not-unpleasant relationship with the officious and fatuous Boniface is testimony to Giotto's often-praised self possession and good humor. He was spared the indignities of others with lesser qualities. One visitor to His Holiness, for some real or imagined breach of protocol, was kicked in the head. Another, a high-ranking prelate, kneeling to receive ashes on his head, found them thrown across his face.

Like his teacher Cimbue, Giotto's work was confined to religious subject matter, but the freshness in his approach is unmistakable. In place of the aura of the supernatural that permeates traditional medieval paintings, his emphasis was on the natural. The settings are not somewhere in the ether of space; they are clearly on planet earth. There are hills and meadows—only as background to be sure, but natural features nonetheless, as well as houses and city structures. No longer does each figure or object occupy its own space; no longer are relationships between them disregarded.

Three dimensional perspective is not to be found, but the figures and objects are in meaningful groups rather than scattered across the paintings like a collage. There is, perhaps for the first time since the Roman Empire, a consciousness of spatial relationships. The feet of the human figures rest on solid ground. No longer do they float in a vast emptiness. The figures themselves, even more than those of his master Cimbue, have volume, which, in human figures, translates as flesh and blood as opposed to lifeless mannequins. Even more dramatic is the sudden appearance of humanity in the faces. Those in Giotto's frescoes, unlike most in earlier paintings, seem capable of human emotion. Even without the fine facial musculature and the glow of subtle feeling or personality that abound in the Renaissance, they manage to look alive.

Questions have been raised as to the validity of the attribution to Giotto of many of the frescoes with which he was generally credited. With most of the questioned works, the weight of authority is solidly on his side. But fortunately, the attribution of the finest of those works is unquestioned. Among them are 92 frescoes depicting the lives of Christ and the Virgin Mary in the Arena Chapel in the Church of the Annunziata in Padua. The plates are distributed in multiple rows along the two walls of the chapel's nave, the triumphal arch at the end, and the portal wall. These alone contain a wealth of the characteristics that stand in stark contrast to the medieval style of earlier works, even those by Cimbue.

Among the panels best illustrating these characteristics—spatial

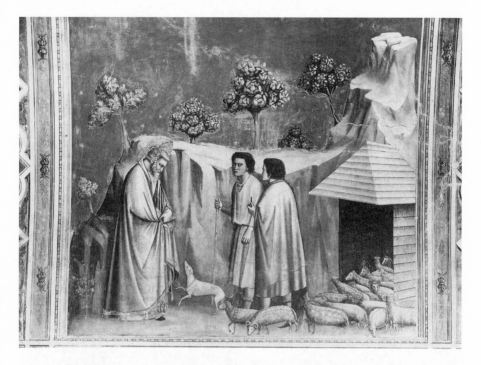

ILLUSTRATION 27. *St. Joachim Returns to the Shepherds of His Flock* (or *St. Joachim Retires to the Sheepfold*), by Giotto. Scrovegni Chapel, Padua, Italy. Photograph credit: Alanari/Art Resource, N.Y. One of an extended series of frescoes depicting the life of Christ.

awareness, volume, and facial expressiveness—are those depicting *The Meeting at the Golden Gate*, *Christ Disputing with the Elders*, and *The Expulsion of the Merchants from the Temple*. The panel depicting *Joachim Retiring to the Sheepfold*, ILLUS. 28, and a few others contain aspects of nature.

Twenty-eight frescoes in the Upper Church of San Francesco in Assisi, illustrating the life of St. Francis, are generally, though not unanimously, considered by the critics to contain much input from Giotto. Numerous other paintings often attributed to him, though disputed, show considerable advance in those characteristics later developed to such remarkable heights in the Renaissance.

The same sense of space that compelled Giotto's placement of figures in a rational manner in relationship to each other, required that his landscape backgrounds resemble, to a reasonable degree, the world we live in. Nonetheless, his focus was still the human figure and the works of humans, and his natural settings reflect the geometric patterns that were fitting to the spiritual nature of his subject matter. This differed

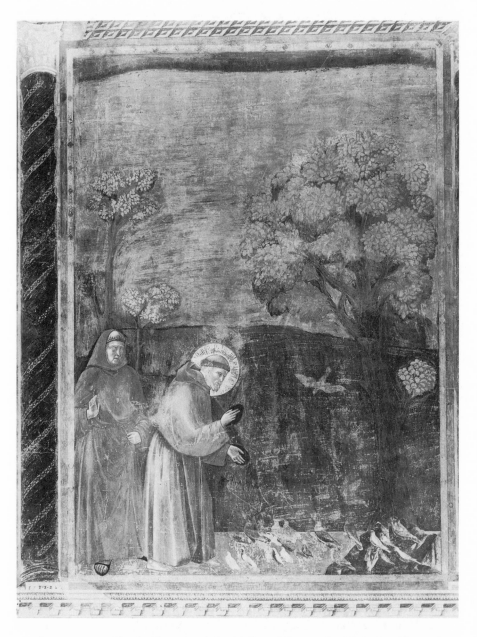

ILLUSTRATION 28. *St. Francis of Assisi Preaching to the Birds*, by Giotto. S. Francesco Assisi, Italy. Photograph credit: Alanari/Art Resource, N.Y. According to the scriptures, Francis was on his way to Bevagna when "he preached to many birds and those creatures did stretch their necks, open their beaks and stroke his cowl."

hardly at all from the spiritual subjects of other artists of medieval times. Examples include two panels from the St. Francis group in the Upper Church at Assisi, *St. Francis Preaching to the Birds*, ILLUS. 28, and *The Miracle of Spring*. The 14th-century innovations in representations of nature were not limited to Giotto. The same stylistic background landscapes can be seen in the works of some of his contemporaries such as Ambrogio Lorenzetti, most particularly in his *Allegory of Good Government*, dating from 1339.

Giotto died in 1337. His influence on later artists was considerable. Among those most directly influenced and most assiduously engaged in perpetuating his innovations, each in his own style, were Taddeo Gaddi, Maso di Banco and Bernardo Daddi. If Giotto was not the first artist of the Renaissance, he was, at least, its first precursor.

Giotto has indeed been referred to by some as the first artist of the Renaissance. More often however, and with more reason, the title has gone to three: Brunelleschi, Masaccio and Donatello. Giotto, with supreme confidence in his own artistic instincts and intuition, stretched the bounds of medieval art and defied tradition to paint what he saw. But Brunelleschi dared to combine his art with science and to create an entire new genre. The new genre concerns perspective only. Both Giotto and this trio of 15th-century artistic geniuses perpetuated the absolute predominance of the traditional subject matter of religious themes. But Masaccio and Donatello continued to perfect and to firmly anchor in the art of Italy the new perspective created by Brunelleschi. It would soon spread through all of Europe and ultimately to her far-flung colonies. It would inevitably change the world-view of artists and of those for whom they painted. It would result in the discovery of a sense of beauty that had not been seen since classical times, if ever at all.

"Masaccio" is a nickname for Tommaso di Giovanni. It has been variously translated as "slovenly" Tom, "naughty" Tom, "clumsy" Tom and "hulking" Tom. He was born in San Giovanni Valdorno in 1401 and died about 1428. Little is known of his short life, but it can be deduced that he, unlike Brunelleschi, Alberti, or Donatello, earned very little money for his genius or for his priceless legacy to the world of art. By sixteen he seems to have been recognized as a painter, if not yet as a master. Numerous paintings are attributed to him. Some are disputed; others are not.

One that is not disputed is the one that concerns us most, a fresco entitled *The Trinity* in the Santa Maria Novella, executed about 1427 (ILLUS. 29). It is, despite the obvious effects of its tortuous history, considered his finest work. From our limited point of view, of more impor-

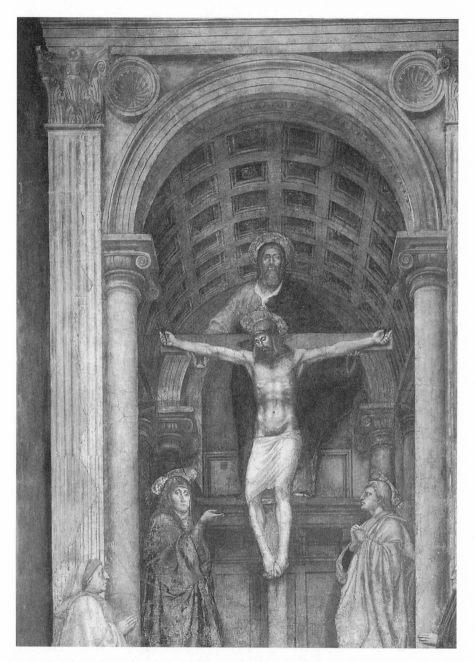

ILLUSTRATION 29. *Trinity*, by Masaccio. Santa Maria Novella, Florence, Italy. Photograph credit: Alanari/Art Resource, N.Y. Fresco 1426–27. Earliest surviving work utilizing rigorously executed three dimensional perspective.

tance is the fact that it is the oldest surviving painting faithfully executed to capture visual realism in accordance with natural laws of geometry. As such it holds a monumental place in art history.

Was it precisely the processes developed by Brunelleschi? The question is all the more interesting for the fact that it preceded by almost ten years the first written document to describe that process, Alberti's *On Painting*. Alberti dedicated his volume to Masaccio, as well as to Brunelleschi, Donatello and others, though whether the author knew Masaccio or had only heard of his reputation is not certain.

Jane Aiken has argued convincingly that Masaccio utilized in the creation of his perspective not only the mathematical principles worked out by Brunelleschi, as later articulated by Alberti, but also certain astronomical conventions dating back to the Greeks of the fourth century B.C.[1] Not until the Renaissance were these conventions utilized in art, when a new appreciation of depth caused the realization that they could contribute to the artistic representation of it. Her reference is to the ancient device known as an "astrolabe," used for measuring the altitudes of heavenly bodies and determining their positions and movements. The use of a central point and the projection of a ray at right angles to the plane of the picture was not only defined later by Alberti, but was typical of medieval astronomical projections, though never applied to art in medieval times.

The pictorial field of *The Trinity*, Aiken points out, is divided into three squares and involves also circles and semicircles, in a manner consistent with the medieval astronomical diagrams. Masaccio's innovation was in utilizing them to establish the illusion of the recession of the barrel vault that is the background for the figures. In *The Trinity*, says Aiken, the rate at which the size of the barrel vault diminishes to create the illusion of depth was based on projections found on the astrolabe. Hence, even prior to Alberti's work, Masaccio may have developed a mathematically based method to portray diminution. And like Brunelleschi before him and Alberti after him, he may have grasped the importance of the vanishing point. But his starting point, according to Aiken, was the diagrams of the ancient astronomers. Interestingly, Aiken also cites evidence that Brunelleschi collaborated significantly in the initial planning of *The Trinity*.

In the Middle Ages the astrolabe was seen as the symbol of the perfection of the universe, evidence of a Divine Order. What appears to many today as surface geometry, that is, the face of the astrolabe, was seen by medieval mathematicians differently. They saw it as a graphic explanation of the "continually changing relations among the systems of heavenly bodies of an earth-centered universe as those systems were projected onto a plane surface." Both Brunelleschi and Masaccio obviously

well understood how this surface geometry could be combined with a mathematical description of the functioning of the forms of Euclidean geometry to convey precisely the illusion of depth. This understanding was made explicit in Alberti's treatise almost a decade after the execution of *The Trinity* (even longer after the frescoes of Brunelleschi), and is vital to the use of linear perspective.

The perspective method of painting, new in the Renaissance, is often referred to as humanism, an acknowledgement of the importance of the viewer, who sees every aspect of the painting from his one viewpoint. A more accessible use of that amorphous term is its application to the human figures, particularly the expressiveness of feeling and emotion in the faces. Once more we see these two aspects of humanism marching hand in hand. The faces in *The Trinity* arrest our attention. They evoke our immediate empathy as we know, or think we know, what feelings grip them. These faces are restrained, they are not blank. Beneath the restraint we can sense the vibrancy. There seems more spirituality in the focus of their eyes than in all the blank "spiritual" faces of antiquity and the Middle Ages. Another of the finer examples is *The Tribute Money*, a fresco in the Brancacci Chapel of the Santa Maria del Carmine in Florence. Drawn faces eloquently describe the intensity of the underlying tension of the scene.

The use to which Donatello put this new technique differed from all who came before him, for Donatello was the first to use linear perspective in sculpture. He was born in Florence in 1386, and died there in 1466. Like Brunelleschi, he was trained as a goldsmith. In his long productive life he worked in at least seventeen cities along the length of the Italian peninsula, from Naples to Venice. Not a great deal is known about his life, but hints of his nature emerge here and there.

He seems to have been known for his sharp-edged wit and sometimes uncontrollable temper. At the age of fifteen he was held to be the instigator of a violent fight. Reportedly, he once obtained the permission of the Marchese of Ferrara to murder a youth in that town by whom he felt aggrieved. Upon tracking the youth down and confronting him, however, the youngster laughed in his face, to which Donatello responded by joining in the laughter, thereby saving both from tragedy. He is a character in a novella set in the early 15th century, published after his death. But he was still alive when he was made a character in a religious drama in the middle of that century.

Like many of his artistic contemporaries he was fiercely competitive and, more than others, highly opinionated and strident on a variety of other than artistic matters. He is the subject of a critical poem, which some believe was authored by Brunelleschi, taking issue with his frequently voiced strong opinions on matters about which he apparently knew little.

ILLUSTRATION 30. *The Assumption of the Virgin,* by Donatello. Sant'Angelo a Nilo. Naples, Italy. Photograph credit: Alanari/Art Resource, N.Y. Detail from Brancacci Monument, ca. 1425–1428. Marble, 53.5 × 78 cm.

His output of splendid sculpture was prodigious; his influence on Italian artists of the age—most notably Masaccio, Botticelli and Michelangelo—tremendous. He was an innovator, particularly in his flattened reliefs, those consisting of lines and scratches with mostly uniform backgrounds and a soft incision for the outline of a figure. It differs from engraving in that, to a limited degree, it permits the representation of depth. He also revived sculpture in the round. Of particular interest here, however, is his appreciation and use of linear perspective in the reliefs.

He used the illusion of depth to emphasize the human content of his narratives. Intensely sensitive to individuality, he demonstrated the utmost concern to detail it in his works. Its presence is to be seen on every type of sculpture with which he worked. Yet many of the faces on his relief sculptures lack, perhaps necessarily because of his medium, the detail of musculature that is so vital to it. His depiction of expression in that medium is most impressive when used to portray unrestrained depth of emotion, rather than subtlety of feeling or character. More than the faces, it is the roundness of his figures, the realism of his illusionary space that is riveting. Empathetic feeling with his characters is not deepest in

those of his reliefs. For that response we must look to some of his sculptures in the round, where composition and perspective play no role.

As with anyone so prolific, it is difficult to select one work as outstanding. But perhaps from the amount of praise and critical acclaim, his *The Assumption of the Virgin* (ILLUS. 30), completed about 1428, is as likely a candidate as any. It is an example of the "flat relief," which to a remarkable degree conveys depth and perspective. One of the finest of his portraits, from the point of view of expressiveness of feeling and portrayal of character, is the *Reliquary Bust of San Rossore,* completed about 1427.

XVI

Landscape in Western Art

Development of painting of nature in 14th and 15th century; Altdorfer as the first true landscape artist; *St. George and the Dragon* and *Landscape with Woodcutter*; necessity of "distance" from nature as a condition for landscape, but visual perception as opposed to physical distance; Bruegel the Elder, Rubens, Rembrandt.

Until the 16th century, in Western art, as with the art of the Chinese, everything stood for something else. Every aspect of the natural setting was present for other reasons than its intrinsic beauty. In the Middle Ages as in antiquity, there is an unreality about the aspects of nature that frame the subject of the painting or sculpture. They were intended to reflect not the mountain, tree, or hill as it was, but rather the perfection of God's creation, the higher reality that invested the lives of the people of the times. These natural features were to convey, not what was perceived by the senses, but what was as eternal and everlasting as would be their lives in the hereafter. To the medieval mind, this meant symmetry and regular shapes, geometric patterns—in a word, abstractions—and neither the irregular contours of mountains or rivers or the chaos of the forests had any place in the harmony of such a perfect world.

Who was the first "true" landscape artist? What was the first genuine landscape painting? There are many nominees for both honors, almost as many as there are art historians who have addressed the subject. Inevitably there are different criteria utilized, yet even applying a uniform set of rules, ample room for judgment, opinion and debate still remains. Based on the criteria appropriate to our subject, it appears that attention should be focused on Albrecht Altdorfer. He is the nominee of art historian Christopher S. Wood, whose criteria come as close to effecting a "secularization of the visible," and diminishing the human presence, as those of any other who has written on the subject.[1]

That criteria describes a landscape that separates humankind from

nature, enables humans to see nature from without, and contributes to their interest in nature as a subject of study and investigation. It describes well that type of landscape that exists for its own sake, in its own time, occupying its own space, and subject to its own internal dynamics and laws. This implies a reversal of setting and subject. Prior to Altdorfer, no matter how much space was occupied by nature or how little by the human presence, humanity was the subject, nature was the setting. With some of Altdorfer's work, a reversal of that relationship was unequivocally effected for the first time in the history of art.

It needs to be stated at this juncture that there is nothing about landscape, as the term is used here or elsewhere, that renders it inherently superior to other forms of art. Perhaps the more important defining feature of Renaissance art is its focus on humanity, the proliferation of splendid portraits of individuals, and of humans engaged in various everyday activities. But as previously emphasized, it is probably no coincidence that portraiture and landscape, at least as background, have risen and fallen together throughout history. Nor is it coincidence that even the background landscape in modern times became vitally realistic. But the rise of landscape as a separate genre, as the term is used in these pages, was new in history, and is significant for its new perspective on nature. It was this new mind-set, one that saw the entire visual field as a unity, that also made the rise of science and the scientific method possible.

Altdorfer's origins are not certain, but he was probably born about 1480 in the southeast German town of Regensburg. It is known that he lived much of his life there and died in that city in 1538. At the turn of the century its population numbered about ten thousand. His father was believed to be Ulrich Altdorfer, a painter of some local reputation. According to city records, Ulrich became a citizen in 1478, but is also known to have left thirteen years later. Albrecht returned to Regensburg in 1505, an event that was recorded in the town's books which described him as a painter from Amberg, about thirty miles to the north. Only about thirty works of his before 1510 (small panel paintings, engravings and drawings) are known. Nonetheless, at about this time he was awarded a commission by the emperor of the Holy Roman Empire to paint a large altarpiece for the church of St. Florian in the Austrian City of Linz.

Altdorfer, like a number of other famed Renaissance artists, was an architect and, in addition to his duties as provost and trustee of the Augustinian church, he served as superintendent of public buildings. In that capacity he oversaw the construction of several structures that still stand, though whether he designed them is not known. He also found time for politics, serving, among other offices, in the Outer Council from 1517, and the more prestigious and more powerful Inner Council after

1526. Nine years later he was designated as the city's representative to Ferdinand I, at that time king of Bohemia, in the capital city of Vienna. Obviously a man of some means, at various times he was owner of three different homes in Regensburg, and of other lands outside the town.

There is no doubt of the influence on Altdorfer by the renowned Albrecht Dürer, a dominant figure in German painting from nearby Nuremberg. It is possible that the most important influence was the many watercolors by Dürer of animals and plants seen by him on his extensive travels. Whether or not the impetus for landscape came in part from Dürer, Altdorfer far surpassed his mentor in that genre of art, if in no other. He left us no writings as to any thoughts he may have had about his works, or about painting or art in general. Hence we cannot know whether Altdorfer executed his landscapes with the aid of any conscious philosophy or conception of principles, or whether he was merely naively painting what appealed to him aesthetically, and what he intuitively saw as necessity.

Whatever the mental processes that underlay his finished product, it is certain that in his landscapes he saw nature as the subject, and (consciously or otherwise) grasped the fact that "nature as subject" does not necessarily exclude humanity; neither human figures, nor human handiwork, nor even references to its legends or symbolism. Both humanity and the trappings of its culture—whether a bridge, abandoned mill, castle, or ancient ruins—can be subsumed in the vast overpowering presence of an all-pervading nature. But nature, whether awesomely terrible in its savage beauty, or quietly breathtaking in its vast openness, accepts this human presence as but a part of itself, and on its terms. In true landscape it will not, however, accept demands that it be subservient to the human element. Altdorfer, as no one before him, saw nature from that perspective, and these principles informed his work.

Judgment as to the works most illustrative of this perception of nature is necessarily somewhat arbitrary, but two in particular are certainly among his finest. As early as 1510 came *St. George and the Dragon*, an oil on parchment (ILLUS. 31). Despite its title, the picture is assuredly not about St. George and the dragon. The absurdly small figures of the combatants serve only to heighten the frightening density of the impenetrable forest beside them. More than to the tiny figures, among whom the horse is the most imposing, our attention is diverted to the clearing behind the dragon, to the suggestion of a small lake and to the distant mountain. Though we know at once the legend to which the two diminutive figures refer, the painting serves only, intentionally or not, to trivialize it. Portrayal of the legend is not the purpose of the painting; there

ILLUSTRATION 31. *St. George and the Dragon*, by Albrecht Altdorfer. Bayerische Staatsgemäldesammlungen, Alte Pinokothek, Munich. 1510, oil on parchment attached to panel, 28.2 × 22.5 cm.

is no purpose except to represent the overpowering beauty of the dark forest. The density, and immensity, of the foliage seems emphasized more by the distant mountain than by the marginalized figures.

Altdorfer's *Landscape with Woodcutter,* ILLUS. 32, may not be the most interesting of his landscapes from every point of view, but as an illustration of the essence of the new genre of landscape painting, this work excels. Humanity and its trappings are much in evidence. There is a man, dwarfed by the tree under which he sits, but nonetheless quite visible. Hanging from the tree high above him is a small wooden structure, perhaps housing some religious symbols. The path to several houses in the distance goes discreetly around the tree, whether through respect or intimidation we cannot know, but about which we cannot help but wonder. But the painting is not about the man, or the small wooden structure in the tree, or the houses down the bend. It is about nature, to which man has accommodated himself. He has had to do so or he would not be permitted within the framework of this painting. As with *St. George and the Dragon,* this painting tells no story, has no moral, is not preaching to us or telling us how to live or how to order our lives. It depicts no particular aspect of the human condition and calls for neither pity for human suffering, nor anger at man's inhumanity to man. The features of the painting symbolize nothing, and they stand for nothing. They represent nothing but the profound beauty of the natural world.

Such simultaneous aloofness from the world of humans and admiration of nature could have come about only when humanity had distanced itself from nature and observed it from without. Absent an appreciation of the aesthetics of three dimensional perspective, it could never have happened. If we knew nothing of the history of the development of this type of landscape, we might be tempted to conclude that such adoration of nature caused the development of perspective. But perspective was perfected at least a century earlier, and during that century was used almost entirely to portray religious or other human symbols or beliefs and activities.

That it was distance between nature and observer that made landscape painting possible, or necessary as is sometimes said, has been almost universally acknowledged. But what is meant here by distance? Wood cites Matthias Eberle and a host of others, artists and art historians alike, who see the new genre of landscape painting in the Renaissance as resulting from a new physical detachment from the land.[2] Where the relationship between nature and human life is close and direct, say these authors, landscape painting is not necessary. As Wood puts it,

ILLUSTRATION 32. *Landscape with Woodcutter*, by Albrecht Altdorfer. Staatliche Museen zu Berlin—Kupferstichkabinett. Photograph Joerg P. Anders. Ca. 1522, pen, watercolor and gouache on paper, 20.1 × 13.6 cm.

Eberle's own "piety for nature" persists, and he, Eberle, "laments the alienation that drove the painter to paint a landscape." Phrased differently, because humanity was now alienated from nature, according to Eberle, and because it longed for that closeness to it, it now became necessary to paint it.

The implication is that men saw the same beauty in nature many centuries before the rise of landscape painting, but that there was no need to paint it since their lives were so very close to it. The history of art and the description of life in the Middle Ages tell us something different. From the beginning of art, humans have painted those things in which they saw beauty, or which aroused deep emotion in them. The cave artists could not have been closer to the animals among whom they lived and depended for food and clothing, yet they spent twenty-five thousand years painting and sculpting them. In later times men continued to paint that part of their surroundings that absorbed their interest, and they also wrote about it, often in emotion-laden verse. Before the Renaissance, humans were not absorbed with the natural world, however physically close they were to it. They were absorbed with the world of the spirit, one that would lead to a more ideal, more perfect world, namely, to the hereafter. This was not love of nature. This was fear of nature, an intellectualizing of nature, a conversion of it into symbols for something else, something more perfect, something it was not. That view of nature went hand in hand with the much-lamented "oneness" with it.

What caused the distance to arise between human life and nature? Some say explicitly, and others implicity, that it was the change in life from largely rural to life in towns and cities. For such a proposition there is scant evidence. Great landscape art is often painted by those who live in the rural areas they paint. For some it was the area of their birth. Others migrate to the outdoors to live in and to paint the landscape they love. But whether in cities or in the country, it is neither unknown or unusual for artists to paint that with which they are most familiar.

Landscape painting arose in the 16th and 17th centuries in small towns in southern Germany and in the low countries of northern Europe. In those centuries the shift in populations from country to city was hardly dramatic anywhere in Europe, and particularly not where landscape painting began. In the 17th century, the momentous rise of population centers was still a hundred years in the future. It was in the industrial age, beginning in the late 18th century, that the growth of cities dwarfed all that had come before. The previous spurts in population growth of cities had occurred in the 11th and 13th centuries, the earlier one occurring first in Italy, then in northern Europe. The later growth saw the rise of huge population centers such as Milan, London and Paris and the large

port cities of northern Germany and Scandinavia. Two and three hundred years later the landscapes began to come from the workshops of many artists; but they came from small villages in southern Germany, and in France, Italy and Holland, not from these large centers whose artists now, supposedly, felt alienated from the land.

What had happened to put distance between man and nature was a change in human perception that came from within. There was a change in the human psyche that may have had little to do with sociological or demographic change, or may have engaged in a symbiotic relationship with those factors, each reinforcing the creative impulse of the other. Whatever the cause, Altdorfer and his successors saw a beauty in raw nature that had not been seen before, just as Brunelleschi and Masaccio had seen beauty in the relationships between objects in a depth of field, that is, in three dimensions. Through the perfection of perspective in art, the only way to fully represent this new sense of beauty, it could be revealed to countless other artists and ultimately to the world at large. It was at this juncture that a new vision of the landscape, and landscape painting, was all but inevitable.

The misdirected longing for the "oneness with nature" and regret over the "alienation" of nature, factors that supposedly caused the painting of landscapes, are unequivocally rejected by Wood. He perceptively notes instead that "pictures themselves actually generate ideas about nature," and he buttresses his opinion with that of other art historians, such as Franz Winzinger, who suggests that the creation of representational art itself played an active role in the formulation of ideas about the cosmos. Further, Winzinger and Otto Benesch have both clearly implied that the coherence of representation in landscape art contributed to the concept of the unity of the physical world by the analogy of the one to the other.[3]

The importance of this perception can hardly be overemphasized. It signifies that the modern concept of a unified nature, the interrelation of the parts, in short, the entire scientific spirit of the modern age, arose at least in part from the beauty and the unity portrayed on the canvases of artists. The insight is similar to that of Oscar Wilde and his explanation that the "source" of the London fog was in literature. It stands in clear opposition to the frequent, unsupported claim that the new painting genre resulted from the advances in science and its concomitant comforts and separation of man from nature.

Lest any doubt linger about the larger meaning of this thesis, Wood, again citing Benesch and Winzinger, claims that "The early landscape transformed the beholder's religious piety into piety for nature," another corroboration for Harries' "secularization of the visible" but through landscape painting, not merely through three dimensional perspective.

ILLUSTRATION 33. *Hunters in the Snow*, by Pieter Bruegel, the elder. Kunsthistorisches Museum, Vienna. 1565. Oil on wood, 1.17 × 1.62 m. Vienna, believed to be December or January from a series of *The Months*.

Wood continues: "The rhetoric of the picture itself was capable of supplanting Christian iconography and installing a new subject."[4]

Changes in styles and genres of art, as in any other human endeavor, are never so seamless as they later appear. There are always precursors and retrogressions. Giotto may well be considered a precursor both to three dimensional painting and to landscape. Perspective was already the accepted style when Altdorfer appeared on the scene, but he may also be termed a precursor to landscape, at least to landscape as subject. This is so because nothing like his landscapes appeared again until about 1532, forty years after his last such work. Only then did landscape began to make its appearance as an accepted form of art for which there was significant demand.

One of the first to follow his lead was Pieter Bruegel the elder, born in the Netherlands in 1525, twelve years before the death of Altdorfer. He painted many magnificent works depicting the labors of the people of the villages of his native country, set against a background of the envi-

ronment in which they worked. In these, his natural backgrounds are displayed with the utmost realism. But importantly, from our perspective, on occasion he reversed the relationship. One example is a work completed just four years before his death in 1569, an oil painting, *Hunters in the Snow* (ILLUS. 33). The painting, however, is not about hunters in the snow. It is about a wind-swept, snow-covered landscape. Here it is the humans who are background, serving only to highlight the dominance of his jagged peaks, frozen rivers and ponds, and the evergreens that dot the plain.

At the end of the 16th century came similar landscapes by Annibale Carracci. Born in Bologna in 1560, he is acknowledged as the creator of the "classical" landscape and influenced many later artists, including Nicolas Poussin, the great French landscape artist of the 17th century. One of Carracci's finest examples of the genre is his *Landscape,* completed in 1590, which now hangs in the National Gallery in Washington, D.C. The outline of the distant city is blurred and, except on close observation, not visible. The fact that it is there at all merely emphasizes the clarity of the important features: the bent trees, the brush and the more

ILLUSTRATION 34. *The Stone Bridge*, by Rembrandt. Rijksmuseum, Amsterdam. Ca. 1638. Oil on wood, 29.5 × 42.5 cm.

distant, but more visible mountains. The small boat and smaller figures in it, placed in the foreground, serve again to emphasize the monumental presence of the natural features.

The rapid spread of this form of artistic expression throughout Europe beginning in the 17th century, the acceptance of its subject matter, and the growth of its popularity, are historical facts. Though no example is adequate to convey the ubiquity of this new art genre, two artists and at least one each of their paintings can hardly escape mention. The first is Peter Paul Rubens, the Flemish master, born in 1577, whose brilliant scenes of his native country influenced so many including later English landscape artists such as Reynolds, Gainsborough and Constable. Rubens' *Landscape with Sunset* was painted near the end of his sixty-three years. He was not, as often is claimed, the first to make landscapes a separate genre, but the depth of his works is such that the claim can be readily understood.

The other is Harmensz van Rijn, known to the world as Rembrandt born in 1606 in Leyden, Holland. He is renowned primarily for his portraits, particularly self-portraits. But his monumental genius is displayed in landscapes no less than in portraiture. His portrayals of nature, perhaps more than those of any of his contemporaries, display a unity of components that create an effect almost startling in their power. His output during the sixty years of his life earned him a place of honor among the half-dozen-or-so greatest names in art history. His oil on wood, *The Stone Bridge* (ILLUS. 34), is one of a large output of similar landscapes which, in addition to many other features that stand as signatures of his genius, display a striking unity of components.

The flow of brilliant landscapes continued, from all of Europe and America through the following years including the 20th century. The works and names of the plethora of landscape artists are a sufficient part of the art world's fabric to render even a partial listing superfluous. The pinnacle of a particular style of landscape, known as the "romantic," seemed to have been reached in the late 18th and 19th centuries, shortly after a dramatic change in the view of nature reflected in European literature. It was a change, as we shall now see, that did not come without controversy.

XVII

The Battle for Nature

Nature before the mid–17th century as a "waste land" and "blemish on the earth"; Thomas Burnet and the Sacred Theory of the Earth; Third Earl of Shaftsbury and Edmund Burke, and the idea of the sublime in nature; its occurrence chronologically prior to the industrial revolution and ease of travel; its relation to three dimensional landscapes in art.

It started in the mid–17th century. In the earlier Renaissance and in the Middle Ages, admiration was reserved for the cultivated, productive land; for meadows, crops, gardens, orchards and ponds, not for nature in the wild. There was a disdain for untamed nature but there was little reason to write much about it. It was generally understood and accepted that wilderness areas, mountains in particular, were wastelands, an unconscious supposition dating back to the earliest times, and literary mentions of such views were casual, almost incidental. Some mountain peaks in classical times were held sacred as religious symbols, abodes of gods, or of supernatural occurrences, but in Christian Europe mountains were generally considered a blemish on the earth and its "perfect" proportions.

Beginning in the mid–17th century, about a hundred years after the beginning of "pure" landscape paintings, there appear a number of writings containing a strident insistence on the lack of beauty in raw nature, and there seems an unmistakable defensiveness in it. Clearly, there was something to be defensive about, for others were now claiming to find a new feeling, a new emotion upon viewing the most wild, the most terrifying aspects of nature. As opposed to what was beautiful, they called it the sublime. But those who found it so were few, until late in that century. The rest might well have uttered the words that Ruskin put into the mouth of an imaginary contemporary viewing landscapes for the first time: "There is something strange in the minds of these modern people!"[1]

Until then, writes Christopher Thacker, only the cultivated part of nature was acceptable. He quotes Madelè de Scudéri, who wrote in 1669 that art embellishes nature; that palaces are more beautiful than caves; and that well-cultivated gardens are more pleasing than a barren waste.[2] In 1681 an English cleric and scientist, Thomas Burnet, in his *Telluris theoria sacra,* which he later translated into English as *Sacred Theory of the Earth,* illustrates a certain ambivalence and hesitation about the new feelings stirring within himself and English society at large. He mounted a vigorous defense of prevailing views. Neither the rugged, jagged shapes of mountains or the irregular, unsymmetrical shapes of coastlines could have been the primary creation by God, he insisted. On the contrary, they could only be signs of His displeasure with the world, being vestiges of that long-ago flood. This, he concluded, was a fallen world "from which much of God's original perfection, the smoothness and symmetry, has been lost."[3] His book became the catalyst for a controversy that raged for almost a hundred years.

He did indeed wax eloquent about the joy felt upon traversing the Alps and seeing before him both the rising peaks and the Mediterranean Sea. Significantly, though, the passage is omitted from his own English translation of the work. One of the first of more recent writers to focus on the change that had occurred in the 17th and 18th centuries was the English poet William Wordsworth. In a letter to a newspaper editor in 1844,[4] he commented that that exclamation of praise by Burnet, found in his original Latin edition, is the sole recorded example of its kind prior to certain rhapsodic language in a journal of the poet Thomas Gray. Gray was also writing about an Alpine journey, one he made in 1739, sixty-eight years after that of Burnet. Yet Gray himself, who has been called one of the first modern Europeans to appreciate wild and romantic scenery, is said to have been a half century in advance of English society in general.

If the conclusion of Wordsworth overstates the lack of enthusiasm for nature in the two centuries preceding his own, the exaggeration must be very small. The new feelings stirring within some of the more sensitive persons were the source of some inner turmoil to many of them. The contradictions felt by Burnet are evident elsewhere, and continued for many decades. The diaries of John Evelyn cover the latter half of the 17th century and almost a decade of the next.[5] In 1644 he wrote of his "pleasant" feelings upon penetrating the clouds of Monte Pientio in the Alps and entering a "most serene heaven." His diary's other comments on mountain scenery, however, are more accurately exemplified by his description of mountains as "heaps of rocks so strangely congested and broken as would frighten one with their horror and menacing postures."

Many others experienced no new emotions and felt no such ambiva-

lence at all. Gilbert Burnet, a Scottish bishop and contemporary, (no relative of Thomas Burnet), described the Alps as so high and irregular that they "cannot be the primary Productions of the Author of Nature: but are the vast Ruines of the first World which at the Deluge broke here into many inequalities."[6] It was the banks of Lake Lausanne that he found beautiful as they were so like a work of art; so evenly laid, and so well cultivated.

The persistence of this view of nature, and its aggressive defense by its proponents, continued through the end of the 17th and into the 18th century. John Locke, in his 1690 essay *Concerning Human Understanding*, is unequivocal. He tells us that our business on earth is to know only those things concerning our conduct and our relationships to each other. This, to him, means excluding "all those areas of the natural world which have no connection with man's social and ethical conduct." The naysayings, at times, were expressed with considerable vehemence. As late as 1775, Samuel Johnson, the English author and critic, could respond to those who expressed admiration for woodlands, lakes, hills and valleys in France, that he had never heard such nonsense: "A blade of grass is always a blade of grass, whether in one country or another."[7] What was important, said Johnson, was whether men and women in another country differed from those left behind. It has been noted that Daniel Defoe's Robinson Crusoe, in the second decade of that century, shows concern only with reproducing the trappings of his former middle-class life, but none whatever with the delights of the island, a subject treated only by Defoe's later imitators.

Mountains, writes Marjorie Nicolson, have been the subjects of the most lavish language by modern poets, but were for centuries described, if at all, "at best in conventional and unexciting imagery, at worst in terms of distaste and repulsion." They were often described as warts, blisters, or pockmarks on the earth, "wasteplaces of the world," with little meaning and less charm. James Howell, writing to his father of his journey through the Pyrenees Mountains in 1621, used just such language.[8] He described them as not so high and hideous as the Alps, but compared to the mountains in Wales they were as blisters are to abscesses, like pimples are to warts. Thus it could not have been the Lord who had carved out mountains, valleys, and ocean depths. For the Lord must certainly have been, as Nicolson put it, a "Classical Sculptor." Henry Moore would have agreed. Writing in 1655, he announced, "There is no one, save those as stupid as the basest of beasts who would not agree that a cube, a tetrahedron or an icosahedron had more beauty in them than any rude broken stone lying in the field or highways."[9]

But change was coming. Artists of uncommon perception and skill continued to capture, or better said, to create, sheer beauty on their can-

vases. Their power could not long be denied. Looking back on the history of human appreciation of wild nature, and on the remarkable transition in attitude, Thacker wrote in the late 20th century that this change was immense in its implications, its effects, and its ramifications, going far beyond a simple matter of what was deemed proper for painting or for poetry.[10] It was, he claimed, as vast a change as "any in the whole history of human attitudes," and that in addition to tastes in art it influenced attitudes in sexual, social and political affairs. He sees it as having occurred in the 18th century. Referring to several landscape paintings by masters of the previous one hundred and fifty years, he claims that to Aristotle they would have seemed unworthy of serious attention and would not have been considered as works of art.

It probably began earlier than the 18th century. In 1693, Richard Bentley, an outspoken critic and philologist, in an essay entitled *The Folly and Unreasonableness of Atheism,* seemingly in answer to Henry Moore and his cubes and tetrahedrons, claimed that "There is no universal reason that a figure by us called regular, which hath equal sides and angles, is absolutely more beautiful than any irregular one."[11] He rejected the notion of absolute standards of beauty residing in geometrical patterns, regularity or symmetry, as well as the claim of "deformity" in nature. That "deformity," said Bentley, is in the minds of men, and not in the things themselves. He saw an irreparable flaw in the construction of standards of beauty through the application of human reason, and the judgment of nature by those standards.

His was the expression of a thought not articulated since ancient, classical times; namely that beauty is not a determined by rational, logical thought, but rather is something perceived and recognized at once, a product of emotion, not of the intellect. This has become an often-repeated truism, similar in its language to that of psychologists describing the difference in functions of the hemispheres of the human brain.

Toward the end of the 17th century, the debate and uncertainty continued, but change that was permanent and deep was afoot. In 1688 John Dennis traveled the Alps and wrote to a friend who had asked for his description of the journey.[12] He and his entourage, he said, had walked to the very brink of an abyss where one stumble would mean the end of life. But experience also produced different emotions in him, which he described as a "delightful horror, and a terrible joy.... I was infinitely pleased, I trembled."

It was noted by Nicolson that his route through the Alps paralleled that taken by Thomas Coryat about seventy-five years earlier. She notes

also that "Terrified every moment, he [Coryat] experienced all the fear of later travelers, yet never for a moment their 'rapture' or 'ecstasy.'"

By the very early part of the next century the change in the prevailing view of nature, by at least a substantial minority of writers, was very much in evidence. This, no doubt, prompted much of the defense of the beauty of the products of culture as opposed to that of nature, which then invited equally vehement rejoinders. Such a rejoinder comes from Anthony Ashley Cooper, otherwise known as the Third Earl of Shaftesbury. His writings in the first two decades of the 18th century reveal a profound admiration for raw nature, and a rejection of the notion that it, or any aspect of it, could be the result of God's anger. Rather, he saw it as a vision, the study of which brings wisdom; the contemplation of which brings delight; and every aspect of which affords a more noble spectacle than all of art. He said, moreover, that "I shall no longer resist the passion in myself for things of a natural kind," where man has not "spoiled their genuine order by breaking in on that primitive state." He spoke of the rude rocks, the mossy caverns, the irregular unwrought grottos, and broken falls of waters as having a magnificence beyond "the formal mockery of princely gardens."[13]

His influence in England was great, and there were many followers and imitators. Clearly, the 18th-century mind was receptive to such feelings. Shaftesbury, says Thacker, more than any other, was the originator of the 18th-century concept of the sublime as opposed to the merely beautiful, the word so often used to describe the manicured gardens of the time, and which meant that which was regular and symmetrical, that which, in short, had been created by man. Inherent in this notion of the sublime was the belief in the "beauty of terror." It was a thought perhaps best articulated by Edmund Burke, the English statesman and political philosopher, in mid-century. Burke wrote his essay *On the Sublime and Beautiful* to make clear just such a distinction.[14]

It is astonishment, says Burke, that operates most forcefully to induce that passion caused by the great and the sublime. Astonishment, he described as "that state of the soul in which all motions are suspended with some degree of horror." Whatever excites ideas of pain and danger—that is, whatever is terrible—is a source of the sublime. It is the strongest emotion that the mind is capable of feeling because, he continues, ideas of pain are much more powerful that those of pleasure. No passion so effectually robs the mind of its power of reason as fear, for fear is an apprehension of pain or death and operates in a manner that resembles pain itself. Whatever causes us terror by looking upon it is sublime. According to Burke, many animals, though small, are capable of inducing ideas of the sublime because they arouse terror. Terror, he concludes, "is the ruling principle of the sublime."

It seems an apt explanation for the naively ecstatic description in the 23rd letter of St. Preaux to Julia in Rousseau's 1761 novel *La Nouvelle Héloise*. About the Alpine "vast cascades ... the tops of mountains ... the yawning abyss," she concluded that there were no words to express the "amazing variety, magnitude, and beauty of a thousand stupendous objects, the pleasure of gazing at an entire new scene ... and beholding, as it were, another Nature and a new world."[15]

Another source of the sublime, says Burke, is "Infinity."[16] Infinity fills the mind with that sort of "delightful horror" which is the most genuine effect of the sublime. Though there are hardly any objects that are truly infinite, when the eye cannot perceive a boundary, the object seems to be infinite and produces the same effects as if it were. This observation of Burke's is all the more interesting in light of the "aesthetics of the infinite," a new vision that arose in the 17th century, as it is described by Nicolson. She termed it an "aesthetic implicit in their response to grandeur, vastness, majesty"; a gratification in the richness and fullness of a universe man might not intellectually comprehend, but that nonetheless "satisfied his soul, fed his insatiability." This aesthetics of the infinite was first laid down by Englishmen, she writes, who "found themselves astounded yet enthralled by infinite space."[17]

One such astounded observer was Joseph Addison. In an essay aptly titled *Pleasures of the Imagination,* written in the first decade of the 18th century, he claimed that nothing could affect his imagination as much as the open sea. Even when calm, "the heaving of this prodigious bulk of waters" caused a very "pleasing astonishment." When it worked itself up into a tempest, however, revealing nothing to the far horizons but "foaming billows and floating mountains," it produced an "agreeable horror" he found impossible to describe.[18]

The main line of attack on traditional dogma was not always a frontal one extolling the newly discovered sublimities of nature. Because a major defense of the old world-view had been the utter uselessness of mountains and the irregularities of the earth, the proponents of the new feeling for nature often found it necessary to point up the folly of these arguments and the use to which these allegedly hideous aspects could be, and had been, put. Bentley, in a series of lectures in 1692 mocked those, such as Burnet, who would have the planet be as "elegant and round as a factitious globe represents it to be; everywhere smooth and equable and as plain as the Elysian Fields." He pointed to the ports and harbors, all the more useful the greater their inlets. A sorry bargain, he declared, to surrender them and their shelter from storms for the "imaginary pleasure of an open and straight shore."

Defending mountains may have been a touch more difficult, but equal to the task was Daniel Defoe, otherwise famed for his *Robinson Crusoe*. Interested as he was in commerce and shipping, he argued in 1713 that it was the dislocation of parts of the earth, the intervention of waters and the distortion of parts that are the causes as well as the assistants to the world's commerce. "As the sin of man once separated nations, commerce may bring nations more closely together and make man realize the interdependence of one upon the other."

By the late 18th century such arguments were unnecessary. Men were now looking at mountains and, as Nicolson puts it, "seeing them." The phrase calls to mind the essay of Wilde, that one does not "see" anything until one sees its beauty. The mountains were no longer repugnant, wrote Keith Thomas. They had been transformed into the "highest form of natural beauty and a reminder of God's sublimity."[19] The ancient view of nature had become history; the perceived supremacy of man-made beauty and of products of culture were now part of the past. The fertile and the symmetrical had given way to the wild and the irregular.

How, and why, did it happen?

It was not humanity's physical conquest of nature that brought it about. By the end of the 18th century, the triumph of "sublime" nature was complete. That two-hundred-year debate was over. But the conquest of nature by science and industry had hardly begun. The change was as Nicolson perceptively described it: "Genesis has given way to geology which in turn has led scientist and laymen to look at a new earth with different eyes."[20] As so often the case in human progress, many aspects of it go hand in hand, each influencing the other. Such a mutuality of cause is not altogether lacking between the new view of the sublime in nature and the rise of scientific enquiry. Yet, this acknowledged, it must also be observed that ease or comfort in travel had little or nothing to do with the new view of nature. As Nicolson has also noted:

> No matter how much roadways were improved in non-mountainous districts, how many more inns were built, mountain travel, as Gray's letters show, was no safer in 1739, when Gray and Walpole crossed the Alps, than it had been when Thomas Coryat made the same journey in 1610. Walpole's terror, indeed, was very similar to Coryat's.... Yet "terror" in the eighteenth–century sense of the word, was an integral part of the new aesthetic experience of men who sought a new language to express their mingled feelings of joy and awe.[21]

In the late 18th century, there was dawning a romantic age that would flower in the 19th. When the great landscapes of Turner, Girtin and Con-

stable were drawing paeans from critics and viewing public alike; when tourists, with imaginations fired by accounts of travelers and by landscape paintings of Italy, were flocking to the mountains; travel was still by horseback, or by horse-drawn carriages or wagons, or was done on foot. Ships were propelled by the same power they had used since early antiquity, the wind; the use of human muscle power and the day of the galley slave had ended on all but naval vessels.

Not until 1764 had the first step been taken toward a steam engine. Five years later one was used to propel a road carriage, but the contraption went nowhere and had no effect on transportation. It was 1783 before one was used successfully for any type of transportation by sea, an upstream journey of fifteen minutes on the Saône River in eastern France. James Watt, patented his steam engine in 1769, and for the balance of the century most progress was in America. Not until 1812 was a steamboat launched in Europe. By then, wild nature's dominance of the human imagination was complete.

The use of steam to propel an engine for pulling cars by rail was, from its infancy, a project of the 19th century. Not until the 3rd decade was its use in a commercial enterprise launched; not for another twenty or thirty years would it become an accepted mode of transportation. Until the end of the 18th century the automobile had never been dreamed of, and it did not become a practical reality until the end of the 19th and the advent of the internal combustion engine. The lowest of the Alpine passes is the Brenner Pass, between Innsbruck and Bolzano. No railroad crossed it until 1867. Only in 1772 was even the first carriage road built, long after the expressions of wonder voiced by Gray, Dennis and Addison.

And not all landscapes, it must be noted, involve high mountains or rugged terrain. Rubens and others of his time painted blindingly beautiful landscapes of the gentle sweep of their native Flemish land, land that was no more accessible to Rubens or Jacob Ruisdael in the 17th century than it had been to countless generations of artist before them.

As discussed in chapter XVI, it has been often claimed that humans were physically too close to the land to see it as something outside of themselves, as a separate entity, and thus able to better admire its beauty. But physical circumstances had little to do with it. The distance is a mental construct, not a physical one. Until the beginning of the 19th century, decades after the widespread popular comprehension of the new view of nature, reaping was done as it had been since Roman times: by a comb-like projection on a box pulled by oxen, or by sickle and scythe. The first improvement of consequence did not come until 1830. The loom had been used for weaving for about six thousand years before some modest improvements in 1733, and until the 19th century, the use

of power looms was virtually unknown. Not until the end of the 18th century did the cotton gin supersede the separation by hand of the cotton fiber from the seeds. Although the effects of electricity had been known since antiquity, and though theory and experimentation quickened after 1600, not until the development of the generator in 1831 was it put to practical application.

The great industrial revolution, involving the use of steam and complex machinery, the factory system, and technological inventions came gradually; but it may generally be said to have occurred between the mid-eighteenth and mid-nineteenth centuries, and, at that early time, only in England. It followed quickly in certain countries on the European continent, more slowly in others. The heated controversy that began with Thomas Burnet was essentially ending as the industrial age was beginning. Neither ease of travel nor distance from the land could have been the primary cause of the new prevailing view of nature. What was?

"What men see in nature," wrote Nicolson, "is a result of what they have been taught to see—lessons they have learned in school, doctrines they have heard in church, books they have read." Are we not entitled to ask how this new view came to the people who taught it in school, preached it in church, and wrote it in books? Her explanation fails even to account for her own observation concerning Dennis's "delightful horror" and "terrible joy." In clear contradiction of her own conclusions, she acknowledges that he had "an experience for which nothing in his training had prepared him."

If nothing in our training is necessary to prepare us for appreciation of the sublime in nature, how did it become so pervasive?

Could a major cause have been the perspective in art developed by the Renaissance artists, and the great landscapes they had been painting for a hundred years?

It has been argued by some that one-point perspective is no more realistic than any other kind; that we do not see anything from one view, or for one moment in time; that even if we stand stock still, our eyes are constantly wandering. We scan. Whether we are taking in a new city scene, or a panorama of mountains or the open sea, we scan. We do so whether it is with one motion of the body, one turn of the head, or one movement of the eyes only. This objection has been advanced particularly by those who extol the virtues of Chinese landscapes' moving eye-levels and focal points, as opposed to Renaissance single-point perspective.

How, they ask, can there be anything so very special in a perspective that shows us the world that we actually see with a rapid scan, by

capturing it with a fixity that is impossible in life? How can they show us the beauty in a scene that we see through eye movement, by showing us that scene as though viewed from one moment in time? Renaissance perspective, they argue, is but one way of painting, one possible view of the world among many, and no closer to realism than any other.

The answer is inherent in the question. What the Renaissance artist has done is to stop our roving eye. And it is precisely because he has done so that we, for the first time, see the way we do. It is because he has forced us to stop for one moment and to view—as we could never view in life—a vanishing point, a unity of space, a place where all of our sight-lines converge, or where we at least catch them in the act of converging. Insofar as the art of prior peoples shows us, and insofar as their litera-ture describes their vision for us, their roving eyes, even those of the ear-lier Chinese, could not see in unadorned nature the beauty that we see today.

And now, no matter how fast or how far our eyes rove, we take that vanishing point with us. No matter how many aspects of a scene we see with our moving eye, consciously or otherwise we see convergence; we see vanishing points—many, if not an infinity of them, or lines begin-ning to converge to them. We see forms and outlines that we never saw until artists showed them to us. Just as it was 19th-century artists of impressionism who showed us the fogs of London, it was the 16th-cen-tury artists of the Renaissance who lifted our eyes from the details of our surroundings. They showed us a larger whole rather than a smaller one, which is one of the defining features of the function of the right brain.

Apparently, something in the right brain of a few artists began to find pleasure in more than the details of the world around them. They began to find it in the outlines of a more vast and all-encompassing scene, an infinity of them in fact, which we see today as we scan the world through different eyes than did our ancestors before the 17th century. Three hundred years before the camera, Renaissance perspective cap-tured the world in a way not possible until the camera was invented. But the very mentality that contributed to the explosion of inventions begin-ning in the late 18th century, including the camera, was at least in part the handiwork of that perspective that first appeared in art.

XVIII

Evolution?

Prevailing belief that evolutionary change is too slow to have occurred in historical times; contrary evidence: genetic and cultural co-evolution, inheritance of "assimilated" characteristics, other evidence of rapid evolution in nature and in laboratories.

Although we now understand how one-point perspective showed us a new view of nature, we still do not know what made it possible for artists to first grasp and portray this view, nor why the viewers were then able to find pleasure in it.

Humans have long seen themselves as something special, first as the center of the universe, later as special creations in a master plan, something apart from "lower" animals. More recently, we may still see vestiges of a tenacious grip on that cherished mentality in our belief that evolution for humankind is over, that, whatever may have occurred over the millions of years of evolution, we have reached a stage where we now control our own destiny through our own will. Culture may now be the newest piece of floating driftwood on which to hold fast to our claim of uniqueness. In our obeisance to culture, we like to believe that we now hold the key to our development and our future. No doubt cultural forces have been at work here and will continue to be. But could there also be other, totally unconscious forces working with it? Could evolution of the human mind be a factor in this remarkable change?

If the development of a different response to nature and the ability to see new relationships in the visual field is truly an evolutionary step, it would certainly, in the overall picture of evolution, be a small one, though its consequences to human society might be large indeed. And if human behavior and feelings are governed at least in part by the individual's genetic makeup, which is now almost universally acknowledged, then evolutionary processes resulting in physical changes would, presumably, apply in equal measure to changes in those human attributes.

It seems entirely logical that some significant and long-lasting changes of that kind would have evolutionary underpinnings, as least in part. Any such argument is necessarily speculative, but no more so than all other theories put forth to date concerning this new human response to nature.

One major objection to suggestions of this sort, apart from the lack of necessity for further evolution for such adaptable minds, is that evolution is a very slow process, requiring eons, and cannot happen so quickly. But much evidence is starting to undermine that view. A look at recent discoveries in evolutionary biology is worthwhile.

Mention has already been made of the work of Lumsden and Wilson, evolutionary biologists, who have convincingly argued that human behavioral evolution can, in certain circumstances, be very rapid.[1] Such changes are often manifested as cultural traits. For any significant change of this nature they believe that fifty generations, or about a thousand years, is sufficient. They also suggest that with strong cultural pressure a biological, or evolutionary, basis may often underlie significant behavioral changes in human populations in ten generations, or only from two to three hundred years. Such changes result from widespread substitution of genetic combinations underlying a favorable, adaptive, trait for those of a less favorable one.

This view, though winning substantial support from biologists, is contrary to the view that has prevailed for over a century: that any evolutionary change results only from accidental and random mutations in the genes during procreation, and that those few changes that result in an adaptive advantage survive and become dominant in a population. The process requires many thousands of years, according to this doctrine, and therefore changes in human behavior over the last twenty-five or thirty-five thousand years could only have been purely cultural in nature. Changes in human behavior in modern times thus result only from freely-made choices, or environmental or historical pressures, the genetic underpinnings of behavior having been fixed during the ice ages at the latest.

Lumsden and Wilson reject such a view and believe that genetically-based behavioral evolution may have proceeded right into modern times, often requiring only two hundred to a thousand years to become dominant in a population. They speak of gene-culture coevolution, and rely on what biologists call "rules of epigenesis," which are rules governing human behavior formed by interaction between the genetic makeup and environmental pressures. The innovations of culture, even the inventions of the mind, are very much influenced by genetics, they claim, and a "feedback then occurs from culture to the genes." Then, they continue:

> The greater biological success of certain kinds of behavior causes the underlying epigenetic rules and their prescribing genes to spread

through the population. Genetic evolution proceeds in this manner, rendering future generations more likely to develop the particular forms of thought and behavior that imparted success during the earlier tests by natural selection.[2]

They claim that when behaviors are advantageous, the "genes tend to shift into different frequency distributions that prescribe epigenetic rules biased toward the new responses."

They are not alone in their belief that changes in behavior can, through various biological mechanisms, influence the genetic component and become heritable. Though differing in the processes they propose, many respected biologists reach the same result. Among them are Eva Jablonka and Marion Lamb.[3] They believe that epigenetic inheritance systems, such as those referred to by Lumsden and Wilson, enable individuals, even those with identical genetic underpinnings for a particular trait, to acquire and to transmit different physical or behavioral characteristics to their offspring. Edward Steele, an Australian immunologist, believes that heritable genetic change can occur rapidly through environmental factors, even in the first generation.[4] He further believes that such changes are possible in other anatomical systems including those portions of the brain governing behavior: "Persistent aspects of our behavioral patterns could select themselves into our germline," meaning that they could become heritable.

Hardly a few months pass without reports of new corroboration, both in experimental laboratories and in nature. These reports involve the very rapid evolution of characteristics well suited to a new environment or to other changed conditions; this is obviously inconsistent with the idea of an evolution caused only by random mutations, or mistakes, in genetic transmission. These changes occur too rapidly and are too adaptive to the new conditions to have occurred through blind chance.

Conrad Waddington was the first to apply to such changes the term "assimilated characteristics" rather than "inherited" ones, that latter term being anathema to many biologists. Waddington claimed that inherited changes sometimes result, not from new genetic material, but from the activation of previously inactive, or dormant, genes or genetic propensities.[5] He believed that living organisms possess much potential for genetic change, and that with appropriate environmental stimulation, the physical changes brought about can ultimately become heritable, manifesting in later generations even without such stimulation. His experiments involved changing, in various ways, the environment in which fruit flies lived, causing modifications in the bodily processes or in the physical

bodies themselves. In one instance, the flies developed four wings instead of two; in another, flies were developed without the usual cross veins. After breeding flies that exhibited such modifications, for twenty, fourteen, and twenty-one generations depending on the type, succeeding generations of flies exhibited the new characteristics from birth. The change persisted in a number of future generations even when bred in the normal medium, that is, without subjection to any of the unusual conditions that caused the change in the original flies.

In another experiment, guppies were removed from one pool in Trinidad that teemed with predators to another in which only one predator lived. In seven generations the transplanted guppies grew similar, in genetically controlled ways, to those guppies native to the new pool. They lived longer and had fewer litters, with fewer and larger offspring per litter. The scientists found the changes to be evolutionary, and expressed surprise that they had occurred many thousands of times faster than in uncontrolled nature as evidenced by fossils.[6] It was proof, according to one, that evolution can be very fast and in certain circumstances can occur in a single generation.[7] In still another experiment, lizards were transposed from one island in the Bahamas to other islands with shorter branches on the vegetation. In ten to fourteen years, the legs of new generations of lizards shortened, each in ways most advantageous to them, namely, in proportion to the length of the branches on the vegetation on each of the new islands.[8]

Concluding that evolution may not be slow or random as previously proposed, *Science* magazine reported in 2000 that Old World fruit flies, first known to have appeared in the New World in Chile in 1978, had spread to much of North America, and that a mere ten years later, biologists had found that the North American flies had grown longer wings than those of the South. The same difference was found between flies of northern and southern Europe.[9]

In October 2000, it was reported that the process of evolution, generally believed to be too slow to be seen in a human lifetime, may have been seen to begin, "not after centuries or millennia, but in just over 50 years." Salmon introduced into a lake near Seattle were found in 1992 to have developed into two different groups, each of which had ceased interbreeding with the other. Differences in breeding strategies had developed and investigation revealed that the groups had also developed "slight genetic differences."

The results were deemed similar to those found by Australian scientists in an experiment involving fruit flies and certain aspects of their courtship behaviors. These changes occurred in only nine generations, about six months. One of the experimenters with the salmon expressed the opinion that rapid evolution occurring through "isolated reproduction"

was probably not limited to fish and could probably be found in other organisms as well.[10]

A discovery featured in *Science News* magazine for June 2002 was termed an "Evolutionary Shocker."[11] It involved two studies that may offer an explanation for the "rapid bursts of body-plan changes" that are occasionally found in the fossil record, confounding the prevailing beliefs of most evolutionary theorists only in "small, gradual changes in a species over long periods." The work of the reporting scientists showed that the existence of a particular protein suppresses the effects of genetic mutations. When conditions change during development, the protein's activity is disrupted, allowing genetic variation that is normally concealed and inactive to emerge, become activated, and result in new and varied forms of a species. The researchers showed also that abnormalities in fruit flies deficient in this protein are inherited from generation to generation. As with all such changes, those that are adaptive will survive. The same results were shown to exist in plants, for example, mustard weed growing in soil containing an inhibitor of the protein in question. Some of the changes were adaptive, such as hairier roots that would improve the uptake of nutrients. As with the fruit flies, the new trait persisted even when the plants' production of the protein returned to normal. The effect of the protein is to permit more genetic variation than would otherwise be possible and to thus assist in the process of evolutionary change in response to the environment.

Another researcher reports ten instances of rapid evolution in primitive and other unicellular organisms, as well as in an insect and in a mouse.[12]

Compared to these physical and behavioral changes, the physiological changes in the human brain involved in creating pleasure in new mental relationships in the visual world seem minor indeed.

There appears, in the present state of the science, no way to definitively prove that evolution has played a role in the changes in mindset we have traced. The ultimate question is whether most humans today are born with something predisposing them to the sense of pleasure in perception of a larger whole (whether in nature or the human face), something that was not present at birth in prior generations. Though not subject to scientific proof, it appears from the foregoing researches that fortuitous changes in mental functioning may have enabled one or a few persons to see the world in a new light; that they may have further enabled some very few to portray this new vision on canvas, making it visible to many; and that this, and the heated controversy it provoked, may have focused the attention of many others. From what we have seen of the propensities of the right cerebral hemisphere, it seems not unlikely that any such occurrences may have been centered in that portion of the

brain. If those occurrences did indeed take place, then perhaps previously unexpressed genetic potential could have been activated in one or more ways described by these scientists, and resulted in the new worldview that ultimately found expression in both literature and science.

It is interesting that many who have studied the cause of the human love for landscape do in fact believe that there is a genetic basis for it. That love is universal enough that it seems difficult to believe otherwise. But, in accordance with the prevailing and accepted wisdom concerning the glacially slow rate of evolutionary change, they believe, according to Malcolm Andrews, that the genetic predisposition arose during the ice ages, perhaps 25,000 to 12,000 years ago.[13] They see it as having evolved when humans would have been obliged to survey the landscape to determine advantages for hunting and gathering, or for combat, "seeing the hunter's prey or hostile forces without being seen oneself." According to this viewpoint, a habitat such as the open savannah with clusters of trees would have translated into a greater sense of security, and a biological adaptation to it. The appeal of the landscape would have then been subsumed, according to this hypothesis, as an aesthetic one after the same needs for survival no longer existed.

It is food for thought, but many questions remain unanswered. What happened to this biologically-based love of landscape during the last 12,000 years, until its brief reappearance in classical times? What happened to it during the Middle Ages, or in the New World before Columbus? What survival value was there in the rugged mountains that were the subject of so many wonderful landscape paintings beginning in the 16th century? Why was natural, untamed nature neither painted nor described until, hesitatingly, in classical times, and ultimately, and so brilliantly, in the middle Renaissance? Why was there such love of manicured and cultured gardens even in the late Renaissance and until the romantic period of the late 18th and 19th centuries? To many, the idea of a genetic basis for any human condition that arose later than the ice ages is unthinkable; but it may be the answer.

XIX

The Final Vanishing Points

Aesthetics as motivating force for both artists and scientists;
goal of both to find unity in nature; search by scientists for
unity in all physical phenomena, and explanation by single
"theory of everything"; unity of purpose in science and in art
as comparable to artists' vanishing points.

Since the beginning of the 19th century, much has been written
about the apparent similarity between concepts of the world as expressed
by scientist on the one hand and by poets and other literary talents on
the other. In literature those concepts began at least two hundred years
earlier, with the great controversy stirred in part by Thomas Burnet and
his *Sacred Theory of the Earth*. By no later than the end of the 18th cen-
tury the great mass of the population, at least in western Europe and
America, were seeing nature though different eyes than were their ances-
tors. By the 19th century, writers and scientists alike spoke of the beauty
of nature and its functioning, all as encompassed in its invariable laws,
its constant motion, and in its unity, the interrelatedness of all of its
aspects. The fear of nature that had gripped the minds of most humans
over the millennia had given way to overpowering curiosity about its
functioning and the awesome forces that drove it. Biologists, zoologists,
botanists, and geologists delved into its myriad of mysteries.

"The 19th century is remarkable for its proliferation of new sciences
and sub-sciences," wrote J.A.V. Chapple, which ranged "from the study
of earthquakes ... to the study of rudimentary forms of life." He found
the relationship between the romantic poets and scientists "exception-
ally close." He noted that:

Both were concerned with the natural universe and tended to think
about it in similar ways. In such a freely speculative age, words like
motion, force and power were variously defined but their conceptual
importance was taken for granted and their fundamental unity asserted.[1]

Notions about evolution preceded Darwin by many decades. The rock-embedded conviction of humanity's special creation, its last refuge from the shredded concepts of the central place of the earth in the universe, was now beginning to crumble. Studies of the earth itself would lay the foundation for proof, in the early 20th century, of continental drift, and the consequent uplifting and eroding of mountains. Even the "everlasting" hills were no longer a bastion of permanence. The unity of the laws governing the natural universe was described in terms of awe by poets and scientists alike. That sense of unity in nature portrayed in three dimensional perspective left its handprints on the work of both.

Humanity no longer looked to gods nor even to a God who had created the universe, either to bring rain or to control natural disasters. The rain gods had become irrelevant, and God, for many, had set in motion irrevocable laws. The new gods, for others, blind and deaf to human prayers, were relationships, those relationships between the winds that blow from the seas, the moisture they carried, the rain and the snows on the mountains that fed the streams, the crops that the streams nourished, the constant movement of natural forces interacting with each other, and the total dynamic of nature.

Science had its harbingers early on. They came in the 16th and 17th centuries, and mighty harbingers they were. They constituted, for the most part, formulations of theories of the nature of the universe. Those theories were foundations of granite for the new age of science that would rise like new superstructures to heights visible to all. As early as the mid–16th century, the earth-centered Ptolemaic model of the universe, unchanged since the second century A.D., gave way to the revolving planetary system of Copernicus with its sun-based center, and its "ballet of the planets," including the earth as a participating member. By the second decade of the 17th century, the ballet was replaced. It had been constructed with perfect circles to conform with the ideas of Copernicus as to what the Creator would have done. It was modified by Kepler into a system of less perfect ellipses to conform to what was seen, yet be explained by more simple and more universal laws of physics.

Almost contemporaneously, Galileo applied the newly discovered magnifying glass to exploration of the heavens and nullified many beautiful mythologies by discovering, among much else, that the moon shone by reflected light of the sun, and that its imagined solitary inhabitant was comprised of mountain ranges. Several decades later, in the 1660s, Sir Isaac Newton described through mathematics, the language in which "God had written the universe," how his principle of gravitation explained both the laws of physics and those of astronomy, and how falling bodies on earth obeyed the same universal principles as did the movement of heavenly bodies in the far reaches of space.

These new scientific theories themselves had little impact on the thinking or the lives of the larger mass of humanity. They did little to imbue the people of the workaday world with the sense of beauty to be found in nature. The extent to which such unity of natural forces as proved by Newton impacted the works of poets and writers cannot be measured, though it certainly existed. The construction of the scientific edifice seemed to stop with theory in that century.

The great discoveries and formulations of natural laws reached a point of stasis. For almost a hundred years, through most of the 18th century, advances in sciences were halting and, for the most part, minor. While the arcane literary battle raged over the questions of the nature of beauty and the beauty of nature, no great breakthroughs were forthcoming in science. Only in the late 18th century did the great Industrial Revolution break, for once and for all time, the barrier between humanity and the workings of nature.

Tess Cosslett has recently written of the 19th century that "Scientific writers, novelists and poets can all be found putting forward similar views of humanity, society and nature, often by means of similar language and imagery." As she also points out, influence between science and literature can work in either direction. But, she says, the direction in which the influence worked is less important than the manner in which scientists and writers are expressing "shared values and assumptions."[2]

True enough. Obviously by the 19th century there was something in the air affecting the thinking of both science and creative literature. But Cosslett mentions neither perspective in art nor the triumph of the notion of the sublime in nature, both occurring well before the emergence of these shared values and assumptions. Three dimensional perspective and the vanishing point were already the central facts of life in contemporary art, and the splendid scenes of nature they made possible were readily available to millions.

Both artists, since the beginning of the Renaissance, and scientists look for unity in nature. Further, there seems little doubt but that aesthetics drives the great scientific discoveries hardly less than it does the work of artists. Brian Greene has recently stated it well:

> Physicists must make choices and exercise judgments about the research direction in which to take their partially completed theory.... But it is certainly the case that some decisions made by theoretical physicists are founded upon an aesthetic sense—a sense of which theories have an elegance and beauty of structure on par with the world we experience.... So far this approach has provided a powerful and insightful guide.[3]

In the first decades of the 20th century, Jules Henri Poincaré, the great French mathematician, said much the same thing in perhaps more elegant words:

> The scientist does not study nature because it is useful; he studies it because he delights in it, and he delights in it because it is beautiful. If nature were not beautiful it would not be worth knowing.... I mean that profounder beauty which comes from the harmonious order of parts.[4]

"Harmonious order of parts"—this testimonial to science came more than half a century before the researches into the functioning of the human brain's right hemisphere and the use by psychologists and neurologists of just such phraseology to describe its special talents. We have also heard from Jerre Levy who similarly credits the impetus for scientific investigation to "the construction of beauty from the raw materials of nature." The annals of the giants of 20th-century science are filled with powerful corroboration.

Three of the greatest, Neils Bohr, Albert Einstein and Werner Heisenberg, have each credited the power of intuition and aesthetics in the formulation of their theories.[5] Robert Wilson, the discoverer of background radiation, explicitly acknowledged that science's description of nature is based on aesthetic decisions.[6] James Maxwell, who formulated the laws governing the relationship between electricity and magnetism, claimed to have based his insights partly on aesthetics, for the reason that he found nature to be "beautiful and elegant."[7] And Paul Dirac, Nobel Prize winner for his relativistic, quantum-mechanical description of the electron, wrote that "It is more important to have beauty in one's equations than to have them fit experiment."[8] If he exaggerates, it is but little.

Modern scientists have their own vanishing point. It is that point, at present a still elusive one, where a single set of laws, or formulas, describes all the known phenomena of the physical world. There is at present no hard evidence that there is such a unity. But scientists cannot accept that there is one set of laws or formulas, the laws of relativity, to describe those gigantic objects of the cosmos known as planets, stars and galaxies and their movements through indescribably vast reaches of space; and another set of laws or formulas, those of quantum mechanics, to describe the behavior of the incredibly small bodies that comprise the subatomic world of electrons and exotically named smaller particles, the muons, gluons, quarks and neutrinos. The most brilliant scientists of our time are working almost furiously to find the single "theory of everything," as they call this undiscovered law, the formula that will describe all motion of all bodies in the universe. According to these

scientists, there *must* be such a law, and they refuse to accept that there can be one law for the unimaginably small and another for the unimaginably large.

The scientists feel there is a point in the distance, if one looks far enough or deep enough, where those things that seem different on the surface merge into one. They have found a unity of three of the four fundamental forces they see in the world: the strong and weak nuclear forces and electromagnetism. They are explained and thus united by the laws of quantum mechanics. But the fourth force, gravity, has not yet been found to fit into that scheme and is seen to stand alone in the universe, described only by the general theory of relativity. Somewhere, these scientists are certain, there must be some place in the depths of nature's mysteries where it all comes together. In the beginning of time, they are convinced, the four were undifferentiated, all one. We are seeing, they insist, four aspects of the one primeval force.

They have come a long way from the ancient wise men who saw a plethora of gods controlling each individual aspect of nature. So imbued is the modern mind with the the necessity for an absolute unity and interrelatedness in nature, that we cannot abide the thought of two sets of rules unrelated to each other. And those of us who have no concept of what these scientists are actually doing, and very little of what they are saying, nonetheless, through uninformed intuition, agree wholeheartedly with their quest for a theory of everything. To think otherwise does violence to what seems our inherent nature, our psyche, even if the unthinkable otherwise is actually true. We believe in a unity in nature as we do in art.

Perhaps there is an even deeper vanishing point, one where art meets science. Perhaps these two human endeavors that seem so firmly separate on most levels do in fact meet on some deeper one. It would be that point where there comes together the unshakable belief of both scientists and artists in the unity of nature and the interrelatedness of its parts. It seems to be one for which the ancient Greeks were reaching before history intervened. Whether its conquest of the modern world occurred through changing cultural or historical conditions alone, or through, at least in part, a change in the physiology of the human brain, cannot yet be definitively said. If an evolutionary step is involved, it would be one tiny in scope, though huge in its manifestations. But if the process of its emergence is uncertain, the perception of those vanishing points is not. It has become the dominating influence on the human outlook in modern times.

Chapter Notes

Chapter II

1. H. Schäfer, *Principles of Egyptian Art*, xxvii–xxviii, quoting E.G. Kolbenheyer.
2. Ibid., 37; S. Giedion, *The Eternal Present*, 6.
3. L. Wright, *Perspective in Perspective*, 14–17.
4. A.G. Miller, *The Mural Painting of Teotihuacán*, 25.
5. W. Worringer, *Abstraction and Empathy*, 7. 8, 14, 15, 18, 19, 39; *Egyptian Art*, 82, 83.

Chapter III

1. N. Geschwind, "Specializations of the human brain."
2. J.L. Bradshaw and N.C. Nettleton, *Human Cerebral Asymmetry*, 38.
3. R. Joseph, *The Right Brain and the Unconscious*, 34–35.
4. R.B. Ivry and L.C. Robertson, *The Two Sides of Perception*, 18–57.
5. R.D. Laing, *The Divided Self*, 72.
6. J. Cutting, *The Right Cerebral Hemisphere and Psychiatric Disorders*, 85–86.
7. J.F. Iaccino, *Left Brain–Right Brain Differences*, 66, fig. 4.4.
8. N.N. Nikolaenko et al., "Representation activity of the right and left hemispheres of the brain."
9. R.M. Bauer, "Visual hypoemotionality as a symptom of visual-limbic disconnect in man."
10. M. Habib, "Visual hypoemotionality and prosopagnosia associated with right temporal lobe isolation."

Chapter IV

1. H. Hufschmidt, "Das Rechts-Links-Profil im kulturhistorischen Längsschnitt."
2. S. Coren and C. Porac, "Fifty centuries of right-handedness: The historical record."
3. K.D. Schick and N. Toth, *Making Silent Stones Speak*, 140–142.
4. H. Schäfer, *Principles of Egyptian Art*, 300, quoting A. Erman.
5. Ibid., 272.
6. O. Grüsser et al., "Cerebral Lateralization and Some Implications for Art."
7. C.J. Lumsden and E.O. Wilson, *Genes, Mind and Culture*, 1, 75–79, 295–301.

Chapter V

1. J. White, *The Birth and Rebirth of Pictorial Space*, 251.
2. Ibid., 249–262.
3. Ibid., 258, 259.
4. G. Richter, *Perspective in Greek and Roman Art*, 52, 53.
5. Ibid., 61.

Chapter VI

1. K. Harries, *Infinity and Perspective*, 83.
2. O. Wilde, "Nature's Imitation of Art."
3. J. Levy, "Cerebral asymmetry and the aesthetic experience."

Chapter VII

1. M.P. Nilsson, *Greek Folk Religion*, 4.
2. A. Biese, *The Development of the Feeling for Nature in the Middle Ages and Modern Times*, 17.
3. H.R. Fairclough, *Love of Nature Among the Greeks and Romans*, 12–13; Introduction by Gilbert Murray.
4. M.P. Nilsson, *Greek Folk Religion*.
5. A. Biese, *The Development of the Feeling for Nature in the Middle Ages and Modern Times*, 3.
6. G. Soutar, *Nature in Greek Poetry*, 11, 56.
7. Ibid., 47.
8. Ibid., 3.
9. Ibid., 57.
10. T. Andersson, *Early Epic Scenery*, 15–32, 45–52, 152.

Chapter VIII

1. J.P. Keenan et al., "Self-recognition and the right hemisphere," "Self-recognition and the right prefrontal cortex," "Left hand advantage in a self-face recognition task," "Hand response differences in a self-face identification task."
2. Gordon Gallup, Jr., as quoted in web site of Drkoop.com, Jan 20, 2001, commenting on the article by Keenan in *Nature*.
3. C. Pfluger, "Progress, Irony and Human Sacrifice," 67–68.
4. M.L. Hoffman, "Interaction of affect and cognition in empathy."
5. M.A. Wheeler et al., "Toward a Theory of Episodic Memory: The Frontal Lobes and Autonoetic Consciousness."
6. K.J. Meador et al., "Anosognosia and asomatognosia during intracarotid amobarbital inactivation"; T.E. Feinberg et al., "Verbal asomatognosia."
7. M.A. Wheeler et al., "Toward a Theory of Episodic Memory: The Frontal Lobes and Autonoeic Consciousness."
8. C. Gill, *Personality in Greek Epic, Tragedy, and Philosophy*.
9. Ibid., 333.
10. C. Pelling, *Conclusion, in Characterization and Individuality in Greek Literature*, 245–262.

11. J. Hatzfield, *History of Ancient Greece*, 74.

Chapter IX

1. D.M. Tucker, "Lateral Brain Function, Emotion and Conceptualization"; D.M. Tucker and P.A. Williamson, "Asymmetric Neural Control Systems in Human Self-Regulation."
2. K.D. Schick and N. Toth, *Making Silent Stones Speak*, 263, 267, 283.
3. G.H. Luquet, *The Art and Religion of Fossil Man*, 28.
4. E. Winner and H. Gardner, "The Comprehension of Metaphor in Brain-Damaged Patients."
5. H.H. Brownell, "Appreciation of Metaphoric and Connotative Word Meaning by Brain-Damaged Patients."
6. N.S. Foldi, "Appreciation of Pragmatic Interpretations of Indirect Commands: Comparison of Right and Left Hemisphere Brain-Damaged Patients."
7. J. Tigay, *The Evolution of the Gilgamesh Epic*, 161–167.
8. B.W. Stanford, *Greek Metaphor: Studies in Theory and Practice*, 28.
9. D. Steiner, *The Crown of Song: Metaphor in Pindar*, 149.
10. P. Ricoeur, *The Rule of Metaphor*, 25
11. R. Alter, *The Art of Biblical Poetry*, 189–190.
12. J. Gabel and C. Wheeler, *The Bible as Literature*, 24.
13. M.E. Chase, *Life and Language in the Old Testament*, 147, 157, 171–183.
14. W. Yip, *Chinese Poetry*, 44.
15. A. Birrell, *New Songs from a Jade Terrace*, 5, 17.
16. Aeschylus, *Seven Against Thebes*; *Agamemnon*.

Chapter X

1. W. Schmalenbach, "Toward an aesthetic of Black African art," 17.
2. V.G. Childe, *The Aryans*, 208.
3. W. Schmalenbach, "Toward an aesthetic of Black African art," 17.
4. P. Kelemen, *Medieval American Art*, 1.

5. P. Ekman, "About brows: Emotional and conversational signals," 202.
6. J. Cole, *About Face*, 47.
7. S. Baron-Cohen, *Mind Blindness: An Essay on Autism and Theory of Mind*, Chapter 7.
8. R. Carpenter, *Greek Sculpture: A Critical Review*, 36.
9. C.M. Havelock, *Hellenistic Art*, 17. 21–23.

Chapter XI

1. A. Geike, *Love of Nature Among the Romans*, 166.
2. Webster, T.B.L., *The Art of Greece: The Age of Hellenism*, 149.
3. A. Geike, *Love of Nature Among the Romans*, 283.
4. Ibid., 317.
5. T. Andersson, *Early Epic Scenery*, 53–57, 158.

Chapter XII

6. F.P. Chambers, *The History of Taste*, 3, 7.
7. H. Gardner, *Art Through the Ages*, 265, 269.
8. A.J. Gurevich, *Categories of Medieval Culture*, 86, 87.
9. O.M. Dalton, *Byzantine Art and Archaeology*, 244, quoted in D. Pearsall and E. Salter, *Landscape and Seasons of the Medieval World*, 28.
10. A. Biese, *The Development of the Feeling for Nature in the Middle Ages and Modern Times*, 94.
11. A.J. Gurevich, *Categories of Medieval Culture*, 62.
12. W. Morris, *Song of the Volsungs and the Nibelungs*.
13. M. Magnusson and H. Pálsson, trans., Njáls saga.
14. M. Magnusson and H. Pálsson, trans., Laxdæla saga.
15. A.J. Gurevich, *Categories of Medieval Culture*, 52.
16. G. Soutar, *Nature in Greek Poetry*, 56.
17. A. Biese, *The Development of the Feeling for Nature in the Middle Ages and Modern Times*, 66–67.
18. A.J. Gurevich, *Categories of Medieval Culture*, 67.

Chapter XIII

1. J.L. Martínez, *Nezahualcóyotl*, 123–133.
2. M. Leon-Pórtilla, *Pre-Columbian Literature of Mexico*, 76.
3. E. Kitzinger, *Early Medieval Art in the British Museum*, 5, 6.
4. J. Burckhardt, *The Civilisation of the Renaissance in Italy*, 129, 308.
5. E. Cassirer, *The Renaissance and the Cosmos in Renaissance Philosophy*.
6. M.M. Bakhtin, *Rabelais and His World*, chapters 5, 6.
7. D. de Rougemont, *Love in the Western World*, 7.
8. A. Wiedemann, *Popular Literature in Ancient Egypt*, 6.
9. F. Goldin, *The Mirror of Narcissus in the Courtly Love Lyric*.

Chapter XIV

1. G. Kuwayama, *Introduction, to Japanese Ink Painting*, 15.
2. L. Wright, *Perspective in Perspective*, 305.
3. L. Binyon, *Flight of the Dragon*, 63.
4. Ibid., quoting Shên Kua.
5. Ibid., 11–12.
6. Ibid., 10–11; O. Sirén, *The Chinese on the Art of Painting*, 18–19.
7. O. Sirén, *The Chinese on the Art of Painting*.
8. M. Sullivan, *The Birth of Landscape Painting in China*, 5.
9. S.E. Lee, *Chinese Landscape Painting*, 5.
10. M. Sullivan, *The Birth of Landscape Painting in China*, 5, 6.

Chapter XV

1. J.A. Aiken, "The perspective construction of Masaccio's Trinity fresco and Medieval astronomical graphics."

Chapter XVI

1. C.S. Wood, *Albrecht Altdorfer and the Origins of Landscape*.
2. Ibid., 26–27.

3. Ibid.
4. Ibid., 27.

Chapter XVII

1. Quoted and cited in M.H. Nicolson, *Mountain Gloom and Mountain Glory*, 4.
2. C. Thacker, *The Wildness Pleases*, 12.
3. T. Burnet, *The Sacred Theory of the Earth*.
4. M.H. Nicolson, *Mountain Gloom and Mountain Glory*, 17–18.
5. Ibid., 61–62.
6. Ibid., 225–226.
7. C. Thacker, *The Wildness Pleases*, 7–8.
8. M.H. Nicolson, *Mountain Gloom and Mountain Glory*, 61.
9. H. Moore, *An Antidote Against Atheism*, 93, quoted in K. Thomas, *Man and the Natural World*, 257.
10. C. Thacker, *The Wildness Pleases*, 1.
11. M.H. Nicolson, *Mountain Gloom and Mountain Glory*, 262.
12. Ibid., 276–279.
13. Ibid., 299–300.
14. E. Burke, *On the Sublime and Beautiful*, 95–125.
15. E. Biese, *The Development of the Feeling for Nature in the Middle Ages and Modern Times*, 276, quoting Rousseau, *La Nouvelle Héloïse*.
16. E. Burke, *On the Sublime and Beautiful*, 128–134.
17. M.H. Nicolson, *Mountain Gloom and Mountain Glory*, 132–143.
18. Ibid., 306–307.
19. K. Thomas, *Man and the Natural World*, 260.
20. M.H. Nicolson, *Mountain Gloom and Mountain Glory*, 368.
21. Ibid., 26.

Chapter XVIII

1. C. Lumsden and O.E. Wilson, *Genes, Mind and Culture*, 1, 75–79, 295–301; "Précis of Genes, Mind and Culture."

2. C. Lumsden and O.E. Wilson, *Promethean Fire*, 153–154.
3. E. Jablonka and M.J. Lamb, *Epigenetic Inheritance and Evolution: The Lamarckian Dimension*, 26, 31.
4. E.J. Steele, *Lamarck's Signature*, 3–8, 22, 26, 167–169, 197, 205; *Somatic Selection and Adaptive Evolution*, 15–57, 56, 90–96.
5. C.H. Waddington, *The Evolution of an Evolutionist*; 59–95; "Evolutionary Adaptation."
6. D.N. Reznick et al., "Evaluation of the rate of evolution in natural populations of guppies."
7. V. Morell, "Predator-free guppies take an evolutionary leap forward," quoting Philip Gingerich.
8. J.B. Losos et al., "Adaptive differentiation following experimental island colonization in Anolis lizards."
9. R.B. Huey et al., "Rapid Evolution of a Geographic Cline in Size in an Introduced Fly."
10. C.K. Yoon, "Scientists' Hopes Raised for a Front-Row Seat to Evolution."
11. J. Travis, "Evolutionary Shocker?"
12. O.E. Landman, "The inheritance of acquired characteristics."
13. M. Andrews, *Landscape and Western Art*, 18–20.

Chapter XIX

1. J.A.V. Chapple, *Science and Literature in the Nineteenth Century*, 20.
2. T. Cosslett, *The "Scientific Movement" and Victorian Literature*, 3.
3. B. Greene, *The Elegant Universe*, 166–167.
4. H. Poincaré, *The Foundations of Science*, cited by J. Levy, Beauty and the Brain.
5. J. Wechsler, *Introduction to Aesthetics in Science*, 5.
6. R. Wilson, "Interview with Linda Dackman."
7. C. Sagan, *The Demon Haunted World*, 389.
8. P. Dirac, "The Evolution of the Physicist's Picture of Nature," quoted in *Aesthetics in Science*, ed. J. Wechsler, 5.

Bibliography

_____. *Seven Against Thebes.* Trans. E.D.A. Morshead. London: Macmillan, 1908.

_____. *Agamemnon.* Trans. E.D.A. Morshead. London: Macmillan, 1904.

Aiken, Jane Andrews. "The perspective construction of Masaccio's Trinity fresco and Medieval astronomical graphics." In *Masaccio's Trinity,* Rona Goffen, ed., 90–106. Cambridge, Mass.: Cambridge University Press, 1998.

Alberti, Leon Battista. *On Painting.* Trans. John Spencer. London: Routledge & Kegan Paul, 1956.

Alland, Alexander Jr. "Affect and aesthetics in human evolution." *The Journal of Aesthetics and Art Criticism* 47.1 (winter 1989), 1–14.

Alter, Robert. *The Art of Biblical Poetry.* New York: Basic Books, 1985.

Andersson, Theodore M. *Early Epic Scenery.* Ithaca, N.Y.: Cornell University Press, 1976.

Andrews, Ian. *Pompeii.* Cambridge, Mass.: Cambridge University Press, 1978.

Andrews, Malcolm. *Landscape and Western Art.* New York: Oxford University Press, 1999.

Andronikos, Manolis. "The Royal Tombs at Aigai (Vergina)." In *Philip of Macedon,* M. Hatzopoules and L. Loukopoulos, eds., 188–231. Athens: Ekdotike Athenon, 1980.

Bakhtin, M.M. *Rabelais and His World.* Trans. Helene Iswolsky. Bloomington: Indiana University Press, 1984.

Baron, Hans, *In Search of Florentine Civic Humanism, Vol I,* Princeton: Princeton University Press, 1988.

Baron-Cohen, Simon. *Mindblindness: An Essay on Autism and Theory of Mind.* Cambridge, Mass.: The MIT Press, 1995.

Batson, C. Daniel, et al. "Is empathetic emotion a source of altruistic motivation?" *Journal of Personality and Social Psychology* 40.2 (1981), 290–302.

Bauer, Russell M. "Visual hypoemotionality as a symptom of visual-limbic disconnection in man." *Archives of Neurology* 39 (1982), 702–708.

Beck, James. *Masaccio: The Documents.* Locust Valley, New York: J.J. Augustin, 1978.

Bennett, Bonnie A., and David G. Wilkins. *Donatello.* Oxford, England: Phaidon Press, 1984.

Bernal, Ignacio. *Mexican Wall Paintings.* New York: New American Library of World Literature, 1963.

Biese, Alfred. *The Development of the Feeling for Nature in the Middle Ages and Modern Times.* London: George Routledge & Sons, 1905.

Binyon, Laurence. *The Flight of the Dragon.* London: John Muray, 1911.

Birrell, Anne. *New Songs from a Jade Terrace.* London: George, Allen & Unwin, 1982.

Boomsa, Dorret, et al. "Genetics of electrophysiology: Linking genes, brain and behavior." *Current Directions in Psychological Sciences* 6.4 (August 1997), 106–110.

Bradshaw, J.L., and N.C. Nettleton. *Human Cerebral Asymmetry*. Englewood Cliffs, N.J.: Prentice Hall, 1983.

Breasted, J.M. *The Conquest of Civilization*. New York: Harper and Row, 1926.

Brown, Philip R. *Authentic Individualism*. Lanham Maryland: University Press of America, 1996.

Brownell, Hiram H. "Appreciation of Metaphoric and Connotative Word Meaning by Brain-Damaged Patients." In *Right Hemisphere Contributions to Lexical Semantics*, Christine Chiarello, ed., 19–31. Berlin: Springer Verlag (1988).

Burckhardt, Jacob. *The Civilisation of the Renaissance in Italy*. Authorized trans. S.G.C. Middlemore. London: Swan Sonnenschein, 1898.

Burke, Edmund. *On the Sublime and Beautiful*. (Originally published London: 1756) Charlottesville, Virginia: Ibis, n.d.

Burnet, Thomas. *The Sacred Theory of the Earth*. Carbondale, Ill.: Southern Illinois University Press, 1965.

Cahill, James. *Chinese Painting*. New York: Rizzoli, 1977.

Cairns, John, et al. "The origin of mutants." *Nature* 335 (8 September 1998), 142–145.

Carli, Enzo. *The Landscape in Art*. Trans. Mary Fitton. New York: William Morrow, 1980.

Carpenter, Rhys. *Greek Sculpture: A Critical Review*. Chicago: The University of Chicago Press, 1960.

Carroll-Spillecke, Maureen. *Landscape Depictions in Greek Relief Sculpture*. Frankfurt am Main: Peter Lang, 1985.

Cassirer, Ernst. *The Renaissance and the Cosmos in Renaissance Philosophy*. New York: Harper & Row, 1963.

Chambers, Frank P. *The History of Taste*. New York: Columbia University Press, 1932.

Chapple, J.A.V. *Science and Literature in the Nineteenth Century*. Hampshire: Macmillan Education, 1986.

Chase, Mary Ellen. *Life and Language in the Old Testament*. New York: W.W. Norton, 1955.

Childe, V.G. *The Aryans*. New York: Dorset Press, 1978.

Clark, Kenneth. "Leon Battista Alberti on Painting." *Proceedings of the British Acadamy*, vol. 30. London: Oxford University Press, 1944.

Cole, Jonathan. *About Face*. Cambridge, Mass.: The MIT Press, 1998.

Conway, Martin A., and David J. Turk. "A Positron Emission Tomography (PET) Study of Autobiographical Memory Retrieval." *Memory* 7.5/6 (1999), 679–702.

Cook, William R., and Ronald B. Herzman. *The Medieval World View*. New York: Oxford University Press, 1983.

Coren, Stanley, and Clare Porac. "Fifty centuries of right-handedness: The historical record." *Science* 198 (November 1977), 631–632.

Cosslett, Tess. *The 'Scientific Movement' and Victorian Literature*. New York: St. Martin's Press, 1982.

Cornford, F.M. *From Religion to Philosophy*. (Originally printed London: Edward Arnold, 1912) Princeton: Princeton University Press, 1991.

Cutting, John. *The Right Cerebral Hemisphere and Psychiatric Disorders*. Oxford, England: Oxford University Press, 1990.

Dalton, O.M. *Byzantine Art and Archaeology*. Oxford: Oxford University Press, 1911.

Deiss, Joseph Jay. *Herculaneum*. New York: Harper & Row, 1985.

De Kerckhove, Derrick. "Critical brain processes involved in deciphering the Greek alphabet." In *The Alphabet and the Brain*, Derick De Kerckhove and Charles J. Lumsden, eds., 401–402. Berlin: Springer Verlag, 1988.

De Silva, Anil. *Chinese Landscape Painting*. London: Methuen, 1967.

Dirac, Paul A.M. "The Evolution of the Physicist's Picture of Nature." *Scientific American* (May 1963), 47.

Edgarton, Samuel. *The Renaissance Rediscovery of Linear Perspective.* New York: Basic Books, 1975.

Eimerl, Sarel. *The World of Giotto.* New York: Time Incorporated, 1967.

Ekman, Paul. "About brows: Emotional and conversational signals." In *Human Ethology,* M. von Cranach et al., eds. Cambridge: Cambridge University Press, 1979.

_____. "Expression and the nature of emotion." In *Approaches to Emotion,* Klaus R. Scherer and Paul Ekman, eds. Hillsdale, N.J.: Lawrence Erlbaum, 1984.

_____. *The Face of Man: The Expressions of Universal Emotions in a New Guinea Village.* New York: Garland STN Press, 1980.

_____. *Telling Lies.* New York: W.W. Norton, 1992.

_____, and Wallace V. Freisen. *Unmasking the Face.* Englewood Cliffs, N.J.: Prentice-Hall, 1975.

Fairclough, Henry Rushton. *Love of Nature Among the Greeks and Romans.* New York: Longmans, Green, 1930.

Fanelli, Giovanni. *Brunelleschi.* Trans, Helene Cassin, Florence: Scala Books, 1980.

Feinberg, Todd E., et al. "Verbal asomatognosia." *Neurology* 40 (September 1990), 1291–1394.

Foldi, Nancy S. "Appreciation of Pragmatic Interpretations of Indirect Commands: Comparison of Right and Left Hemisphere Brain-Damaged Patients." *Brain and Language* 31 (1987), 88–108.

Fridlund, Alan J. *Human Facial Expression.* San Diego: Academic Press, 1994.

Fuchs, R.H. *Dutch Painting.* New York: Thames & Hudson, 1978.

Gabel, John, and Charles Wheeler. *The Bible as Literature.* 2nd ed. Oxford: Oxford University Press, 1990.

Gablik, Suzi. *Progress in Art.* New York: Rizzoli, 1977.

Gardner, Helen. *Art Through the Ages.* 8th ed. San Diego: Harcourt Brace Jovanovich, 1986.

Gardner, John, and John Maier, with the assistance of Richard A. Henshaw. *Gilgamesh.* New York: Vintage Books, 1985.

Geike, Archibald. *The Love of Nature Among the Romans.* London: John Murray, 1912.

Geschwind, Norman. "Specializations of the human brain." In *The Emergence of Language: Readings from Scientific American Magazine,* ed. William S.-Y. Yang, 77. New York: W.H. Freeman, 1990.

Giedion, S. *The Eternal Present: The Beginning of Art.* New York: Bollingen Foundation, 1962.

Gill, Christopher. *Personality in Greek Epic, Tragedy, and Philosophy.* New York: Oxford University Press, 1996.

Goldin, Frederick. *The Mirror of Narcissus in the Courtly Love Lyric.* Ithaca: Cornell University Press, 1967.

Gowans, Alan. "Child Art as an Instrument for Studying History." *Art History.* 2.3 (September 1979), 247–274.

Grant, Michael. *Cities of Vesuvius: Pompeii and Herculaneum.* New York: Penguin Books, 1976.

Greene, Brian. *The Elegant Universe.* New York: Vintage Books, 2000.

Grüsser, Otto-Joachim, Thomas Selke, and Barbara Zynda. "Cerebral Lateralization and Some Implications for Art." In *Beauty and the Brain,* Ingo Rentschler et al., eds., 257–296. Basel: Birkhäuser Verlag, 1988.

Gurevich, A.J. *Categories of Medieval Culture.* Trans. from the Russian by G.L. Campbell. London: Routledge & Kegan Paul, 1985.

_____. *Historical Anthropology of the Middle Ages.* Chicago: University of Chicago Press, 1992.

_____. *Medieval Popular Culture: Problems of Belief and Perception.* Trans. János M.

Bak and Paul A. Hollingsworth. Cambridge, England: Cambridge University Press, 1988.

Habib, Michel. "Visual hypoemotionality and prosopagnosia associated with right temporal lobe isolation." *Neuropsychologia*. 2.4 (1986), 577–582.

Hadingham, Evan. *Secrets of the Ice Age*. New York: Walker, 1979.

Harries, Karsten. *Infinity and Perspective*. Cambridge, Mass.: The MIT Press, 2001.

Hatzfeld, Jean. *History of Ancient Greece*. Trans. A.C. Harrison. New York: W.W. Norton, 1968.

Havelock, Christine Mitchell. *Hellenistic Art*. 2nd ed. New York: W.W. Norton, 1981.

Ho, Mae-Wan. "Environment and heredity in development and evolution." In *Beyond Neo-Darwinism: An Introduction to the New Evolutionary Paradigm*, Mae-Wan Ho and P.T. Saunders, eds., 267–290. London: Academic Press 1984.

_____, and Peter T. Saunders. "The epigenetic approach to the evolution of organisms—with notes on its relevance to social and cultural evolution." In *Learning, Development and Culture*, H.C. Plotkin ed., 343–361. Chichester, New York: John Wiley & Sons, 1982.

Hoffman, Martin L. "Interaction of affect and cognition in empathy." In *Emotions, Cognition and Behavior*, Carroll E. Izard, Jerome Kagan and Robert B. Zajonc eds., 103–131. Cambridge: Cambridge University Press, 1984.

Holmes, George. *The Florentine Enlightenment*. New York: Oxford University Press, 1969.

_____. *The Iliad*. Trans. Robert Fitzgerald. Chicago: University of Chicago Press, 1951.

_____. *The Odyssey*. Trans. Robert Fitzgerald. New York: Doubleday, 1961.

Huey, Raymond B., et al. "Rapid Evolution of a Geographic Cline in Size in an Introduced Fly." *Science* 287 (January 14, 2000), 308–309.

Hufschmidt, Hans-Joachim. "Das Rechts-Links Profil im kulturhistorischen Längschnitt." *Archiv für Psychiatrie und Nervenkrankenheiten* 229 (1980), 17–43.

Hussey, Edward. *The Presocratics*. New York: Scribner's Sons, 1972.

Hyman, Isabelle, ed. *Brunelleschi in Perspective*. Englewood Cliffs, N.J.: Prentice-Hall, 1974.

Iaccino, James F. *Left Brain–Right Brain Differences*. Hillsdale, N.J.: Lawrence Erlbaum, 1993.

Ivins, William M., Jr. *Art and Geometry*. Cambridge, Mass.: Harvard University Press, 1946.

Ivry, Richard B., and Lynn C. Robertson. *The Two Sides of Perception*. Cambridge Mass.: MIT Press, 1998.

Jablonka, Eva, and Marion Lamb. *Epigenetic Inheritance and Evolution: The Lamarckian Dimension*. New York: Oxford University Press, 1995.

Janson, H.W. *History of Art*. New York: Harry N. Abrams, n.d.

Joseph, R. *The Right Brain and the Unconscious*. New York: Plenum Press, 1992.

Kähler, Heinz. *The Art of Rome and Her Empire*. Trans. J.R. Foster. Rev. ed. New York: Greystone, 1965.

Kahn, Peter H., Jr. *The Human Relationship with Nature*, Cambridge, Mass.: The MIT Press, 1999.

Kantorowicz, Gertrude. *The Inner Nature of Greek Art*. Trans. J.L. Benson. New Rochelle, New York: Aristide D. Caratzas, 1992.

Keenan, Julian Paul, et al. "Hand response differences in a self-face identification task." *Neuropsychologia* 38.7 (June 2000), 1047–1053.

_____, et al. "Left hand advantage in a self-face recognition task." *Neuropsychologia* 37.12 (November 1999),1421–1425.

_____, et al. "Self-recognition and the right hemisphere." *Nature* 409 (January 18, 2001), 305.

_____, et al. "Self-recognition and the right prefrontal cortex." *Trends in Cognitive Sciences* 4.10, (October 2000), 403.

Kelemen, Pál. *Medieval American Art*. 3rd rev. ed. New York: Dover Publications, 1969.

Kemp, Martin. "Science, Non-Science and Nonsense: The Interpretation of Brunelleschi's Perspective." *Art History* 1.2 (June 1978), 134–161.

Kircher, Tilo T.J., et al. "The neural correlates of intentional and incidental self processing." *Neuropsychologia* 40 (2002), 683–692.

Kitzinger, Ernst. *Early Medieval Art in the British Museum*. London: The Trustees of the British Museum, 1960.

Koontz, Rex, et al. *Landscape and Power in Ancient Mesoamerica*. Boulder, Colo.: Westview Press, 2001.

Kubovy, Michael. *The Psychology of Perspective and Renaissance Art*. Cambridge, Mass.: Cambridge University Press, 1986.

Kuwayama, George, ed. Introduction to *Japanese Ink Painting*. Los Angeles: Museum Associates, Los Angeles County Museum of Art, 1985.

Laing, Ronald D. *The Divided Self*. Harmondsworth, U.K.: Penguin Books, 1965.

Landman, Otto E. "The inheritance of acquired characteristics." *Annual Review of Genetics* 25 (1991), 1–20.

_____. "Inheritance of acquired characteristics revisited." *Bioscience*. 43.10 (November 1993), 696–705.

Lee, Sherman E. *Chinese Landscape Painting*. 2nd ed. Cleveland: The Cleveland Museum of Art, n.d.

Le Goff, Jacques. *Medieval Civilization*. Trans. Julia Barrow. London: Basil Blackwell, 1989.

León-Portilla, Miguel. *Pre-Columbian Literatures of Mexico*. Norman: University of Oklahoma Press, 1969.

Levy, Jerre. "Cerebral asymmetry and the aesthetic experience." In *Beauty and the Brain*, Ingo Rentschler, et al., eds., 219–242. Basel: Birkhäuser Verlag, 1988.

Lewis, C.S. *The Allegory of Love*. London: Oxford University Press, 1936.

Losos, Jonathan B., et al. "Adaptive differentiation following experimental island colonization in Anolis lizards." *Nature* 387 (1 May 1997), 70–72.

Lullies, Reinhard, and Max Hirmer. *Greek Sculpture*. New York: Harry N. Abrams, 1957.

Lumsden, Charles J., and Edward O. Wilson, *Genes, Mind and Culture*. Cambridge: Harvard University Press, 1981.

_____, and _____. "Précis of Genes, Mind and Culture." *The Behavioral and Brain Sciences* 5 (1982), 1–37.

_____, and _____. *Promethean Fire*. Cambridge, Mass.: Harvard University Press, 1983.

Luquet, Georges Henri. *The Art and Religion of Fossil Man*. Trans. J. Townsend Russell Jr. New Haven: Yale University Press, 1930.

MacPhee, Donald. "Directed evolution reconsidered." *American Scientist* 81 (November-December 1993), 544.

Magnusson, Magnus, trans. *Laxdæla Saga*. London: Penguin, 1969.

_____. *Njals Saga*. London: Penguin, 1960.

Maguire, Eleanor A., and Catherine J. Mummery. "Differential Modulation of a Common Memory Retrieval Network Revealed by Positron Emission Tomography." *Hippocampus* 9 (1999), 54–61.

Manetti, Antonio di Tuccio. *The Life of Brunelleschi*. Trans. Catherine Enggass. University Park: Pennsylvania State University Press, 1970.

Marcucci, Luisa, and Emma Micheletti. *Medieval Painting*. Trans. H.E. Scott. New York: The Viking Press, 1960.

Martínez, José Luis. *Nezahualcóyotl*. Mexico, D.F.: Fondo De Cultura Económica, 1972.

Maus, Marce. "A category of the human mind; the notion of person; the notion of

self." In *The Category of the Person,* Michael Carrithers et al., eds. Cambridge, Mass.: Cambridge University Press, 1985.

Meador, K.J., et al. "Anosognosia and asomatognosia during intracarotid amobarbital inactivation," *Neurology* 55 (September 2000), 816–820.

Michalowski, Kazimierz. *Art of Ancient Egypt.* New York: Harry N. Abrams, n.d.

Mikalson, Jon D. *Athenian Popular Religion.* Chapel Hill, N.C.: University of North Carolina Press, 1983.

Miller, Arthur G. *The Mural Painting of Teotihuacán.* Washington, D.C.: Dumbarton Oaks Research Library and Collection Trustees for Harvard University, 1973.

Miller, Mary Ellen. *The Murals of Bonampak.* Princeton: Princeton University Press, 1987.

Molnar, François. "A science of vision for visual aesthetics." In *Emerging Visions of the Aesthetic Process,* Gerald Cupchik and János László, eds. Cambridge, Mass.: Cambridge University Press, 1992.

Morell, Virginia. "Predator-free guppies take an evolutionary leap forward." *Science* 275 (28 March 1997), 1880. Quoting Philip Gingerich.

Morris, Colin. *The Discovery of the Individual, 1050–1200.* 2nd ed. Toronto: University of Toronto Press, 1987.

Morris, William, trans. *Song of the Volsungs and the Nibelungs.* Chicago: Henry Regnery, 1949.

Munakata, Kiyohiko. *Sacred Mountains in Chinese Art.* Urbana and Chicago: University of Illinois Press, 1991.

Murdoch, Iris. *The Fire and the Sun.* London: Oxford University Press, 1977.

Myers, Bernard S. *Art and Civilization.* New York: McGraw-Hill, 1957.

Naveh, Joseph. "The origin of the Greek alphabet." In *The Alphabet and the Brain,* Derrick de Kerckhave and Charles J. Lumsden, eds. 84–91. Berlin: Springer-Verlag 1988.

Nebes, Robert D. "Superiority of the minor hemisphere in commissurotomized man for the perception of part-whole relations." *Cortex* 7 (1971), 333–349.

Nicolson, Marjorie Hope. *Mountain Gloom and Mountain Glory.* (First published, Cornell University, 1959) Seattle: University of Washington Press, 1997.

_____. *Science and Imagination.* Ithaca, NY: Great Seal Books, 1956.

Nikolaenko, N.N., et al. "Representation activity of the right and left hemispheres of the brain." *Behavioral Neurology* 10 (1997), 49–59.

_____, and A.Yu Egorov. "The role of the right and left cerebral hemispheres in space perception: Communication I. Object perception and reflection in the frontal plane." *Human Physiology* 24.5 (1998), 566–575. Trans. from *Fiziologiya Cheloveka* 24.5 (1998), 54–64.

Nilsson, Martin P. *Greek Folk Religion.* Philadelphia: University of Pennsylvania Press, 1984.

Oke, Arvin, et al. "Lateralization of Norepinephrine in Human Thalamus." *Science* 200 (23 June 1978), 1411–1413.

Pearsall, Derek, and Elizabeth Salter. *Landscape and Seasons of the Medieval World.* London: Paul Elek, 1973.

Pelling, Christopher, ed. *Characterization and Individuality in Greek Literature.* New York: Oxford University Press, 1990.

Pfluger, Carl. "Progress, Irony and Human Sacrifice." *The Hudson Review* 48.1 (spring 1995) 67–92.

Pfuhl, Ernst. *Masterpieces of Greek Drawing and Painting.* Trans. J.D. Beazley. New York: Hacker Art Books, 1979.

Piaget, Jean, and Bärbel Inhelder. *The Child's Conception of Space.* Trans. F.J. Langdon & J.L. Lunzzer. New York: W.W. Norton, 1967.

Plato. *The Republic.* Trans. Benjamin Jowett. New York: Airmont Publishing, 1968.

Poincaré, H. *The Foundations of Science.* New York: The Science Press, 1913.

Pollitt, J.J. *Art in the Hellenistic Age*. Cambridge, Mass.: Cambridge University Press, 1986.

Polo, Marco. *The Travels of Marco Polo*. New York: The New American Library of World Literature, 1961.

Rankin, H.D. *Plato and the Individual*. London: Methuen, 1964.

Reznick, David N., et al. "Evaluation of the rate of evolution in natural populations of guppies (Poecillia reticulate)." *Science* 275 (28 March 1997), 1934–1937.

Richter, Gisela. Introduction to *Greek Painting*. New York: Metropolitan Museum of Art, 1952.

_____. *Perspective in Greek and Roman Art*. London: Phaidon Press, n.d.

Ricouer, Paul. *The Rule of Metaphor*. Trans. Robert Cserny with Kathleen McLaughlin and John Costello. Toronto: University of Toronto Press, 1977.

Rinn, William E. "The neuropsychology of facial expression: A review of the neurological and psychological mechanisms for producing facial expressions." *Psychological Bulletin* 95.1 (1984).

Rose, H.J. *Religion in Greece and Rome*. New York: Harper & Brothers, 1959.

Rougemont, Denis de. *Love in the Western World*. Trans. Montgomery Belgion. Rev. and augmented ed. Princeton, N.J.: Princeton University Press, 1983.

Routtenberg, Aryeh. "The Reward System of the Brain." In *Scientific American: The Workings of the Brain, Development, Memory, and Perception*, 75–87. New York: W.H. Freeman, 1990.

Sagan, Carl. *The Demon Haunted World*. New York: Ballentine Books, 1996.

Salvani, Roberto. *All the Paintings of Giotto*, part I. Trans. Paul Colaccicchi. London: Oldbourne, 1963.

Schäfer, Heinrich. *Principles of Egyptian Art*. 1st English ed. Trans. John Baines; Emma Brunner-Traut and John Baines, eds. Oxford: Oxford University Press, 1974.

Schick, Kathy D., and Nicholas Toth. *Making Silent Stones Speak*. New York: Simon & Schuster, 1993.

Schmalenbach, Werner. "Toward an aesthetic of Black African Art." In *African Art*, trans. Jeffrey Haight and Russell Stockman; Werner Schmalenbach, ed. Munich: Prestel-Verlag, 1988.

Selfe, L. *Normal and Anomalous Representational Drawing Ability in Children*. London: Academic Press, 1983.

Sickman, Laurence C.S., and Alexander Soper. *The Art and Architecture of China*. Baltimore: Penguin Books, 1971.

Sieveking, Ann. *The Cave Artists*. London: Thames and Hudson, 1979.

Sirén, Osvald. *The Chinese on the Art of Painting*. Peiping: Henri Vetch, 1936.

Skoyles, John Robert. "The case against the left hemisphere literacy paradigm." In *The Alphabet and the Brain*, Derrick de Kerckhove and Charles J. Lumsden, eds., 362–380. Berlin: Springer-Verlag, 1988.

Soutar, George. *Nature in Greek Poetry*. London: Oxford University Press, 1939.

Springer, Sally, and Georg Deutsch. *Left Brian, Right Brain*. Rev. ed. New York: W.H. Freeman, 1985.

Stanford, Bedell W. *Greek Metaphor: Studies in Theory and Practice*. Oxford: Basil Blackwell, 1936.

Steele, Edward J. *Somatic Selection and Adaptive Evolution*, 2d ed. Chicago: The University of Chicago Press, 1981.

_____, et al. *Lamarck's Signature*. Reading, Mass.: Perseus Books, 1988.

Steiner, Deborah. *The Crown of Song: Metaphor in Pindar*. London: Gerald Duckworth, 1986.

Stephens, John. *The Italian Renaissance*. London: Longman, 1990.

Stokstad, Marilyn. *Art History*. New York: Harry N. Abrams, 1995.

Sullivan, Michael. *The Birth of Landscape Painting in China*. Berkeley: University of California Press, 1962.

Swann, Peter. *Art of China, Korea and Japan*. New York: Frederick A. Praeger, 1963.

Thacker, Christopher. *The Wildness Pleases*. New York: St. Martin's Press, 1983.

Thomas, Keith. *Man and the Natural World*. London: Penguin Books, 1983.

Tigay, Jeffrey H. *The Evolution of the Gilgamesh Epic*. Philadelphia: University of Pennsylvania Press, 1982.

Travis, John. "Evolutionary Shocker?" *Science News* 161 (June 22, 2002) 394–396.

Tregeau, Mary. *Chinese Art*. London: Thames and Hudson, 1980.

Tucker, Don M. "Lateral Brain Function, Emotion, and Conceptualization." *Psychological Bulletin* 89.1 (1981), 19–46.

_____, and Peter A. Williamson. "Asymmetric Neural Control Systems in Human Self-Regulation." *Psychological Review* 91.2 (1984), 185–215.

Turner, Norman. "The Semantic of Linear Perspective." *The Philosophical Forum* 27.4 (summer 1996), 357–379.

Ucko, Peter J., and Andrée Rosenfeld. *Palaeolithic Cave Art*. Trans. Sara Champion. Cambridge (Cambridgeshire): Cambridge University Press, 1982.

Vasari, Gorgio. *The Lives of the Painters, Sculptors and Architects*. Vol. 1. London: J.M. Dent & Sons, 1980.

Waddington, C.H. *The Evolution of an Evolutionist*. Ithaca: Cornell University Press, 1975.

_____. "Evolutionary Adaptation." In *Learning, Development and Culture,* H.C. Plotkin, Chichester, ed. 173–193. New York: John Wiley & Sons, 1982.

Warry, J.G. *Greek Aesthetic Theory*. New York: Barnes & Noble, 1962.

Webster, T.B.L. *The Art of Greece: The Age of Hellenism*. Rev. ed. New York: Greystone Press, 1967.

Wechsler, Judith. Introduction to *Aesthetics in Science*. Judith Wechsler, ed. Cambridge, Mass.: MIT Press, 1978.

Wheeler, Mark A., et al. "Toward a Theory of Episodic Memory: The Frontal Lobes and Autonoetic Consciousness." *Psychological Bulletin* 121.3 (1997), 331–354.

White, John. *The Birth and Rebirth of Pictorial Space*. New York: Thomas Yoseloff, 1958.

Wiedemann, Alfred. *Popular Literature in Ancient Egypt*. Trans. Jane Hutchinson. London: David Nutt, 1902.

Wilde, Oscar. "The Decay of Lying." Reprinted in part as "Nature's Imitation of Art," in *A Modern Book of Esthetics,* 3rd ed., Melvin Rader, ed., 20–22. New York: Holt Rinehart and Winston, 1961.

Wilson, Robert. "Interview with Linda Dackman." *Arts and Architecture* 3.1 (1984).

Winner, Ellen, and Howard Gardner. "The Comprehension of Metaphor in Brain-Damaged Patients." *Brain* 100 (1977), 717–729.

Wood, Christopher S. *Albrecht Altdorfer and the Origins of Landscape*. Chicago: The University of Chicago Press, 1993.

Worringer, Wilhelm. *Abstraction and Empathy*. (First German publication 1908) Trans. Michael Bullock. New York: International Universities Press, 1953.

_____. *Egyptian Art*. London: Putnam's Sons, 1928.

Wright, Lawrence. *Perspective in Perspective*. London: Routledge & Kegan Paul, 1983.

Yip, Wai-lim, ed. and trans. *An Anthology of Major Modes and Genres*. Durham: Duke University Press, 1997.

Yoon, Carol Kaeesuk. "Scientists' Hopes Raised for a Front-Row Seat to Evolution." *New York Times* (October 24, 2000), D5.

Index